New York Interiors

AT THE
TURN OF THE CENTURY

New York Interiors
AT THE
TURN OF THE CENTURY

IN 131 PHOTOGRAPHS BY

Joseph Byron

*From the Byron Collection of the Museum
of the City of New York*

TEXT BY CLAY LANCASTER

*Published in Cooperation
with the Museum of the City of New York by*

DOVER PUBLICATIONS, INC., NEW YORK

ACKNOWLEDGMENT

This project is a joint endeavor of the Museum of the City of New York and Dover Publications.

The Dover staff is grateful for the unstinting cooperation of the Museum personnel, special thanks being due to Mr. Joseph Veach Noble, Director; Mr. A. K. Baragwanath, Senior Curator; and Mrs. Susan McTigue, Registrar.

Published in Canada by General Publishing Company, Ltd., 30 Lesmill Road, Don Mills, Toronto, Ontario.
Published in the United Kingdom by Constable and Company, Ltd., 10 Orange Street, London WC 2.

New York Interiors at the Turn of the Century is a new work, first published by Dover Publications, Inc., New York, in 1976.

International Standard Book Number: 0-486-23359-6
Library of Congress Catalog Card Number: 76-8308

Manufactured in the United States of America
Dover Publications, Inc.
180 Varick Street
New York, N.Y. 10014

Introduction

In 1888 Joseph Byron landed in America. Byron's family had been professional photographers for three generations, originally in Nottingham on the Trent, England, and he was bent upon opening a studio in New York City. Accompanying him were his wife, Julia Lewin, and his eldest daughter, Maude Mary. The following year the four other children arrived, escorted by their grandmother. The older son, Percy C., then eleven, had been taking pictures for several years, and he and his brother, Louis Philip, and sisters (including Florence Mabel and Georgiana) and their mother all were to work in various departments of the Byron photography plant.

The business got off to a modest start in New York, but by the early 1890s Joseph Byron was receiving commissions to record a wide selection of metropolitan life and its setting, ascending to the highest stratum of society. That the volume accelerated phenomenally is indicated by the numbering on the prints, which during the first years increased annually by a few hundred, but by the beginning of the twentieth century was skyrocketing each year by the thousands.

The Byron camera was focused on everything from the Charles Scribner's Sons building to Lower East Side pushcarts, from Central Park to slum playgrounds, from Madison Square Garden to the Battery "el" station, from fashionable Turkish baths to the Coney Island beach, from millionaires' palaces on Fifth Avenue to "Little Italy" tenements of Harlem, from summer roof gardens to winter blizzards, from Broadway theatres to bicycle shows, from fancy balls to the hurdy-gurdy, from a display of new automobiles at the Astor to bobtailed trolleys, from a lavish Arabesque stairhall to a college student's dormitory, from the Aeolian Music Hall to a Bowery mission, from a busy luncheon scene at Delmonico's to a lull at Childs, from the lounge of a luxury liner at its New York wharf to the arrival of immigrants in steerage, and from the Easter Parade by the old Fifth Avenue reservoir to Sabbath ramblings in Greenwood Cemetery.

Joseph Byron photographed the great and near-great, including Elsie de Wolfe, Mrs. Frank Leslie, Lola Montez, Mark Twain, Eastman Johnson, J. Q. A. Ward, Ernest Thompson Seton and Prince Louis of Battenberg. His roster of theatrical portraits included the names of David Belasco, Joseph M. Weber, John Drew, Mme. Réjane, Maude Adams, Ethel Barrymore, Alice Nielsen, Lillian Russell and Sarah Bernhardt. The divine Sarah was so pleased with the photographer and his work that she called him "Lord" Byron. Among his wealthy clients were Cornelius Vanderbilt II, Mrs. William B. Astor, William Collins Whitney, Chauncey Mitchell Depew, Mrs. Theodore Augus-

tus Havemeyer and Helen Gould. Joseph Byron also shot the flats of lowly tailors, the kitchens of suburbanites, the dens of athletes, a child's nursery, and barber shops, corporation offices, ticket agencies, counting rooms, soda fountains, stores and cigar stands.

His wide range of subjects afforded breadth to the present album of interiors selected from the Byron Collection at the Museum of the City of New York. The pictures cover that exuberant design period—lasting the two decades between the Chicago Columbian Exposition and the outbreak of World War I—during which Eclecticism culminated and terminated. This American era is often translated into the English equivalent, as the late Victorian and Edwardian periods, though it actually extends a few years longer, Edward VII having died in 1910. Byron's photographs were limited to New York City and its environs, the most distant example being at Lyndhurst (Plate 1), only 14 miles away from the northern extremity of Manhattan Island. But because the cultural domain was expansive, and this was, after all, cosmopolitan New York, the interiors shown represent the taste of the nation at large and the style trend of most of the civilized world.

Joseph Byron's interior photographs were made by flashlight, that is, were lit by exploding magnesium powder from somewhere in the vicinity of the camera to minimize shadows. The portrait photographer in Plate 124 holds such a source of illumination in his right hand. Often (as in the plate cited) artificial and natural lighting were combined to obtain a realistic effect. In large places, two or three flashes would be used, all going off simultaneously. In Plate 91, depicting the automobile show in the Hotel Astor ballroom, one can discern several separate shadows (as beyond the front wheels of the first car to the left), indicating the number of flashes. In the lower left-hand corner of this photograph, beneath the usual signature ("Byron N.Y."), appears the inscription "Photo by 'Byrolight.'" The writing was imposed upon the negative and appeared on every print. The lighting notice (like the copyright and date) is rare, usually having the negative number in its place.

If Byron can be said to have specialized, it was in taking theatre pictures, of which only a related subject, the Aeolian Music Hall, formerly on West 42nd Street, is included in our collection (Plate 103). Often they would show a full cast on the stage. These were made at the time of a dress rehearsal (sometimes before reaching New York) and were used for publicity.* The Byron crew carried along a portable platform for the camera. It was set up on top of the seats and could be moved forward or backward for taking close-ups or the entire stage. Because of the thick cloud of smoke that followed each flash, there was often a long wait for the atmosphere to clear before taking another picture. Or, sometimes, to get the better of Father Time, two nearby shots could be made before the first billow of blackness descended. The photographer's letterhead, early in the century, reproduced three medals awarded for artificial lighting. The letterhead slogan read: "THE STAGE IS MY STUDIO."

Actually, as has been suggested, New York City was his studio. Of the nearly eleven dozen photographs making up the present album, about two-thirds are domestic scenes, and the balance are of institutions, hostelries, public refectories, refreshment and recreational places, banks and commercial establishments, offices, and a British steamship moored in New York harbor. People's homes offer the most intimate glimpses of a civilization. We can get closer to the personal life of the Romans through the residential findings at Pompeii than through all of the fora, circuses, theatres and amphitheatres, triumphal arches, palaces, basilicas, temples and other monuments throughout the Mediterranean empire. We may be awed by the Colosseum, but we can relate to and in our imagination inhabit the House of Pansa. What can we grasp of the Greeks from the Acropolis? Something of the high and specialized —actually limited—order of their art, of their culture on parade, but next to nothing of the people themselves, of their feelings and everyday preferences. These would have been reflected at the hearthside, but no Vesuvius packed an Athenian home in ashes for later generations to uncover, as along the Bay of Naples. The late Victorian and Edwardian civilizations of New York have been superseded by cultures as different from them as those that replaced old Rome and Athens were different from the ancient nations bordering the Adriatic and Aegean seas. With the acceleration of change in the twentieth century, the pre-World War I era has come to seem virtually as remote as antiquity.

* Twenty-three Byron theatre pictures with actors on stage are included in the 1976 Dover volume *The New York Stage; Famous Productions in Photographs,* edited by Stanley Appelbaum.

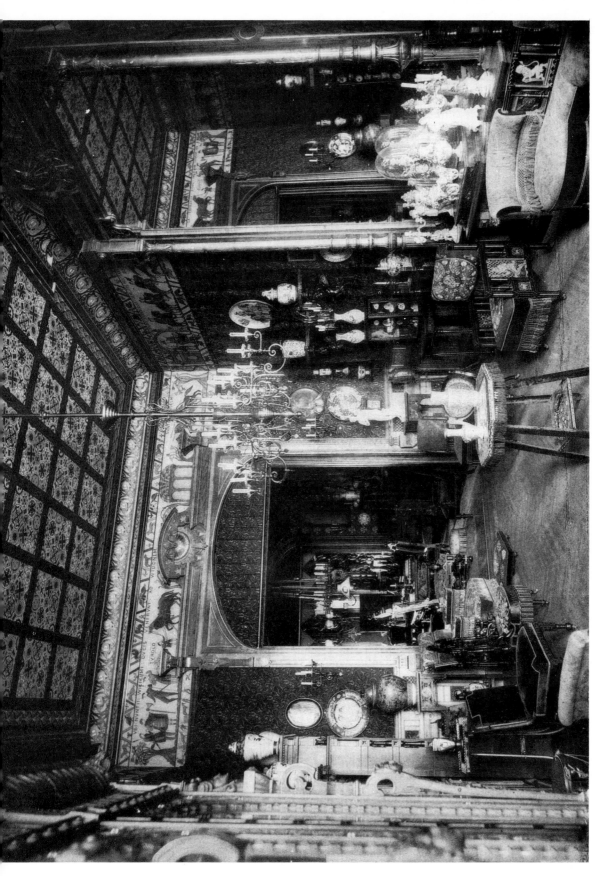

FIG. A. Drawing Room in Dr. William A. Hammond's House, West 54th Street (from *Artistic Houses*, Vol. I, Part II, New York, 1883–84).

Joseph Byron was our Vesuvius, who blew off his magnesium and thus preserved the setting of a vanished race, which was not buried beneath cinders and lava but mirrored on sensitized glass plates that readily surrender the most delicate details of their recordings. The "things" shown in the photographs, as individual items, in combination and as arrangements, tell us much about their owners. Some of the buildings to which these interiors belong were upwards of a half-century old at the time they were photographed, and retain earlier features. This is true for the Gothic Revival Lyndhurst (Plate 1) and two Greek Revival residences in the Greenwich Village section (Plates 6 and 47). Lyndhurst had kept not only architectural features of the house but some of the belongings of former owners, such as the sculpture group. We have the opportunity of observing another example of retention of much of the décor of a former owner in Byron's views of the Chauncey Mitchell Depew house (Plates 38–41), several of whose interiors had been published in *Artistic Houses* (New York, 1883–84), showing them as decorated for Dr. William A. Hammond in 1873. Reproduced here from that volume (Figure A) is the drawing room, with its frieze design taken from the tapestry in the museum at Bayeux. The frieze, ceiling, mantel, mirror and wall covering remained intact under the later owner (Plate 40).

A number of pictures show what must be family heirlooms. The most obvious are the portraits on the back wall of the parlor of Mrs. Kress, who stands before them herself, assuming the nobility of expression befitting an ancestor (Plate 24).

By the end of the nineteenth century, the furniture industry in the United States had shifted from shops in the population centers along the East Coast to the Great Lakes region; instead of showing local and personal characteristics of name makers, furniture was being mass-produced along cold industrial lines or else copied after well-defined period pieces. The latter category required great adaptation of the mechanical means, more attention to details, and hence it was more expensive. It is to be found in the homes of the wealthy, supplementing or substituting for genuine antiques, as in the Astor and Whitney ballrooms (Plates 10 and 26). From photographs one cannot tell whether these pieces are of old or recent manufacture. Insofar as effect is concerned, it does not really matter. When one finds twenty chairs exactly alike, one suspects the source as being Grand Rapids. It was from the World's

Columbian Exposition at nearby Chicago in 1892–93 that the Michigan furniture mart took its cue of assuming a borrowed traditionalism. This was by way of compensating for its grass-roots self-consciousness. The same sense of provincialism prompted the assertion of an innate creativeness, which was a secondary factor at the fair and accounts for the nontraditional type of furniture made. The new forms that evolved from the stimulus of the Columbian Exposition generally were more exciting as Chicago School architecture than as Grand Rapids furniture. But more of this anon.

Any period covering a score of years in America, following permanent white settlement, is one of transition and of contrasts. Seventeenth-century Englishmen at the extremes of society lived at different time levels: the poor people maintained their old, indigenous (mostly Gothic) inheritance, whereas the aristocracy had adopted new (Renaissance) palatial surroundings imported from Italy. Colonizers after religious freedom settling farms in bleak New England adhered to the former, and landed gentry acquiring vast plantations in Virginia and the Carolinas gravitated to the latter. Elements of the retarded or medieval style persisted through the eighteenth and up to at least the middle of the nineteenth century in American building, whereas classic columned doorways, pediments, balustraded balconies and sash windows already had begun to appear in rudimentary form during the late 1600s. Steady immigration from abroad fed the diversity, and although most of the country had become fairly well unified in character by the time of the nation's hundredth birthday, in the ports of entry—of which New York remained foremost—the unmixed strains of influx continued to persist to a marked degree. Our New York interiors of from 1893 to 1916 show considerable diversity.

Nevertheless, on the whole, New York always has been admittedly conservative in design matters. The exotic styles (the Chinese, and the Greek and Gothic Revivals) that were introduced in Philadelphia at the end of the eighteenth century (and even the Renaissance Revival of the early nineteenth) were not manifested in New York until several decades later. Town houses remained essentially Federal in style until the middle third of the 1800s. Although the Romanesque Revival got its start in the United States in Richard Upjohn's Church of the Pilgrims (1844) on Brooklyn Heights (for a long time an isolated example),

and although J. C. Cady's main building of the American Museum of Natural History is contemporary with Henry Hobson Richardson's Trinity Church in Boston, New York was not to employ the Richardsonian manner to the extent it was endorsed elsewhere. The innovator Louis Sullivan, given hearty patronage outside, was associated in producing only two works in New York, Carnegie Hall (1891) and the Bayard Building (1897–98) on Bleecker Street. A Frank Lloyd Wright building for New York, the Guggenheim Museum, did not materialize until 1959, in Wright's seventy-second year of practice and the year he died. Even the skyscraper, for which New York is famous, is claimed to have originated with Leroy S. Buffington in Minneapolis or in William LeBaron Jenney's ten-story Home Insurance Company building (1883–85) in Chicago. New York made worthy contributions, like the Singer Building at 149 Broadway, built in 1897–98, with tower added in 1906–08, though its outstanding specimens (Raymond M. Hood's Daily News Building, Rockefeller Center, Ludwig Mies van der Rohe and Philip Johnson's Seagram Building, etc.) are beyond the time limits of the current study.

We do injustice to New York if we overlook its distinguished architectural monuments. Favorites are the Roger Morris house ("Jumel Mansion," 1765, with later portico), Thomas McBean's St. Paul's Chapel (1766, tower by James Crommelin Lawrence, 1793–94), Joseph Mangin and John McComb's City Hall (1803–12), James Renwick's Grace Church (1846), certain works by the firm of McKim, Mead and White, such as the Villard Mansions (1885), the second Madison Square Garden (1890), Columbia University (1892–97) and Pennsylvania Station (1906–10), Carrère and Hasting's New York Public Library (1902–09), Warren and Wetmore's Grand Central Station (1903–13), Richard Morris Hunt's Metropolitan Museum of Art (1902), and the same architect's W. K. Vanderbilt (1882) and Mrs. William B. Astor (1891) châteaux, and Cass Gilbert's Woolworth Building (1911–13). These all were in existence during the Byron period, though some have been razed since. The majority show remarkably fine solutions to the architectural and urban problems confronted, yet they cannot be said to be particularly innovative in design styling. Mention should be made at this point of a type of New York building that was a new phenomenon in the annals of construction, though initially it left much to be desired aesthetically. This was the all-iron building, initiated by engineer James Bogardus during the late 1840s, using module pieces, as in his factory at Duane and Centre Streets. Within a decade, due to the fabrication of a full line of classic-order members, iron facades became ornamental assets to the metropolis, and the mode lasted until early in the twentieth century.

So much for the setting. Our proper subject is a penetration into the buildings. In terms of design, interiors ought to be integral with external architecture. The rule was relaxed during the regime of Eclecticism, which came after the more consistent and uniform revivals of the eighteenth and early nineteenth centuries. This was especially true in the city, where multiple-family buildings were regarded impersonally by the tenants. In fact, even though most of Byron's clients lived in private houses, those dwellings in which several rooms are represented in photographs usually show a mixture of styles—if not in the same room, at least from room to room. The exceptions were the homes of the extremely wealthy, those who could afford to have a single architect or firm design the building in its entirety. In the next lower monetary bracket, rooms and furnishings were integrated to each other but generally had little to do with the architectural shell housing them. This situation bears the mark of professional interior decorators, who, then as now, strove for superficial effects, ignoring overall considerations. Finally, the less affluent, dispensing with hired assistance, resorted to furnishings dictated by their own taste and finances, used in whatever spaces were available. The last group, of course, constituted the vast majority of the population.

It will be observed that the interiors shown in this album spottily reflect the gamut of world cultures as they then were known and understood. Historical chronology offers a convenient guide through the maze of forms used during the 1893–1916 period. Some examples are clearly derivative and others only remotely related to their archetypes. The starting point is with the ancient Egyptian style. It is reflected in the library of the Depew house and was part of the décor of the original owner (Plate 39). Included was an elaborately painted frieze and coved cornice, and there were Egyptianized heads on the mantel and decorative panel above. Nothing else in the room (in Depew's day) was dynastic, the Easternized gas chandelier being modern. Egyptian motifs played a part in the Napoleonic style, and an Empire chair in the Lauterbach bedroom has Pharaoh heads sup-

porting the arms on the front posts (Plate 32). An unexpected item is the stool in Plate 16, whose concave seat, strutted framework and shaped legs seem to be taken directly from New Kingdom models, either painted representations or actual finds. The stool in Mrs. Schroeder's bedroom is related (Plate 59).

Furniture of the Greeks and Romans had been exploited immeasurably during the reign of Classicism, so that our period borrowed conveniently from this recent source without having to go back to the original. Examples appearing in the Byron collection will be discussed in sequence pertaining to the later derivatives.

Accessories of the interim period between the disintegration of the Roman Empire and the advent of High Gothic made virtually no impression on later cultures, either because of being unknown or striking no favorable response. Overlapping and following the Classical Revival, the fifteenth-century style enjoyed a popular resurgence as the Gothic Revival, which will be taken up in due order.

Furnishings of the early Renaissance, which began in Italy, were sparse and largely architectural in character, prompting one to assume that the architects of the palazzi and villas designed the main pieces. Tables, beds, cupboards and dressers made use of classic orders, often as elongated colonnettes (as in the table in Plate 14 and cabinet in Plate 87), balusters (chair in doorway, Plate 87), and caryatids and terms as supports (sideboards in Plates 5 and 56). Sixteenth-century Italian tables took on the forms of Roman prototypes with sculptured supports, like that in Mrs. Kellogg's drawing room (Plate 75). Smaller pieces of furniture, such as chairs, often retained the Gothic square, although lighter in construction (Plates 14 and 20), and resorted to the curves of the antique curule—the Dante type—as in the upper hall of the Brandus house (Plate 51). Renaissance furniture occasionally combined several uses, as in the *cassapanca*, the chest-settle, evidently a remote ancestor of the bench-cabinets in the Sloane display (Plate 115).

The development of the Renaissance known as the Baroque, in force during the seventeenth century, was characterized by an emotionalism prompted by religious fervor under Catholicism and the megalomania of ambitious rulers (Louis XIV). Renaissance static articulation of parts gave way to a dynamic unification of design. Furniture followed the lead of Baroque architecture in em-

ploying manipulated and reduplicated elements, and both frequently incorporated twisted sculptured figures and other carvings among their members. Plain triangular pediments were replaced by irregularly shaped tympanums with broken and gooseneck cornices, resembling that capping the sideboards in the Mayer and Ziegler dining rooms (Plates 14 and 55). Figural table supports became distorted (something like those seen in Plate 18), stool and chair legs and arms changed from straight to curved (Plate 2—other than the benches), turned members changed to spirals (table in Plate 67), and curved console shapes and volutes abounded (bench in Plate 87). Larger pieces, stationed against the wall, became weighted down with sculpture in the round, accompanied by carved moldings, from which the sideboard in the Schroeder dining room derived (Plate 56). The Baroque period saw not only extraneous ornamentation of serviceable furniture but the appearance of purely decorative pieces, such as stands to hold busts or urns, bequeathing such articles to later generations (Plate 51).

The Rococo style of the early to middle eighteenth century was a fantasy, whose forms were inspired (as its name implies) from natural oddities, like rocks and seashells. The crescendo of writhing architectural members gave way to the piping of swaying grasses and scrolls, and delicate abstract undulations. The benches in the Havemeyer hall and the Hughes drawing room are typical (Plates 2 and 34). The Louis XV phase in France resorted to bulging shapes that were imitated in England (desk in Plate 64). The era of Louis XV was one of powdered hair and faces, and love of jewelry, prompting a pale interior tonality of ivory and gilt, with lobated panels holding winged cherubs painted in pastel colors, and dainty reliefs undulating in unexpected places. The bedroom in Plate 73 shows studied imitation of this manner. Chippendale exemplified the Rococo style in Georgian England; a couple of imperfect side chairs of the type show in Plates 36 and 40, and a cumbersome wing chair in Plate 67. They are of dark-stained mahogany and would be more characteristic if they had cabriole legs and ball-and-claw feet. Belonging to the same family is the American Philadelphia high chest with bonnet top. The example in Plate 52 seems to be a Centennial reproduction. The reverse-curve (cabriole) leg had been in use in China for several centuries when adopted in the West. Its derivation soon was forgotten, but influence from the Far East manifested itself con-

vincingly in Anglo-Chinese gardens (English parks) and *chinoiserie* decoration, which last subject will be taken up below.

The sobering aftermath of the frivolous Rococo was a return to Classicism, the new phase called the Classic Revival. Although a refined lightness remained, undulating lines were straightened through reinstatement of the column, or rather attenuated colonnette or baluster, for supports, as in table and chair legs and bed posts, and also applied to chests of drawers and cabinet fronts. Classicism prevailed from the Louis XVI (chair facing camera in Plate 10 and pair of cabinets in Plate 18) to the Napoleonic or Empire period (chair to the right in Plate 9 and furniture in the Lauterbach bedroom, Plate 32) in France; in Sheraton (chair by fireplace in Plate 21 and side chairs in Plate 47), Hepplewhite and Adam (small chair in Plate 6, wide seat in Plate 34 and center table in Plate 64—all modified) designs in England; and in the Federal period (largely influenced by the three British types) in America. The Roman-inspired Classic Revival was followed by the Greek Revival, during which the New York artisan Duncan Phyfe adapted the Greek *klismos* to a graceful chair with sabre legs (like that by the fireplace in Plate 7). Part of a late version of a Phyfe-type couch is shown in the Sherrill library (Plate 76). Distinctly Hellenic was the New York pier table of the second quarter of the nineteenth century. It had marble colonettes, pilasters and top and provided the model for the bar in Plate 95 and soda fountain in Plate 111.

Reaction against classic influences, which had taken on a number of forms over a span of five centuries, manifested itself as Romanticism during the late eighteenth and nineteenth centuries. The principal counterpart to the Classic and Greek Revivals in this era was the Gothic Revival. Romanticism and the Gothic mood were nourished largely by literature, by the English Graveyard Poets, led by Thomas Gray, and by novelists, of which group Horace Walpole (author of *The Castle of Otranto*), William Beckford (author of *Vathek*) and Sir Walter Scott (who wrote the Waverly novels, the narrative poem *The Lady of the Lake*, etc.) built great domestic establishments in the medieval style. Gray was adviser on archaeological correctness to Walpole's Strawberry Hill. Edgar Allan Poe's tales fed the vogue in the United States. Here one of the foremost architectural monuments of the Gothic Revival is the castellated Lyndhurst, a part of whose drawing

room is shown in Plate 1. When this photograph was made in 1893 the original accessories had been removed. Appropriate furniture for such buildings came largely from designs published by the Pugins in London, (Auguste Charles) *Pugin's Gothic Furniture* (1820) and Auguste Welby Pugin's *Gothic Furniture in the Style of the 15th Century* (1835). Chairs in the Lauterbach dining room bear a resemblance to specimens in the latter book (Plate 29). High-backed chairs in the Schroeder dining room (Plate 56) are similar to the "Scott" type in the garden pavilion at Buckingham Palace, as depicted by L. Gruner in his book on *The Decorations of the Garden-Pavilion*, issued in 1846. Except for the ceiling beams and baluster-legged table (unconvincing in execution), there is nothing else about the latter room suggestive of the Middle Ages. On the other hand, the Lauterbach refectory is romanticized Gothic throughout. Other examples derived from medieval sources are chairs and tables with shaped-board sides and (in chairs) backs. Several appear in the club room presented in Plate 68. A chair here has been called "Alpine," as many of the type appear in the mountainous region of Italy, France and Germany, but the prototype also is to be found elsewhere, as in England and even in Pennsylvania "Dutch" settlements in America.

The revivals were followed by Eclecticism in the United States during the middle of the nineteenth century. Prominent was a curvilinear mode of furniture, the lower part of which was based upon the Louis XV and the upper part (of seats at least) on the Louis XVI and Hepplewhite styles. The foremost exponent of the vogue in New York was John Henry Belter. The three open-back side chairs in the Dodd library (Plate 23) and the sofa and armchair by the polar-bear rug in the Hughes drawing room (Plate 35) are undoubtedly from his shop. Inasmuch as Belter adhered to the style up to the time of the Civil War, these pieces would have been but a single generation old when the photographs were made and originals rather than copies.

The innermost soul of Eclecticism was expressed in combining elements from unrelated sources creatively, thus contributing a new phenomenon to the march of civilization. The English Aesthetic movement of the latter half of the nineteenth century embraced this ideal. Following the precedent set by the Gothic Revival, it had a medieval background that was fostered by publications, chief of which were John Ruskin's *The Seven*

Lamps of Architecture (1849) and *The Stones of Venice* (1851), issued simultaneously in London and New York. For public buildings, multicolored Venetian Gothic, with its grid facade module, largely replaced drab British or North European models, with their strong vertical thrust. The companion in the domestic field was "Queen Anne," popularized by Richard Norman Shaw in England after 1860 (a decade later in America) and named after the early eighteenth-century ruler whose reign was characterized by style transition. In furniture, a wider range of colors and textures, and the panel system, were much in evidence. Generally it took the name of the author of *Hints on Household Taste* (1868), Charles Locke Eastlake, who gathered together previously published articles into his pace-setting book. Though essayists popularized the vogue, indispensable to its existence were the designers who devised its forms: Shaw has been mentioned, and alongside him should be placed other architects whose work encompassed the interior field, Philip Webb, William Butterfield and William Burgess, and the manufacturers issuing illustrated catalogs, William Morris, Bruce Talbert and Edward William Godwin. "Queen Anne" buildings and Eastlake interiors were elastic in what they included, the former ranging from the Romanesque to the Colonial Revival (in America), and the latter from European medieval to South Asian and Japanese.

The other side of the coin as regards major influences on mid-to-late-nineteenth-century design was that which came from Renaissance-Baroque sources. It was especially apparent in the New York brownstone row house, and furniture of this persuasion occupied it appropriately. Attention has been called to the Mayer and Ziegler sideboard pediments, and the pieces themselves merit further comment. In the base of the former are arches that could be either Romanesque or Renaissance, and the same may be said for the upper piers (Plate 14). The leaded glass in the outer panels and the turnings in the topmost gallery are medieval; supports similar in feeling, and cresting, occur on the door and the window frames of the room. Leaded glass also figures in the bracketed superstructure of the Ziegler example (Plate 55). Between and terminating the pairs of doors are tapering pedestals, which, like the pediment above, are classical. The large size of both sideboards calls to mind that the English designers devising Eastlakian pieces were contributors to the Crystal

Palace expositions, where the spectacular promoted patronage.

An original ornament that earmarks Eastlake design is a sinuous incision, looking like a jigsaw cutout in a thin plank, illustrated in the center panel of the Dodd library mantel (Plate 23). The shallow, abstract floral motif appeared not only recessed in stone, iron and wood, both outside and inside buildings, but as wrought-iron fences and facade crestings, and as inlay, stencil or printed-on-paper decorations, as in the frieze in the front room of Muschenheim's Arena (Plate 98).

The panel system of the style is illustrated in the wood and leaded-glass screen of the Crimmins study, which is partly medieval and partly classic (Plate 20). In the O'Neill and Bristol Oyster and Chop House the ceiling seems Japanese and the upright screen on the stair railing Near Eastern or East Indian (Plate 97). The metal ceiling of the Café Savarin ties in with the thick supports, low arches and strap panel reliefs, which are Romanesque (Plate 93).

Paneling is much in evidence in the Butterick office, dating from the beginning of the twentieth century, but it has a new connotation (Plate 126). The glass units have a stylized tulip that is too compact to be Eastlake, and the furniture is an almost unregenerated-lumber style called craftsman mission. The "mission" element of the term refers to Spanish Colonial contributions. The chief exponent of such furniture was Gustav Stickley, who had been manufacturing traditional furniture with five brothers prior to setting up his own plant at Syracuse, N.Y., in 1898 or 1899. Two years later he launched *The Craftsman* magazine. Initially beholden to the theories of John Ruskin and the designs of William Morris, Stickley already had switched to simple, geometric shapes when he supplied furnishings for the Butterick Building, which was decorated by Louis Comfort Tiffany. Later, in 1913, Gustav Stickley built the 12-story Craftsman Building in New York City. It was east of Fifth Avenue between 38th and 39th Streets and housed workshops, publishing and other offices, display rooms and a restaurant. Unfortunately, Stickley had overextended himself and, becoming bankrupt, lost both building and business within a couple of years.

That the crafts movement took to folk styles, other than Spanish mission, at the beginning of the century is perceptible in the club room in Plate 68. Work already done and in progress is of simple form and bears peasant and other naïve decorations

in hand tooling. Despite the worthiness of the idea, the results here look fairly dull.

Grand Rapids came out with equally bland innovations as mass-produced counterparts of the personally crafted pieces. The spiral-legged table in the Dodd library is an outgrowth of the spool variety (Plate 23). This specimen seems to be all of wood, whereas many have brass claws grasping crystal balls for feet. The bookcase behind reflects orthodoxy only in having base and crowning, but their treatment is mutative. The rocker to the left is novel in design but far from an aesthetic achievement. An armchair in Mrs. Elliott's living room (Plate 52) is a Grand Rapids compromise between stark mission and traditional types, the squared-off animal feet and the spirals supporting the shaped-slab arms modifying a strict utilitarianism. The dining-room suite in the Busby residence (Plate 74) is of two materials, oak and leather (both distasteful to later generations), and the details are a bit precious, but the outlines of the pieces have a pedestrian originality.

Perhaps the city's basic conservatism explains why the extreme mode, Art Nouveau, does not figure more in the Byron photographs of New York interiors. Art Nouveau set out to accomplish a complete break with tradition and went off on a number of tangents. One characteristic phase resorted to the dynamism of the whiplash line. The table in the Stevens smoking room makes a mild pretense of using it (Plate 7). Curls in the transom inserts in the Lyndhurst drawing room pertain to it, and the stylization of the birds is characteristic (Plate 1). The static and near-geometric side of Art Nouveau is illustrated by the tulip design in the Butterick office, and craftsman-mission furniture is Art Nouveau in the idea of effecting change (Plate 126). An example of a decorative piece is the large ceramic ewer with dramatically posed figure standing on the table in the Schroeder drawing room (Plate 58). The butterfly urchin in the bow window of the Weber drawing room is also Art Nouveau in that it is not anything else (Plate 62).

The whatnot stand opposite the fireplace in this room is of bentwood, as is the rocking chair in the Whitridge parlor (Plate 47). Many restaurants used bentwood chairs during this period, and we find them in Fritz's Café, the Childs restaurant and the O'Neill and Bristol Oyster and Chop House (Plates 95, 96 and 97). Furniture made from round pieces of wood, steamed and bent into light and sometimes graceful shapes, was the invention of Michel Thonet, a German cabinet-maker, in 1830. He designed and made furniture for Viennese royalty (including the Emperor Franz Josef) and later opened a factory in Czechoslovakia. By the end of the nineteenth century the process was public property and in use around the world.

Of a kindred nature is rattan or wickerwork furniture, occurring in Miss Ford's sitting room, Mrs. Hughes's and Miss McNamara's bedrooms, and the lounges of the Hotels Prince George and Endicott (Plates 15, 33, 72, 88 and 89). Wickerwork has a more venerable history than bentwood, traceable to antiquity. A third-century Roman relief in the Rheinisches Landesmuseum in Trier, Germany, depicts a woman sitting in a wickerwork chair with a high rounded back. Rattan sometimes was combined with bentwood, as in the lounge of the *S. S. Lusitania,* and much of such furniture was made in the Far East (Plate 130). In this regard it relates to imitation bamboo, which was popular during the eighteenth century owing to Chinese influence, and which persisted into the Edwardian period, as in Miss Dodd's drawing room and the Farrand music room (Plates 22 and 48). Imitation bamboo is akin to delicate turnings, and chairs with members of both kinds are in the middle of Mrs. Leoni's parlor (Plate 8).

Exoticism had a different connotation during the late Victorian and Edwardian periods than heretofore. Its first great efflorescence in modern Europe as *chinoiserie,* during the late seventeenth and eighteenth centuries, was prompted by an awe for Cathay, the land of fireworks, tea, silks and porcelain. *Chinoiserie* became an important phase of Rococo, exchanging plump cherubs for sprite-like orientals disporting among weird plants and airy pavilions, and it was even more innovative than the parent style. Only imported vases and textiles figured in settings wherein everything else was devised according to the imperfect and playful visualization of China by Western designers. *Chinoiserie* literally was more colorful than Rococo proper, with polychromed faience revetments and bright lacquer supplementing or replacing the usual ivory and gold. It should be mentioned that the companion of the Chinese manner was *turquerie,* similarly inspired by cultures of the Near East.

In the United States the precedent for oriental interiors was established firmly by the Dutch trader Everardus van Braam Houckgeest, who had become an American citizen and built his home,

China's Retreat, on the Delaware River upstream from Philadelphia, at the end of the eighteenth century. Houckgeest furnished his house, which was larger than Mount Vernon, with articles he collected in the Flowery Kingdom. Stay-at-homes had to wait until exports came to them, and the process attained notable proportions for the first time at the Philadelphia Centennial of 1876. A photograph in the John Robinson scrapbook at the Peabody Museum, Salem, taken inside the Chinese booth at the fair, shows marble-topped tables and stools, lacquered boxes and cases full of silks and porcelains. Among them is the armchair that later stood in Mrs. Schroeder's library (Plate 57).

The room overwhelmingly Chinese is in the Havemeyer house (Plate 3). All of the furnishings visible, exclusive of the fireplace accessories and carpet, were produced in China. The atmosphere is Victorian. The Chinese would no more think of hanging their robes on a cabinet than Mrs. Havemeyer of draping her nightgown in the parlor. The same is true for the armor in the Lauterbach Japanese room (Plate 31). Even a *kakemono* (vertical scroll painting) would be hung in a specially designed *tokonoma* (recess) in a Japanese house, not framed and suspended over a bamboo lattice on a landscape-sketch mural. The same spirit of clutter characterizes that other *fin-de-siècle* escape nook to Asia, the Turkish "corner." The tented oasis in Mrs. Hughes's drawing room is a combination arsenal and knickknack bazaar (Plate 35). The "corner" is amplified to the entire room in the Lauterbach stairhall, where the architectural décor forms an appropriate background to the array of Turkish imports (Plate 28). Here the overall effect is more akin to the prototype than in the Japanese gaming room under the same roof. The Casino Café bar employs Saracenic forms in the architecture without the slightest sympathy shown toward it in the furnishings (Plate 94).

Reaction to all types of the unfamiliar, against foreign importations, imitations and current innovations, brought about the Colonial Revival. This style received as much impetus from the Philadelphia Centennial as did the exotics on display, through the primary motivation of the fair being the glorification of the American achievement. Seventeen years later it was given a second boost by the Columbian Exposition at Chicago, only this took a special direction suggested by the architecture of the fair. Buildings wore an impressive classic (Neo-classic) dress, unified by the module

of a 60-foot order and painted white, the complex becoming known as "The White City." As a result the Colonial Revival gravitated toward the classic elements in early American—actually mostly Federal—building. Popular motifs included coupled columns, like those in the W. & J. Sloane furniture display (Plate 115). The fireplace focus of rooms took on a new look. It assumed reduplicated mantel shelves, and columns or colonnettes literally rose in prominence, from the floor to the upper level, over the mirror (Plates 21, 25, 51 and 74). In some instances colonnettes were superimposed (Plate 8), and in others the supports only appear between the two shelves (Plate 54). These were colonialized versions of the earlier Eastlake *étagère* mantel (Plates 14, 38 and 82). The transition stage between them is illustrated by the gilded overmantel in Mrs. Hughes's drawing room (Plate 34). Colonial Revival classic ranged from an isolated banister railing at the brink of an upper level in a restaurant (Plate 98) to a fully Adamesque interior, like the auditorium of the Aeolian Music Hall (Plate 103).

As can be seen in the plates cited, furnishings in these classic rooms were not appropriate to them. Pieces made during the period, like the Philadelphia "highboy" and Windsor chair in Mrs. Elliott's living room (Plate 52), were of earlier styles.

Floors generally are shown at least partially covered, the exceptions being the slum room and its imitation, a billiard room, conservatory, usually kitchens and, of course, bathrooms and public rooms (Plates 11, 17, 31, 43, 60, 68 and 106, etc.). The unidentified drawing room in Plate 9 has exposed parquetry except that in front of the sofa is a disagreeable-looking grizzly-bear pelt. Other animal skins include a tiger in the Lauterbach drawing room (Plate 30), polar bears here, in the Hughes, Schroeder and National Conservatory of Music drawing rooms (Plates 34, 35, 58 and 82), other bears in the Seton studio (Plate 36), Depew library (Plate 39), Whitridge parlor (Plate 47) and Joseph den (Plate 70), with another smaller animal skin here and one in the Weber dressing room (Plate 65).

The Kress parlor and Farrand music room have factory-made floral carpeting in repeated patterns with borders adjusted to the floor size (Plates 24 and 48). In the de Wolfe library, Crimmins drawing room, Hughes bedroom and drawing room and Barnard dormitory room are plain wall-to-wall carpeting (Plates 19, 21, 33, 34 and 81). Other

homes have solid-color rugs, as in the Havemeyer entrance hall (Plate 2). Some have industrialized "orientals," as in Mrs. Leoni's parlor (Plate 8).

The noteworthy floor habiliment was genuine Oriental rugs. As had been the case for several hundred years, during the late nineteenth and early twentieth centuries they were the most beautiful, distinctive and finest carpets obtainable, and we find more of them than of any other type among the Byron pictures. The knotted-pile rug had been woven in the Levant for upwards of two-and-a-half millennia. It had been imported to the West since at least the early sixteenth century, as it is included in portraits by Holbein. In England during the Renaissance all Oriental rugs were called Turkish, which denoted their place of exportation if not of origin. Besides Turkey, they were made mainly in Caucasia, Turkestan and Afghanistan, not to overlook the homeland of the master works, Persia. From the fifteenth century onward Persian miniature painters designed rugs, raising the art of weaving to a high aesthetic level. The Biblical abhorrence of "graven images" extended in Islam to exact representation and gave rise to the graceful abstractions, somewhat inflorescent, called arabesques. Skillful artisans could overlay repeated designs in intricate ways, obtaining great richness of effect.

The ancient cultural centers of Iran or Persia produced the most sophisticated specimens. We find rugs from Kashan in the Crimmins study and Kellogg drawing room (Plates 20 and 75—to the left), one from Meshed in the Whitney ballroom and one from Feraghan in the drawing room (Plates 26 and 27), one from Bijar or Tabriz in the Lauterbach stairhall and one from Sarouk in the dining room (Plates 28 and 29), one from Bijar in the Sherrill library (Plate 76) and a huge example from Kirmanshah in the Ritz-Carlton lounge (Plate 90). As a sort of never-never garden, the last contributed to the outdoor effect sought in the palm-spangled court.

Despite the religious restriction against depicting them, living beings occasionally appeared on rugs. Flowers sometimes were naturalistic, and use was made of animals and, infrequently, of human beings. Blossoms and flowering branches are distinguishable on the Meshed rug in the Whitney ballroom (Plate 26). Also included among decorative motifs were inscriptions. If the texts were from the Koran, these rugs were not meant to be floor coverings, to which use Western unbelievers put them, as in Mrs. Schroeder's drawing room

(Plate 58). Verses from the Koran frequently appeared on prayer rugs, which differed from other types in being of limited size (only large enough for a kneeling and prostrate figure) and the inclusion in the design of the *mihrab* or niche arch, which was to be pointed toward Mecca during devotions. Prayer rugs frequently appeared by the hearthside in America, as in the Stevens smoking room and Crimmins drawing room (Plates 7 and 21). In the Kellogg parlor (having no visible fireplace), a prayer rug is used in the middle of the floor, between the two sofas (Plate 75).

Rugs from more provincial places in the Near East, whether made in villages or by wandering tribesmen, are seldom large, and their design is simpler, being two-dimensional and geometric, like the Hamadan runner in the Astor ballroom (Plate 10). Many of this species are from outlying countries. West of Persia, from Kurdistan came the Mosul runner on the Lauterbach stairs, and from old Anatolia, or Turkey, came the prayer rug in the Kellogg parlor (Plates 28 and 75). From the Caucasus, to the northwest, came the rugs in the smoking room of the Stevens house, in the Elliott living room (foreground), in the room of the Hotel Marie Antoinette (foreground) and in the ladies' department of the New Amsterdam Bank (Plates 7, 52, 87 and 100). From Turkestan, to the north, came the carpets in the Lauterbach and Schroeder bedrooms, and the Bokhara (right) in the Kellogg parlor (Plates 32, 59 and 75).

It is interesting that the Chinese room of the Havemeyer house has a rug from Western Asia on the floor (Plate 3). The Chinese, like the peoples of Kashmir, India and Tibet—which lie between Persia and China—made rugs. The example in the Schroeder dining room appears to be Chinese (Plate 56). Usually rugs from Cathay are more easily distinguished by the display of dragon and cloud motifs, ideograms and other symbols (like the swastika), frets and various animals (bats, birds and butterflies) and flowers (especially the peony).

Textiles from the East, other than pile rugs, include the bird-butterfly-and-flower silk hanging in the Havemeyer Chinese room (Plate 3), the Tibetan hanging suspended from the ceiling in the Hall reception room (Plate 13), the Japanese silk embroideries on the Lauterbach piano and pool table (Plates 30 and 31) and the Syrian embroidered spread on the dining table in the National Conservatory of Music (Plate 83). Turkish and Turkestani kilims, tapestry-weave spreads of

geometric design, are on the couch in the Elliott bedroom and the table in Mr. Fox's apartment (Plates 53 and 61).

Most Western textiles shown could have come from sundry sources, but some exceptional items ought to be pointed out. Conspicuous are lace curtains at windows, as in the Stevens parlor, in the two rooms of Miss Dodd's house, in the Whitney drawing room, Farrand music room, Schroeder drawing room and Joseph dining room (Plates 6, 22, 23, 27, 48, 58 and 71). The lace hanging from the mantel shelf and hand-embroidered bedspread in the Plate 69 chamber show intricate and fine workmanship. Mention should be made of the lace, embroidery, ruffled and fringed lamp shades of the 1890s, resembling wimples or Gainsborough hats, seen in Plates 5, 6, 7, 8, 9, 10, 12, 18, 22, 23, 27 and 98. A patchwork quilt is in the posed-for-poverty shot in Plate 17. One notes that no hooked or braided rugs, which are rural types, are to be found in the Byron photographs. The clearly defined Occidental weaving is the Gobelin tapestry in the Havemeyer dining room (Plate 5). The composition and treatment of figures show the influence of Rubens, who provided cartoons for the early French examples. The tapestry in the Schroeder drawing room is Flemish (Plate 58).

Tapestries bridge the gap between applied and fine arts, relating to the former in that they are manufactured and to the latter in that they serve as pictures on the wall. At the turn of the century, as today, wealthy collectors mostly bought paintings that appealed to them, without regard for their being milestones in the progress of art. Framed easel paintings in the Havemeyer and Astor picture galleries (Plates 4 and 10), the Lauterbach drawing room and Brandus upper hall (Plates 30 and 51) and the unidentified auction or sales room in Plate 123 show a preference for landscapes and genre subjects executed along traditional lines. Prominent in the Lauterbach drawing room are full-scale, three-quarter-length portraits of the master and mistress of the house, propped at the hall doorway (Plate 30). In the Crimmins drawing room, over the piano, is an oval portrait of Madame holding Whistler lilies (Plate 21). Mrs. Kress's old family likenesses maintain sturdy dominion over the rear wall of her parlor (Plate 24). Seton's interest in natural history expresses itself in ethnic portrayals and wolves howling in the snow (Plates 36 and 37). Mrs. Schroeder has a watercolor of Venice over the mantel in her bedroom (Plate 59). Putti in the

style of Boucher are in appropriate panels in the elegant white Louis XV chamber in Plate 73, and they hover over a nude Venus in a sentimental watercolor in Mrs. Hughes's bedroom (Plate 33). The large painting in the Weber music room has the crudity of technique of the painted pillows on the couch in the dressing room (Plates 64 and 65).

Most framed pictures on walls are prints; some of these are original etchings or engravings (as in the Stevens smoking room and Crimmins study, Plates 7 and 20), but most are reduced facsimiles of paintings. The Gainsborough portrait of Georgiana, Duchess of Devonshire, appears three times (Plates 16, 34 and 69), no doubt because of the timely fashion connotation of the hat. In the Elliott bedroom and Barnard College girl's dormitory are reproductions of Corot landscapes (Plates 53 and 81). The bedroom in the National Conservatory of Music has head studies from Leonardo and Botticelli (Plate 84). Mr. Arthur's den features a copy of Alma-Tadema's *Reading from Homer* (Plate 70). In Mrs. Elliott's living room is a print of William Morris Hunt's *Bathers* (Plate 52). The last is an unique instance of an American painting and keys in with the owner's modernity. Photographs, especially of people, had begun to be used as home decorations, mostly set around on horizontal surfaces (Plates 19, 25, 34 and 50). Their presentation on walls was considered a mark of low taste (Plate 61).

Inasmuch as the Byron domestic photographs—exclusive of one picture of a kitchen and one of a nursery—were made before New York was hit by the Armory Show of 1913, that late trend, as exemplified in the work of Picasso, Duchamp, Kandinsky, Lehmbruck and Brancusi, had not yet had proper introduction to America. Sculpture, no less than painting, was of late classic persuasion (Hellenistic or Baroque-manner), with an occasional fresh breath of Impressionism. The marble Cupid and Psyche at Lyndhurst (Plate 1) had clung to their phial of love in the oriel since shortly after the Civil War, and although belonging to an earlier period were still in vogue at the end of the century. The form and pose of the figures are reminiscent of Bernini's *Apollo and Daphne* in the Borghese Gallery, Rome. The plaster group by John Rogers in the Dodd library also was a generation old when it was photographed (Plate 23). The little boy in the Farrand music room seems to be of the same era (Plate 48). The bronze adolescent in the Havemeyer gallery strikes an attitude that was properly demure for the end of the cen-

tury but was soon to become a dated affectation (Plate 4). Marble busts in the Brandus and Weber homes belong to the school focusing on facial "expressions" and delicacies of texture (Plates 51, 62 and 63). The bronze figures in Plate 63 added action to those ideals. The grotesque extreme to which such realism could go is illustrated in the grinning puppets in real clothes elsewhere in the house (Plate 64)—but of course this was the home of a popular comedian. Small facsimiles of classics include the Herculaneum wrestler in Mrs. Elliott's living room and the Giovanni da Bologna Mercury on the loving cup atop the bookcase in the Sherrill library (Plates 52 and 76). The Art Nouveau figure on the ewer in the Schroeder drawing room would be thought of as an accessory rather than as a fine-arts object (Plate 58).

Plants were an adjunct to interior decoration. One that is conspicuous because of attaining the greatest size is the palm. Being tropical, the palm thrives in warm and well-lighted places, like the entrance hall and gallery of the Havemeyer house (Plates 2 and 4), the Hotel Endicott and Ritz-Carlton lounges (Plates 89 and 90) and the Simpson-Crawford court (Plate 122). These have long fronds and may be of the Areca or Kentian variety. There is also the short-leaf palmetto, as in Plate 16, and the Chinese-fan palm shown in Mrs. Hughes's drawing room (left in Plate 34). Palms also appear with ferns, which require considerably more moisture and are usually employed only temporarily, as on the banquet table set up in the Whitney ballroom (Plate 26), although they seem to thrive permanently together in the drawing room of the same house (Plate 27). These are the sword or Boston fern, and they are also in the Schroeder drawing room and Joseph dining room (Plates 58 and 71). Asparagus ferns drip from the trellis in the Munroe greenhouse (Plate 60). Another of the more popular house flora of the period was the aspidistra, aptly called the "cast-iron" plant because of its hardiness. Examples of this cap the table divider in the O'Neill and Bristol Oyster and Chop House (Plate 97), flank the bed in Mrs. Hughes's chamber (Plate 33) and are to the left and right of the screen in the Weber reception hall (Plate 63). In the window of the last is a dracaena, or dragon's-blood tree. Also found frequently is the rubber tree, as in the Stevens drawing room, Schroeder library and Hotel Prince George lounge (Plates 6, 57 and 88).

Potted geraniums bloom in the Smith living room, hyacinths are on the sideboard in the Na-

tional Conservatory of Music dining room, and jonquils or narcissus brighten Mrs. Schroeder's bedroom (Plates 67, 83 and 59). Lilies figure in the Easter decorations in the Simpson-Crawford store (Plate 122). Prominent among cut flowers are roses. They are featured in the Fleischman floral shop (Plate 118) and figure in the Kellogg drawing room and on tables in the Green Teapot tea room (Plates 75 and 99). Lilies appear in a vase in the Stevens drawing room (Plate 6). Tulips are scattered around the smaller room in the Smith studio house (Plate 66), and jonquils or daffodils are on the dining-room table in the National Conservatory of Music (Plate 83). Dried pampas grass in the bay window of the Busby dining room is for decorative effect (Plate 74), and dehydrated specimens join the zoological relics in the Seton studio as natural curios (Plate 36). Artificial roses are used as tie-back accents on the mantel drapery in Mrs. Leoni's miscellaneous parlor and on the bed canopy in the elegant Louis XV chamber (Plates 8 and 73).

If any conclusions are to be drawn regarding late Victorian and Edwardian taste in interiors from the Byron photographs of New York City, they will be in the nature of generalizations, because of contrasts. Rooms range from a composite of periods (with leftovers from former owners), as at Lyndhurst and in the Hammond-Depew house (Plates 1, 38, 39, 40 and 41), to the instant unity of the Louis XV bedroom (Plate 73). They vary in size from the great rotunda of the Astor mansion, stacked with expensive gold-framed paintings, to the insignificant and dismal family slum room, neither one containing much useful furniture (Plates 10 and 11). At one extreme is the airy marble temple of the Greenwich Savings Bank for hoarding money, and at the other the barn-like meeting hall of the McAuley Bowery Mission for saving souls (Plates 101 and 105). On the one hand is the methodical collection of curios from the far side of the globe in the Havemeyer Chinese room, and on the other the haphazard accumulation from no farther away than Klein's bargain basement in the Leoni parlor (Plates 3 and 8). Rooms range from the effete femininity of Mrs. Hughes's chamber, with its elevated, canopied and pillow-backed bed, frilly wallpaper, portieres in the doorway and phantasmal painting, to the tawdry masculinity of Mr. Fox's quarters, with family and club mementoes overspreading the walls, and drinking and pugilistic appurtenances strewn about on sideboard and mantel (Plates 33

and 61). Within the radius of a few blocks in the metropolis one could dance in a royal Rococo ballroom, feast in a robber baron's Gothic dining hall, sleep in an emperor's Napoleonic chamber and relax in a brightly lighted crystal-palace lounge (Plates 26, 29, 32 and 89).

By way of getting at the period content more specifically, let us narrow the array of rooms to two. The first choice is Blakely Hall's reception room of 1896, and the second is Mrs. Elliott's living room two years over the line into the new century.

A quick glance at the Hall reception room gives the impression of a tent (Plate 13). Except for window stanchions, no hard architectural lines are in view. Ceiling, fenestration, doorway, chimney breast, walls to each side all are draped in billows of patterned textiles. The floor is completely covered with carpeting. A continuous seat spans the far end of the room and curves a substantial way along both side walls. Cushions, small tables and tea service are handy for one's comfort and refreshment. It is a room in which to luxuriate, heedless of particulars. Here one's eye can roam passively from one color, one intricacy, one sheen— and one's hand from one texture, one softness, one smoothness—to the next. The room is an artful achievement conducive to complete complacence.

The Elliott living room is made up of flat planes, straight lines and right angles (Plate 52). Rather than closing in on itself, it opens out: rather than being introverted, it is extroverted. Each piece of furniture, each rug, each article is a distinct entity. Not only do no two belong to the same set, they do not even belong to the same style or period. Many are not lined up parallel with each other or with the room, thus asserting their individuality through orientation. Provision is made for many active enjoyments. The music stand denotes participation in music, art objects show an interest in the visual-culture field, books are for reading— upright chairs serve for essays and the lounge for novels. Compared to the Hall parlor, housework here is reduced to a minimum, Mrs. Elliott perhaps (unlike Mrs. Hall) performing her own. The

Hall interior was soothing to the senses and afforded mental and bodily repose. Items in the Elliott living room compelled attention and provided stimulation for new worlds of exploration. If the Hall parlor represented a passive backward glance, Mrs. Elliott's living room looked frankly out at the New York of the early 1900s, and provoked a creative forward vista into the twentieth century.

The foregoing capsule comparison of two rooms, the latitude of types (both domestic and otherwise) mentioned, the inventory of items (which has constituted the bulk of this introduction) and, of course, study of the individual pictures show that the 20-year era following the Columbian Exposition was both a culmination and a changeover. Eclecticism had reached its zenith and built up enough momentum to propel it through the World War I period. While millionaires were keeping up Versailles-like social intercourse in appropriate settings, the middle class was affecting a new mode of living, which was attuned to the technical and mechanical advances of the day. The time span under consideration saw the establishment of tall buildings with elevators, the widespread use of electric trolleys and gasoline automobiles, the invention of heavier-than-air flying machines and the popularization of moving pictures. As these altered the aggregate life of the American people, gas and electric lighting, bathroom and kitchen conveniences, and telephones were changing their home life. Improvements in illumination and labor-saving devices lengthened the day and shortened work time. Additional hours were gained for personal investment, and they called for new interests and endeavors to fill them. A fresh pattern of living was being concocted.

What did the innermost places of the greatest city on earth reveal about its inhabitants as they were being catapulted into the twentieth century? To what extent did they subsist under the accumulation of the ages, and to what extent did they take a pioneering step into the wilderness of the future? These are the questions that have fostered the presentation of the following plates.

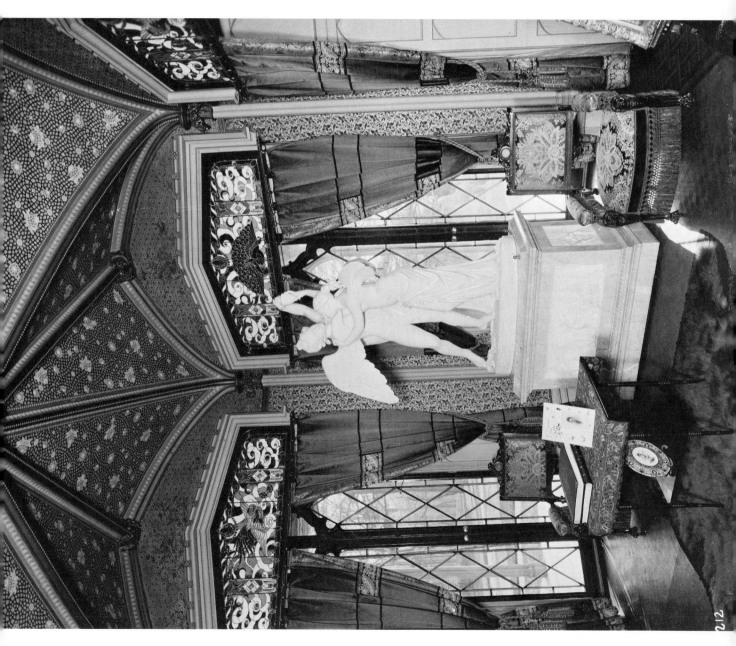

1. Drawing-room Oriel at Lyndhurst, Tarrytown (1893).

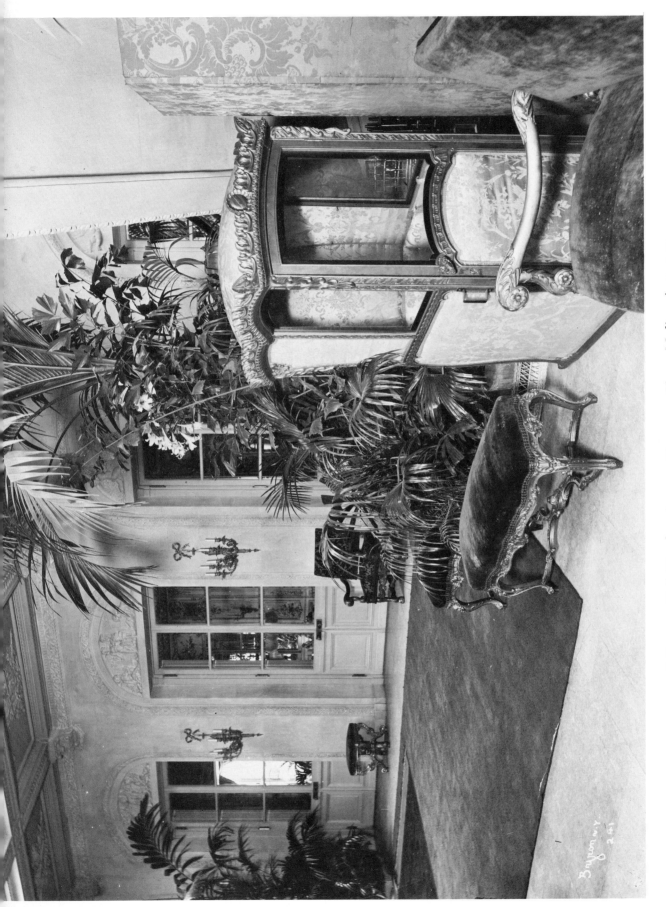

2. Entrance Hall, Theodore Augustus Havemeyer House, Madison Avenue at 38th Street (1893).

3. BELOW: Chinese Room in the Havemeyer House (1893).

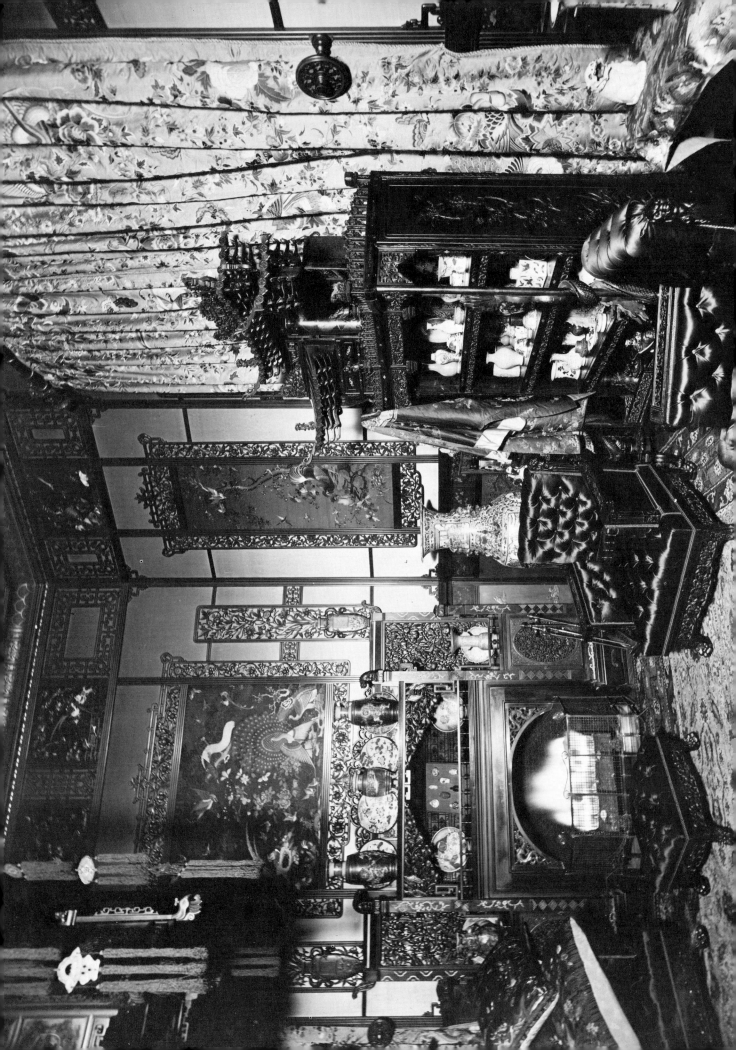

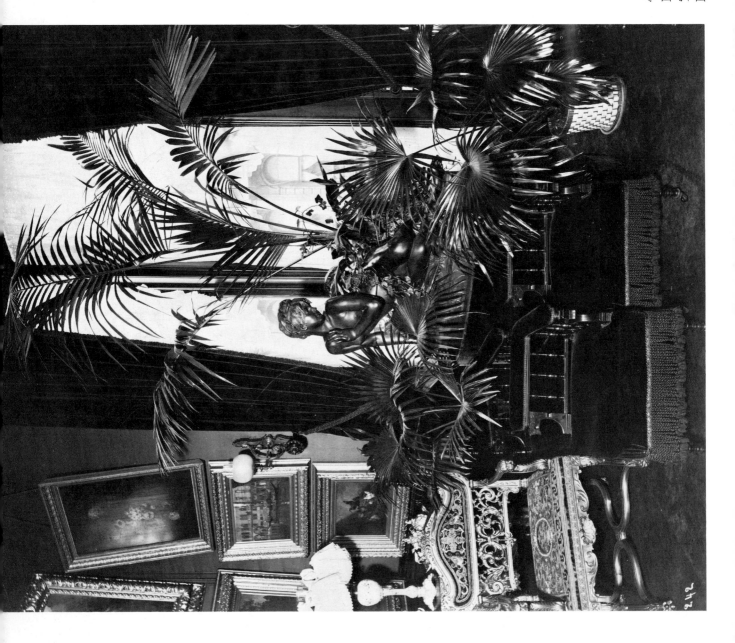

4. LEFT: A Corner of the Picture Gallery, Havemeyer House (1893).

5. BELOW: Dining Room in the Havemeyer House (1893).

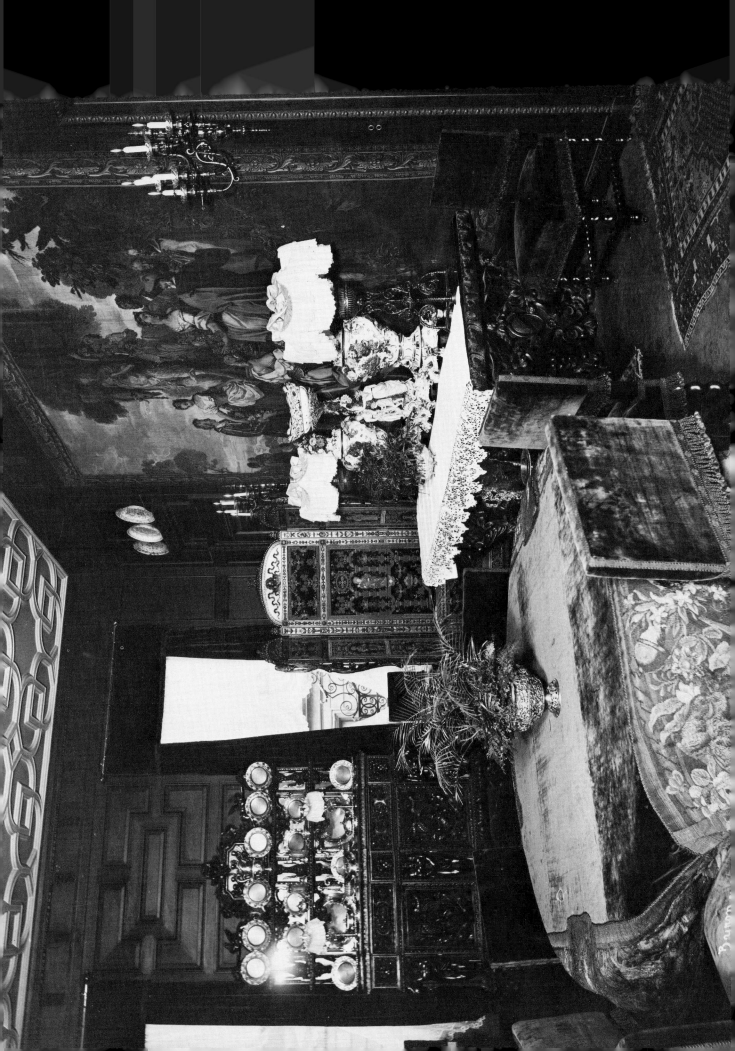

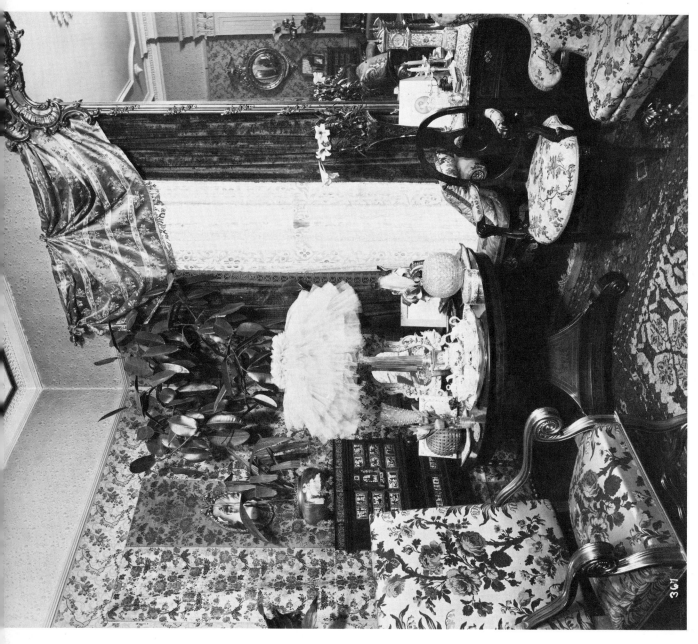

6. LEFT: Drawing Room of the Albert Stevens House, 13 East 9th Street (1894).
7. BELOW: Smoking Room in the Stevens House (1894).

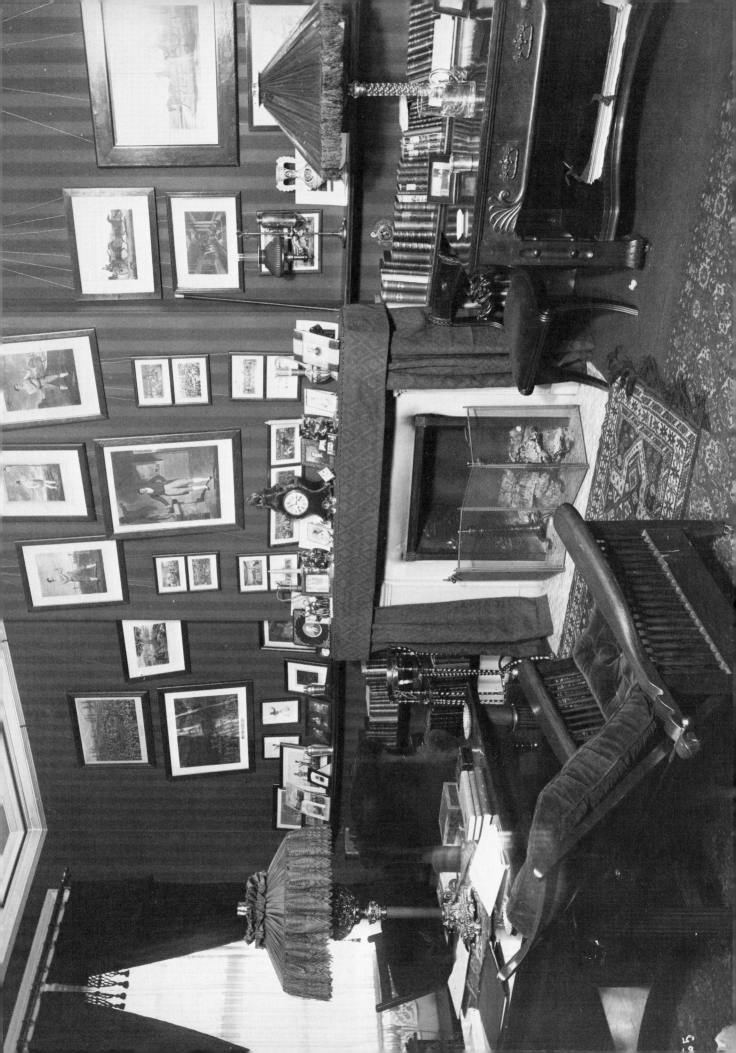

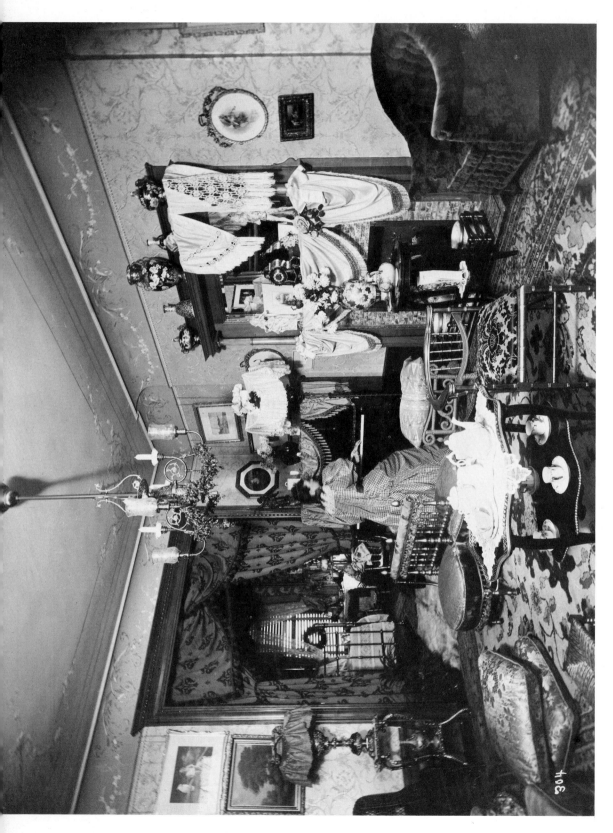

8. Parlor in the Home of Mrs. Leoni (1894).
9. BELOW: A Drawing Room (1894).

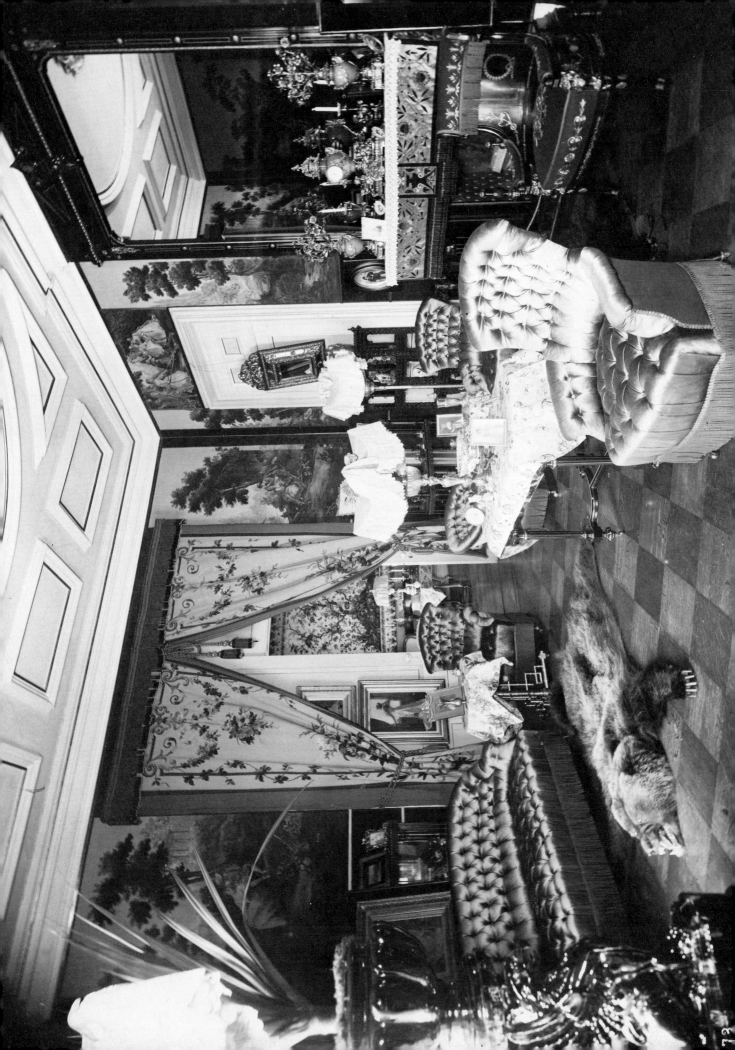

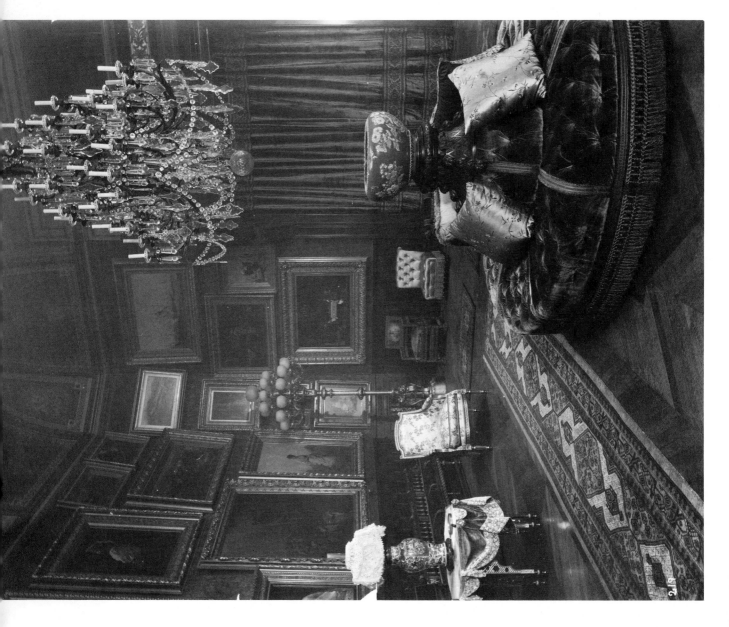

10. LEFT: Art Gallery and Ballroom in Mrs. William B. Astor's Mansion, 350 Fifth Avenue (1893–94).
11. BELOW: Slum Dwelling (1896).

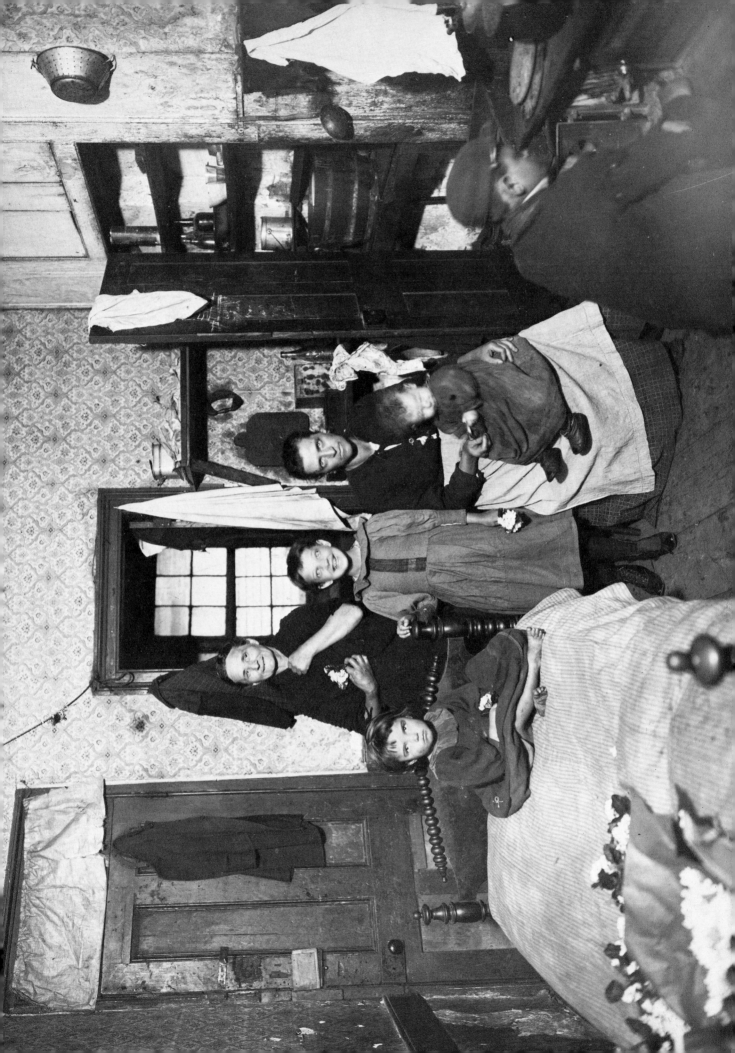

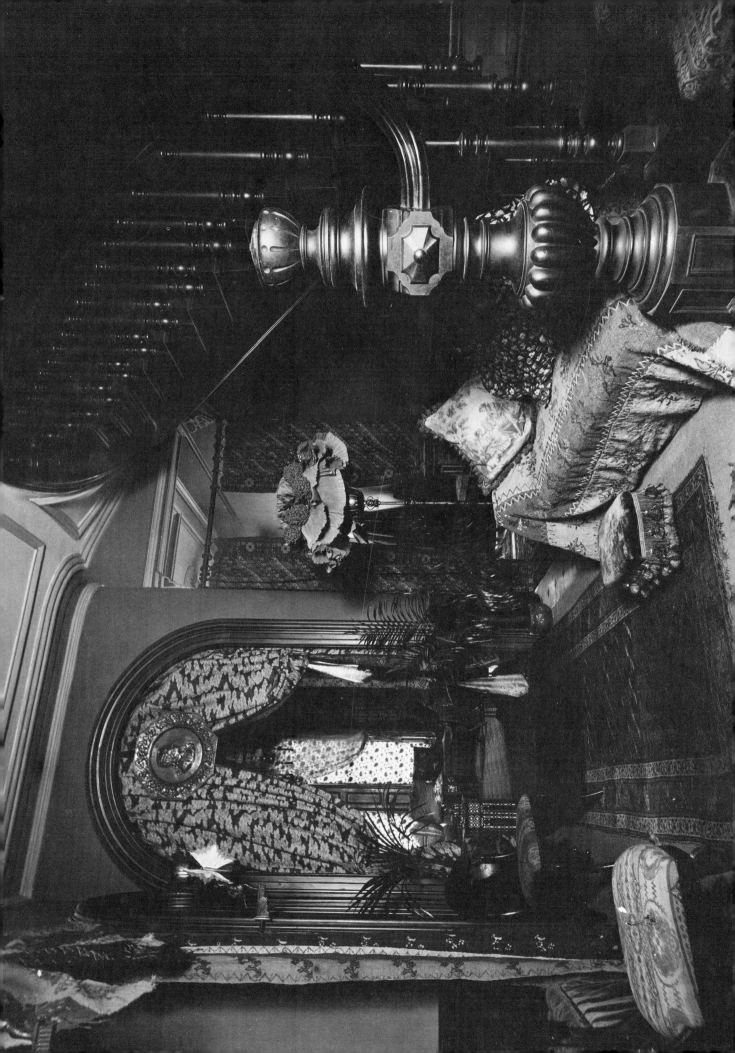

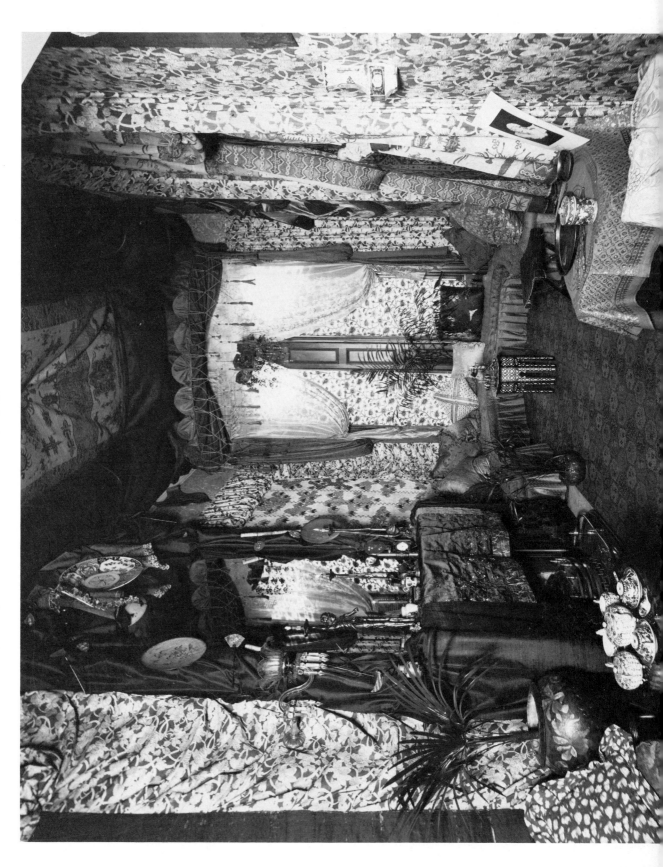

12. ABOVE: Stairhall in the Blakely Hall House, 11 West 45th Street (1896).
13. Reception Room in the Hall House (1896).

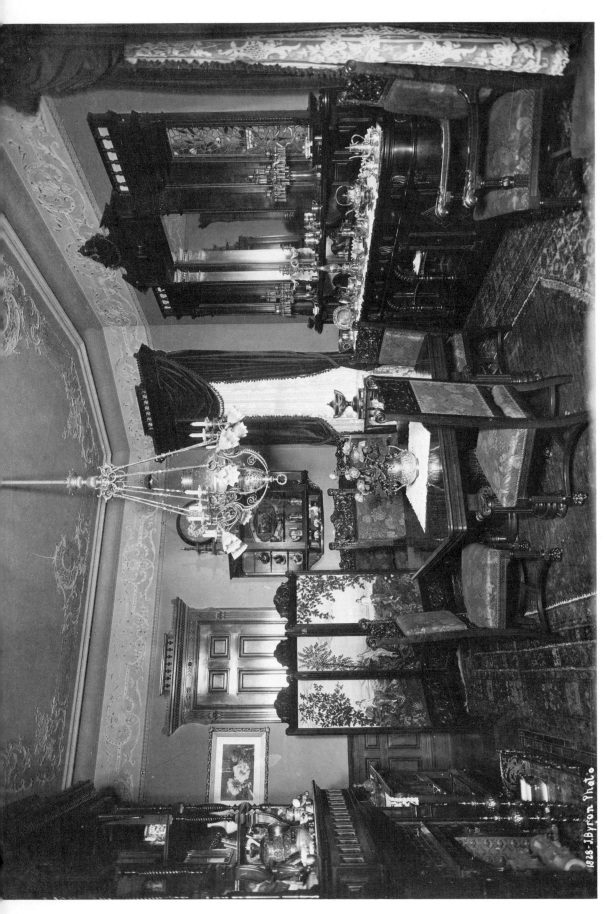

14. Dining Room in the Home of Mrs. Mayer (1896).
15. BELOW: Sitting Room in the Home of Miss Ford (1896).

1828 J.Byron Photo

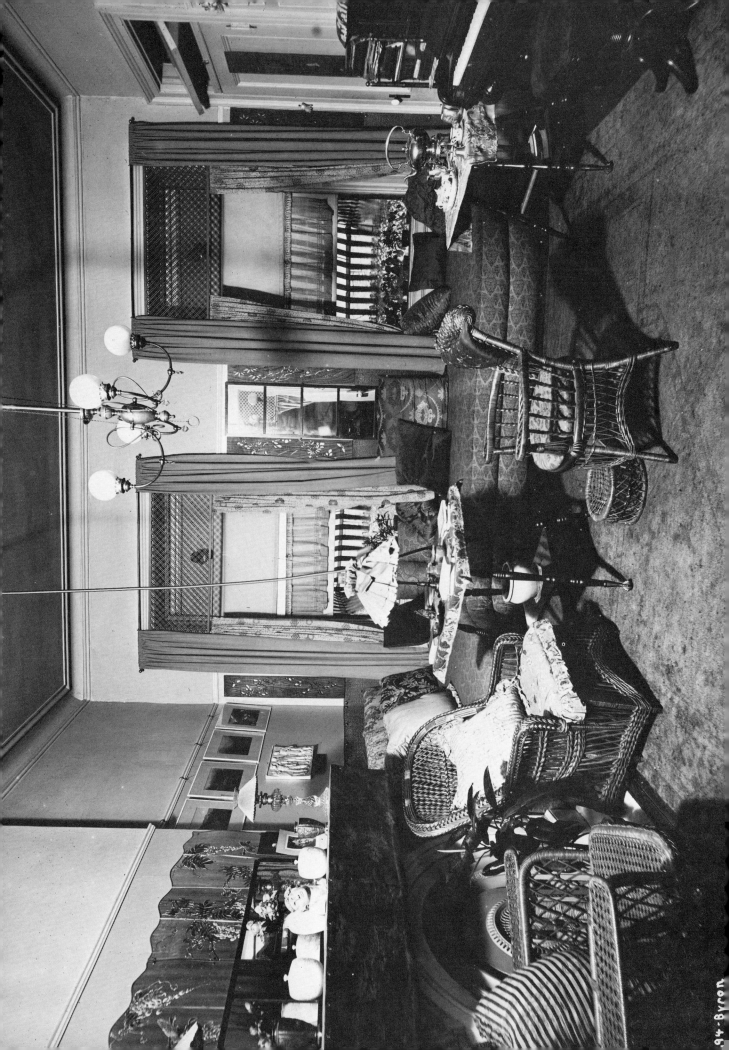

94-Byron

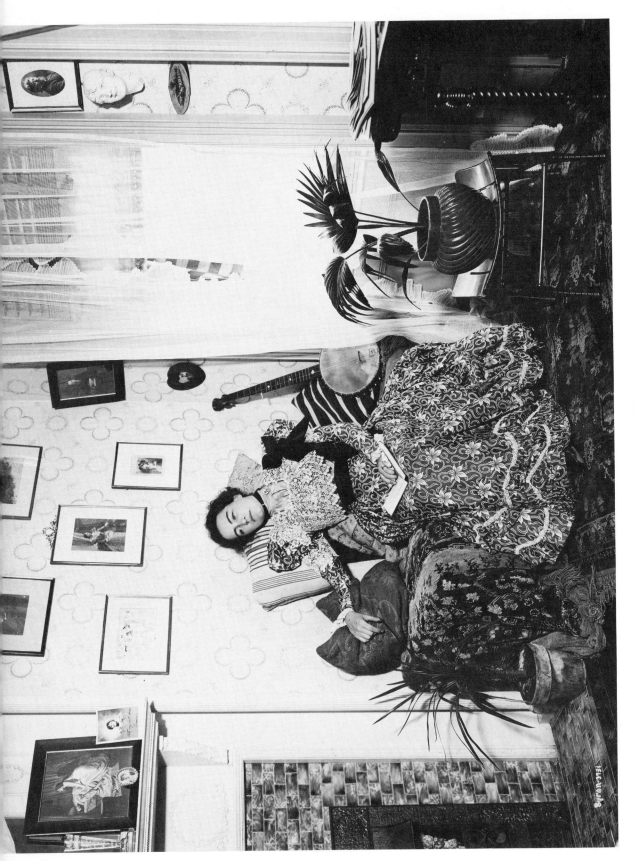

16. Relaxing in the Parlor (1897).

17. BELOW: Eating Breakfast by Candle Light (1897).

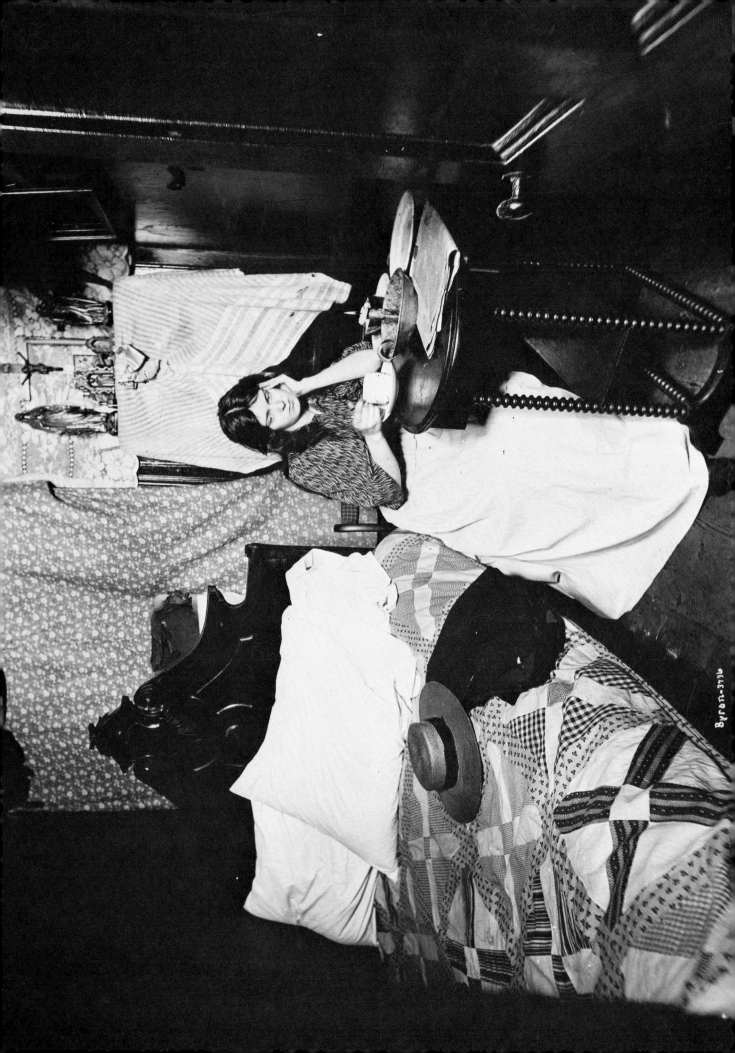

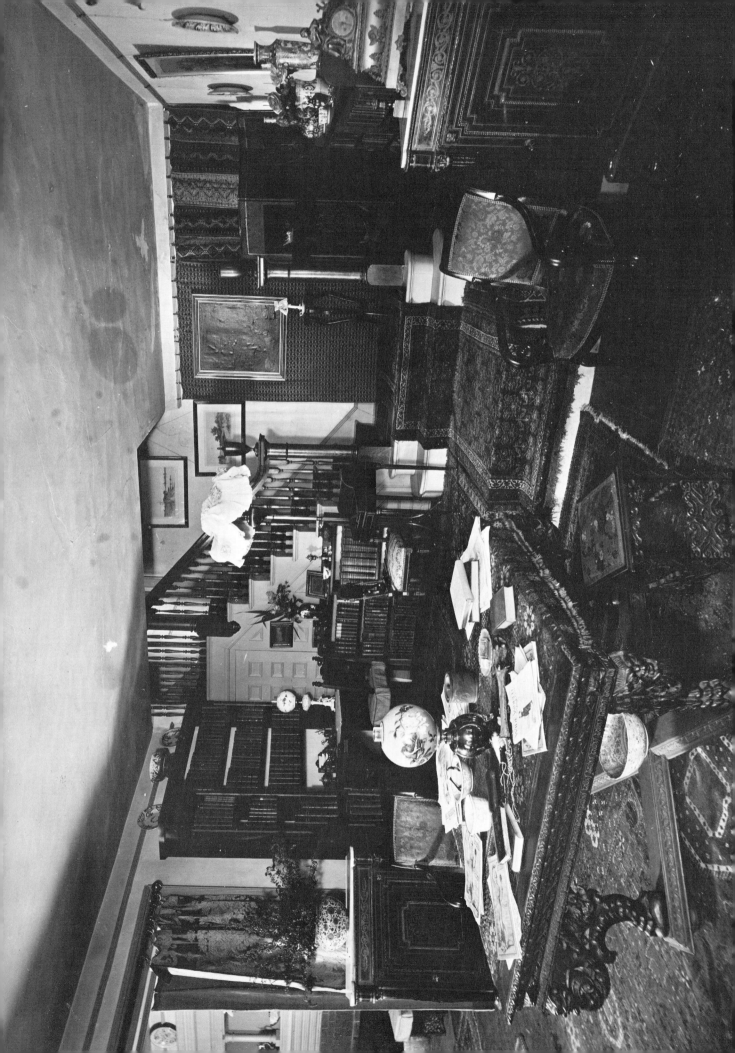

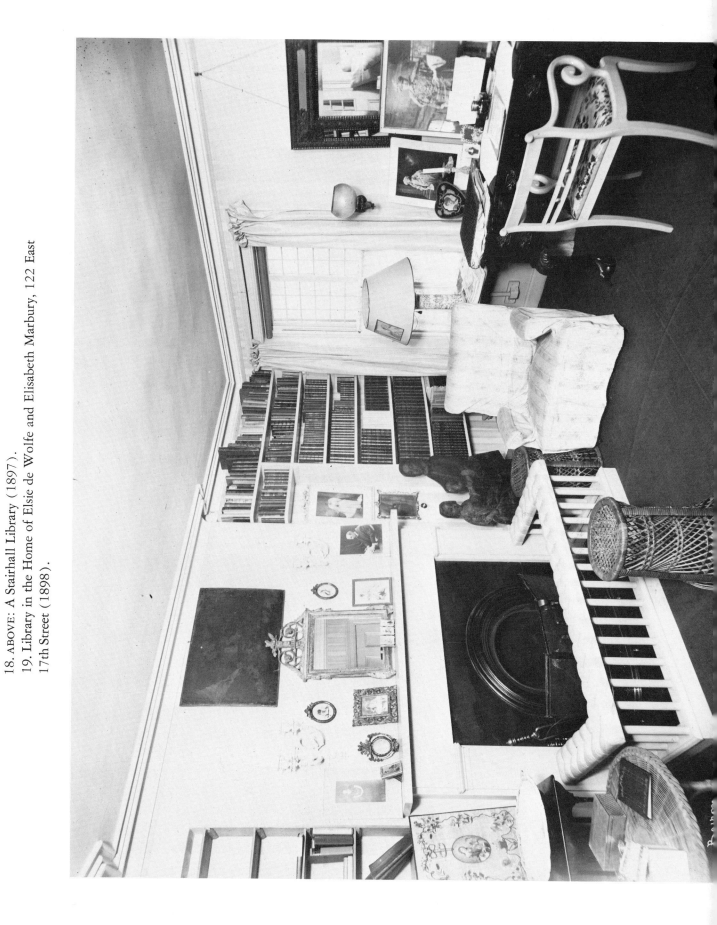

18. ABOVE: A Stairhall Library (1897).
19. Library in the Home of Elsie de Wolfe and Elisabeth Marbury, 122 East 17th Street (1898).

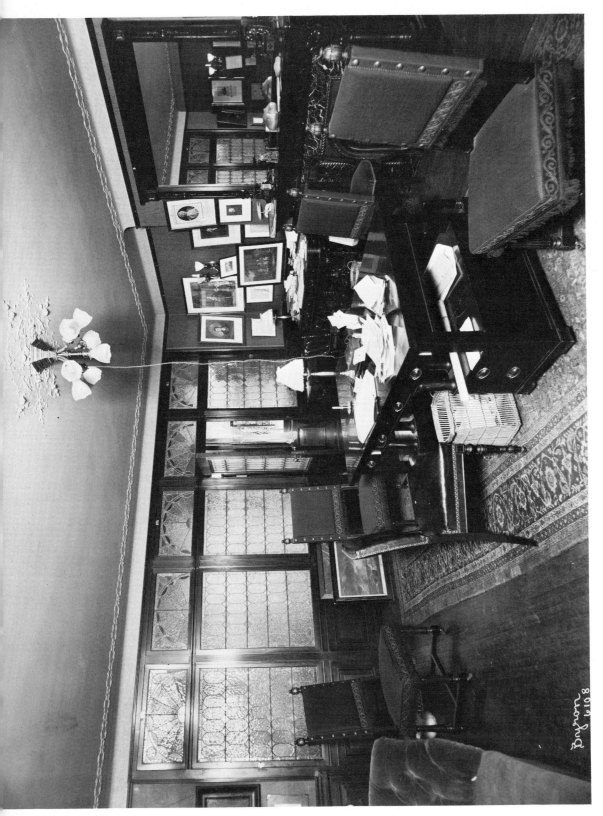

20. Study in the Home of John Daniel Crimmins, 40 East 68th Street (1898).
21. BELOW: Drawing Room in the Crimmins Home (1898).

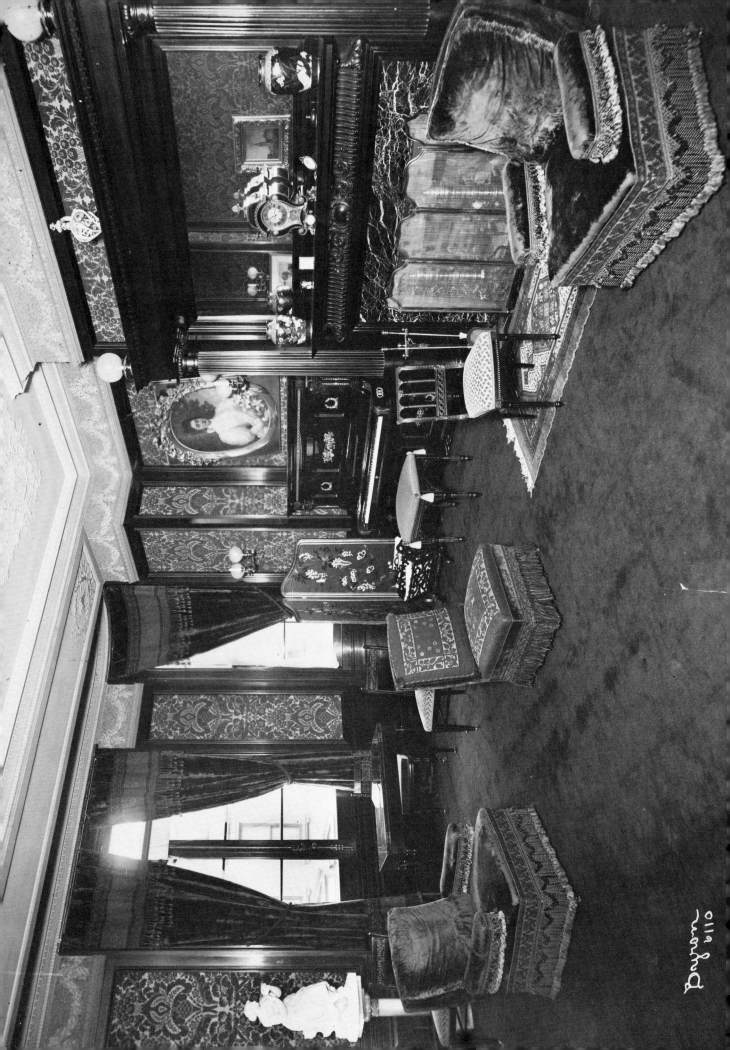

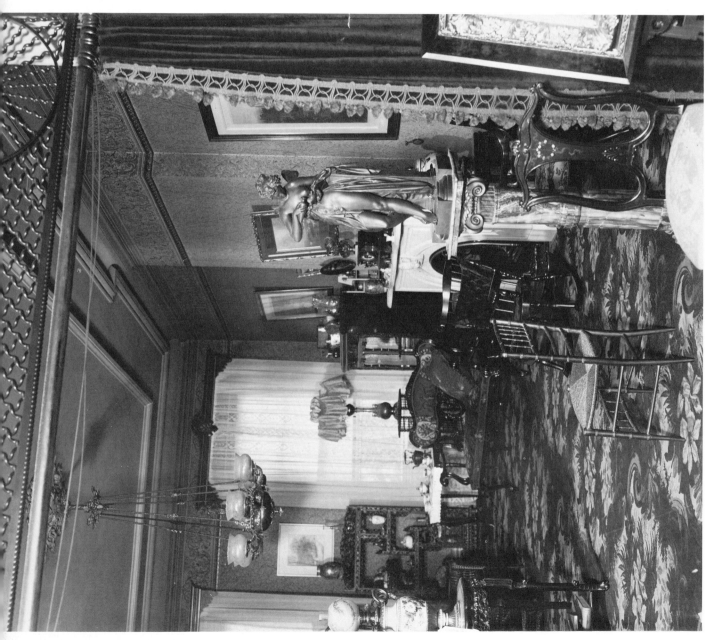

22. LEFT: Drawing Room in the Home of Miss Dodd, 231 West 21st Street (1898).
23. BELOW: Library in Miss Dodd's Home (1898).

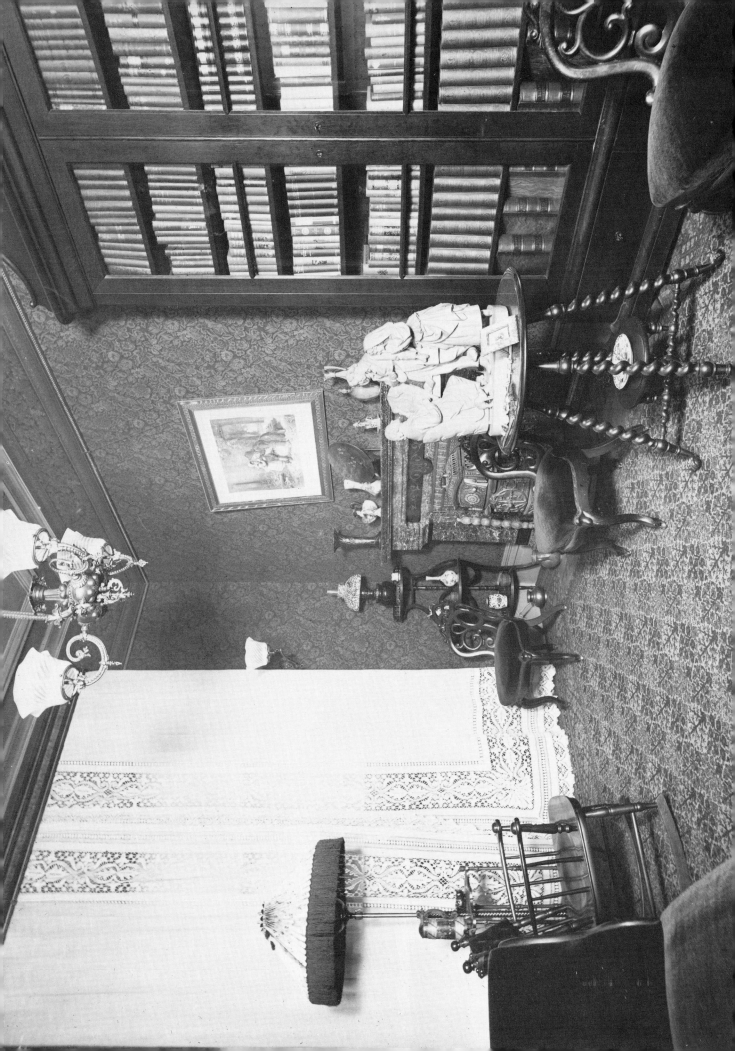

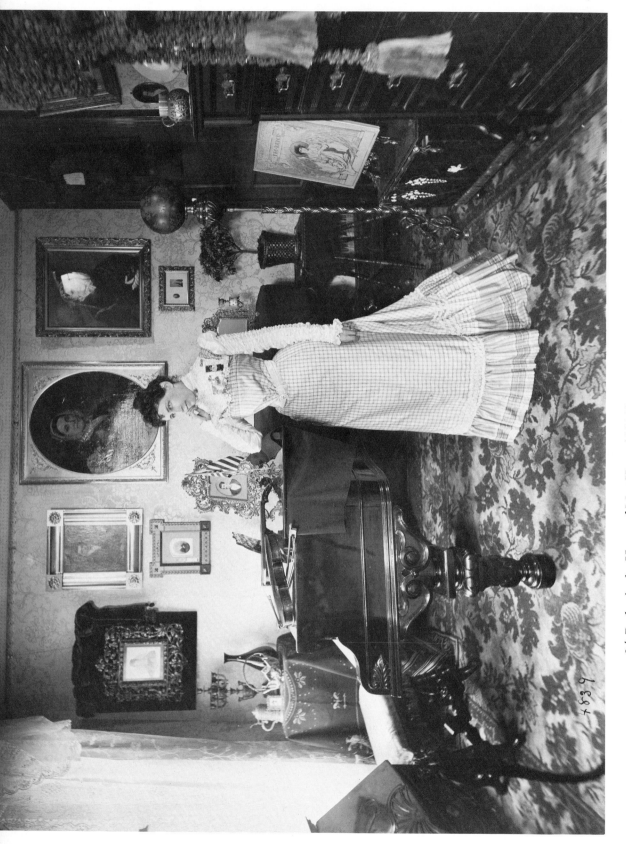

24. Parlor in the Home of Mrs. Kress (1898).
25. BELOW: Sitting Room in the Home of Mrs. Haughey, Manhattan Avenue and 117th Street (1898).

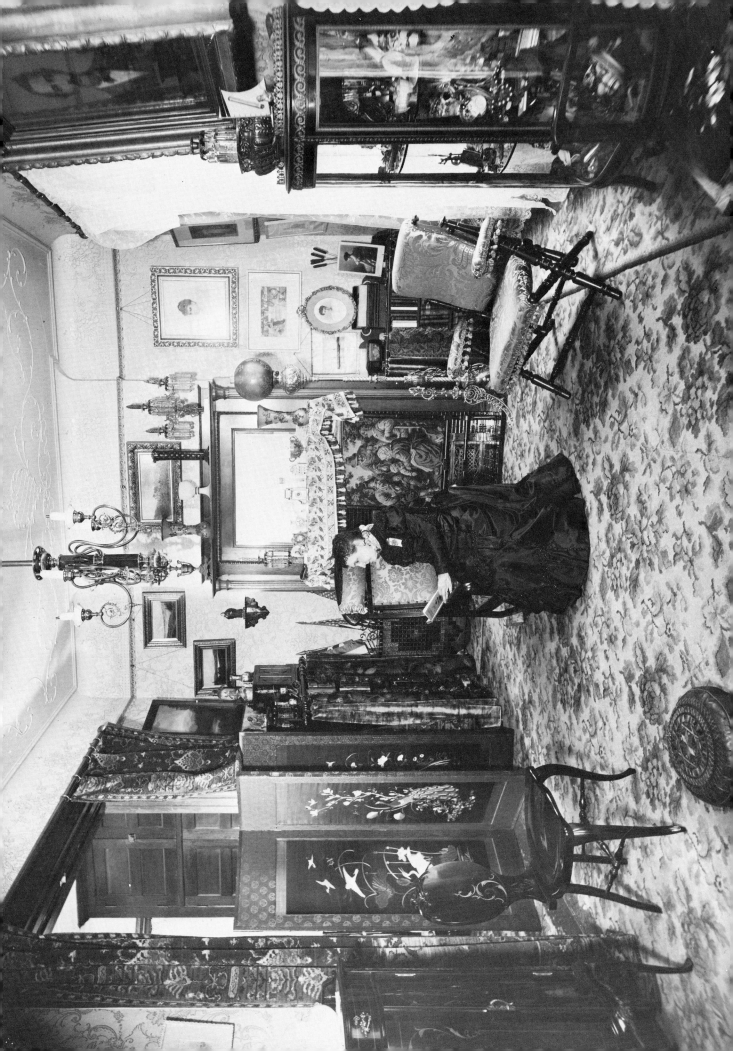

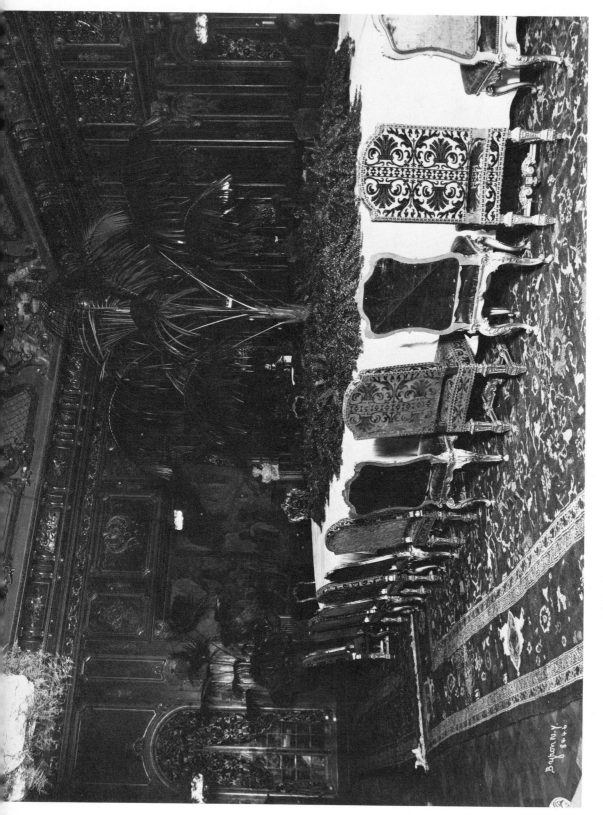

26. Ballroom in the William Collins Whitney House, 871 Fifth Avenue at 68th Street (1899).

27. BELOW: Drawing Room in the Whitney House (1899).

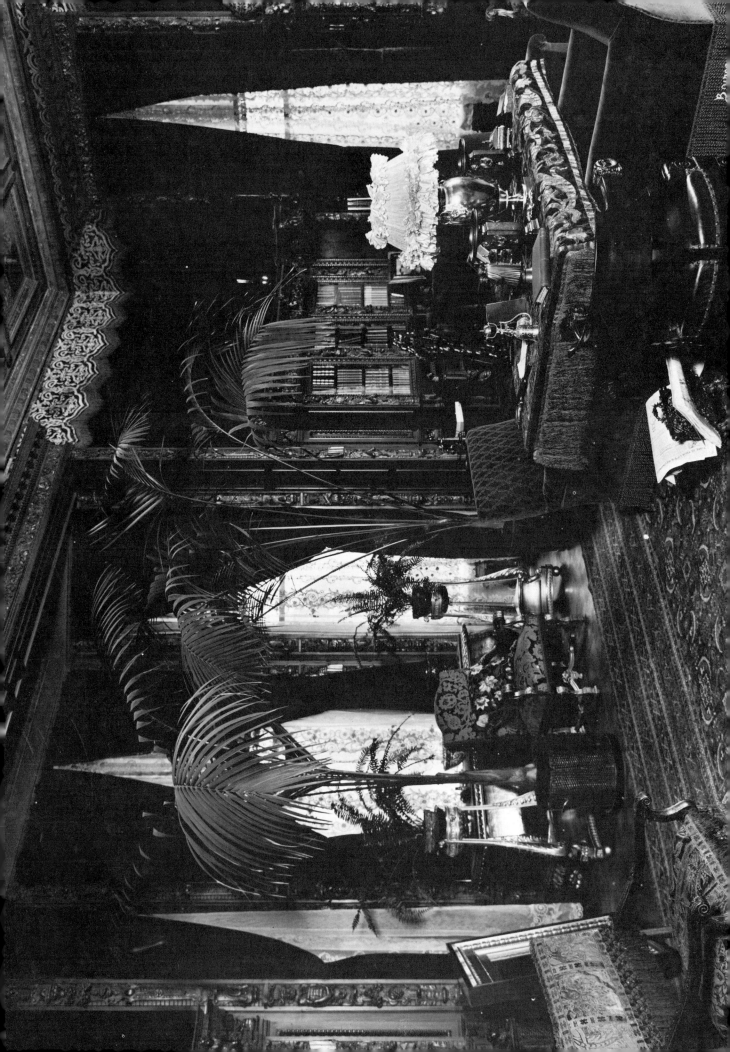

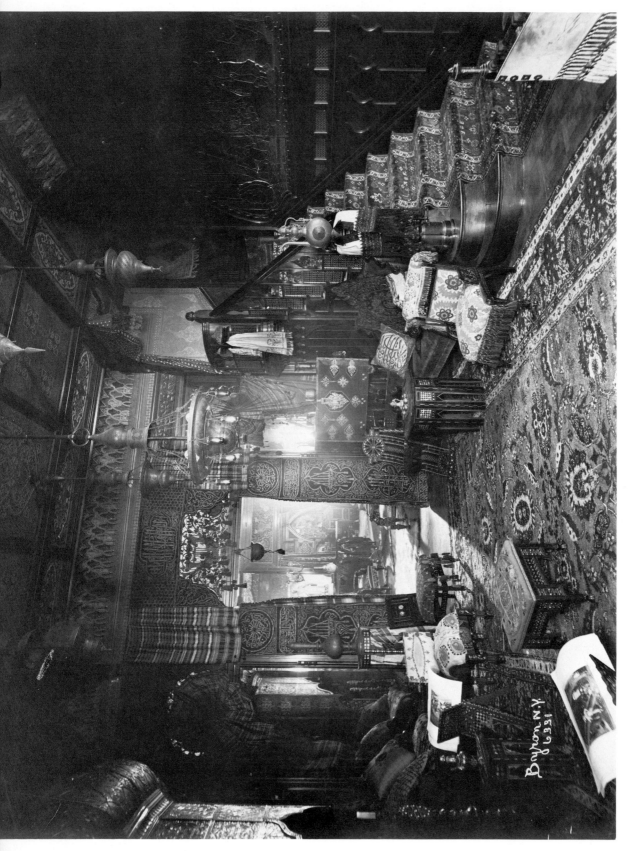

28. Hall in the Edward Lauterbach House, 2 East 78th Street (1899).

29. BELOW: Dining Room in the Lauterbach House (1899).

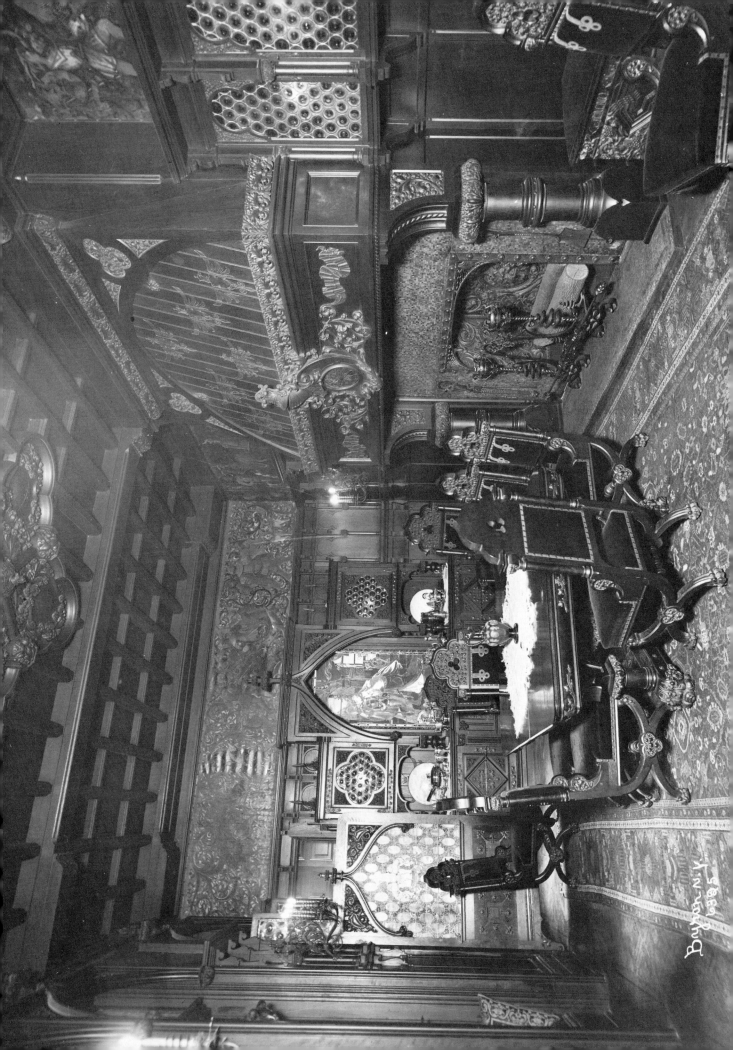

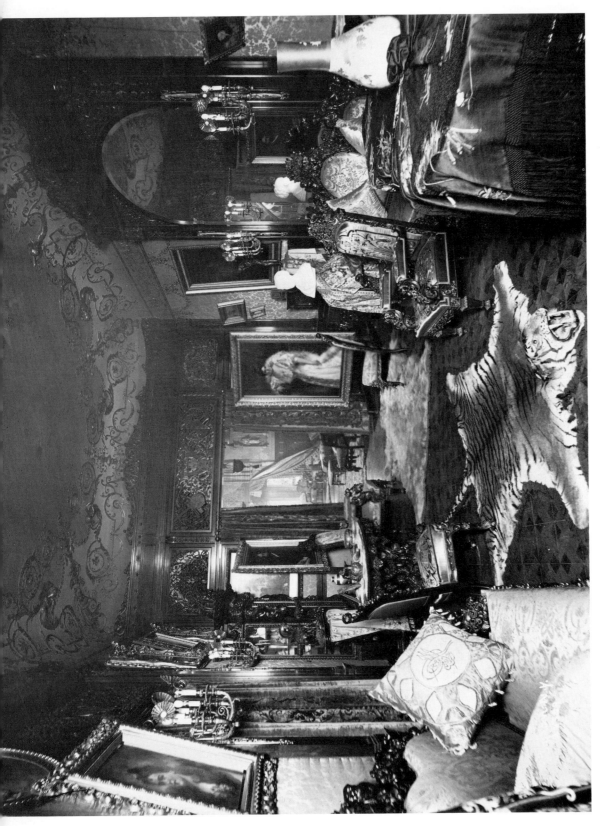

30. Drawing Room in the Lauterbach House (1899).

31. BELOW: Billiard Room in the Lauterbach House (1899).

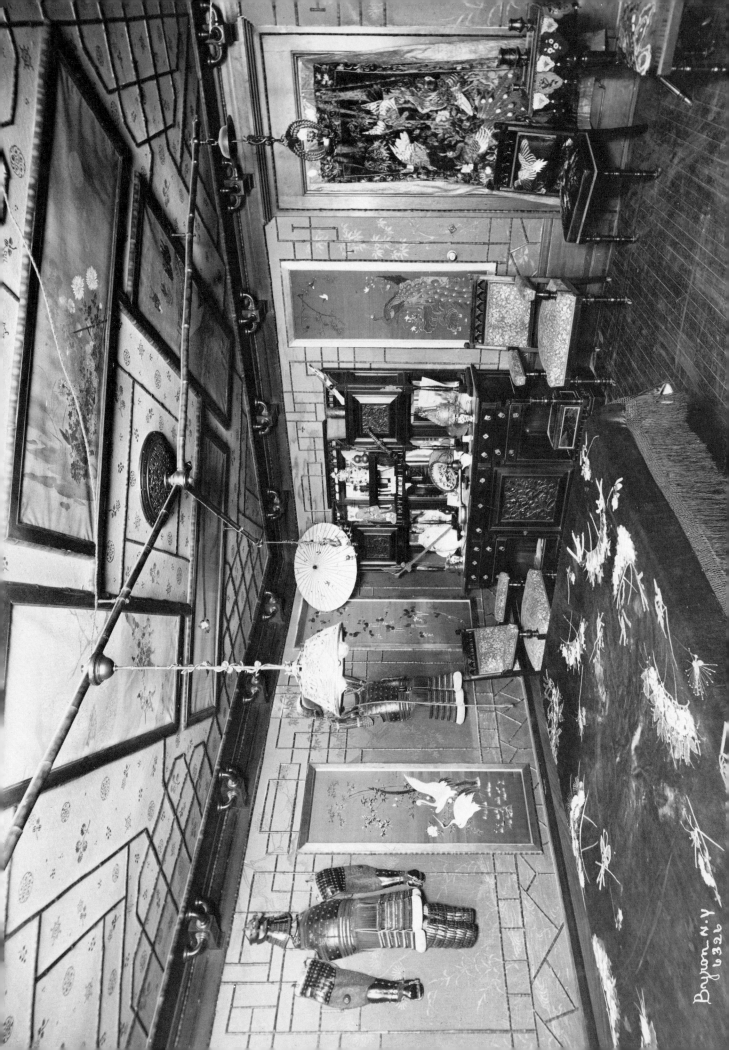

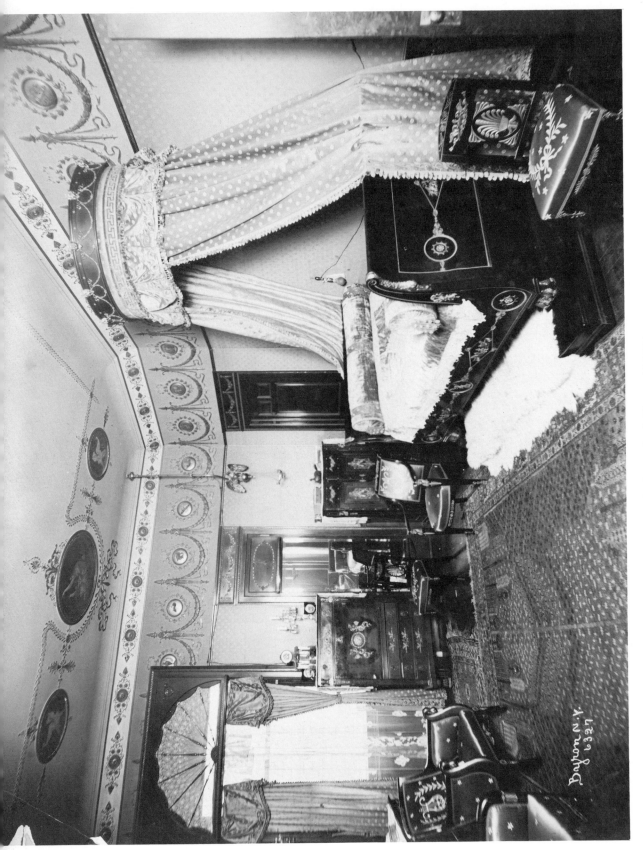

32. Bedroom in the Lauterbach House (1899).

33. BELOW: Bedroom in the Home of Mrs. Hughes (1899).

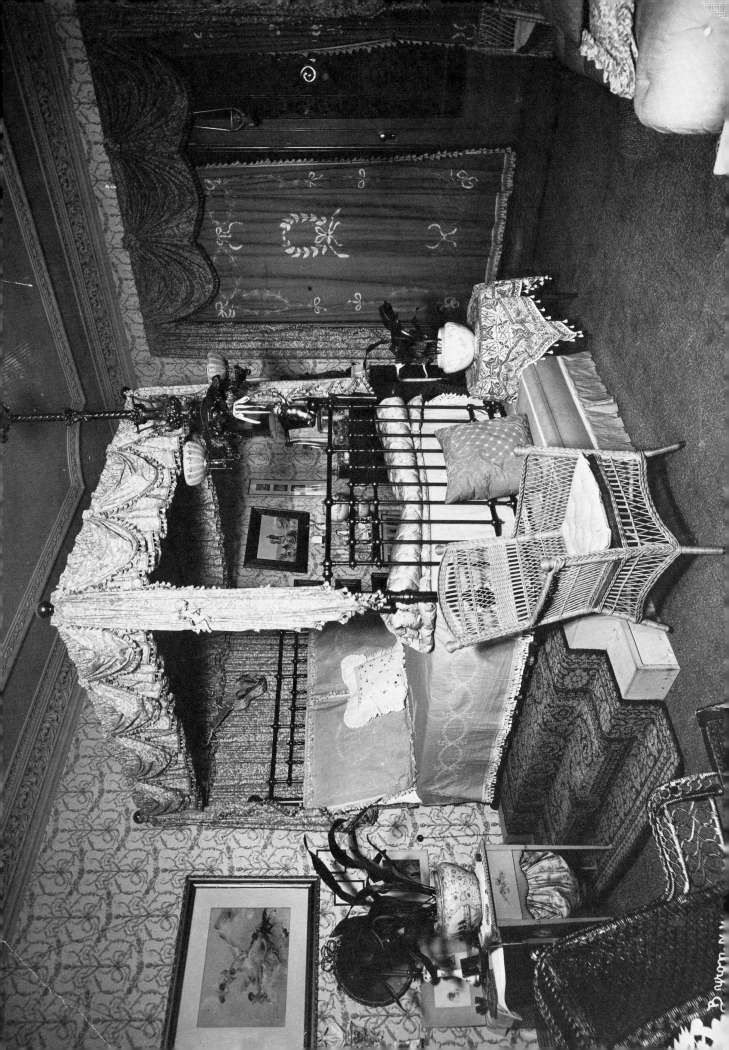

Byron N.Y.

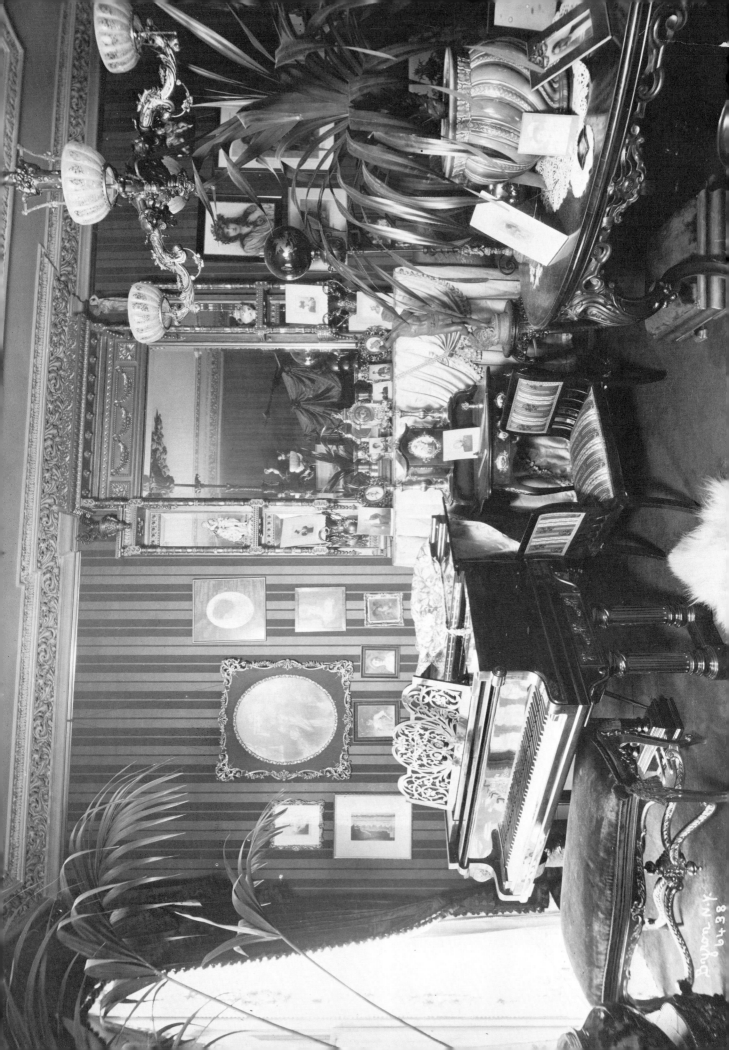

Byron N.Y.
8438

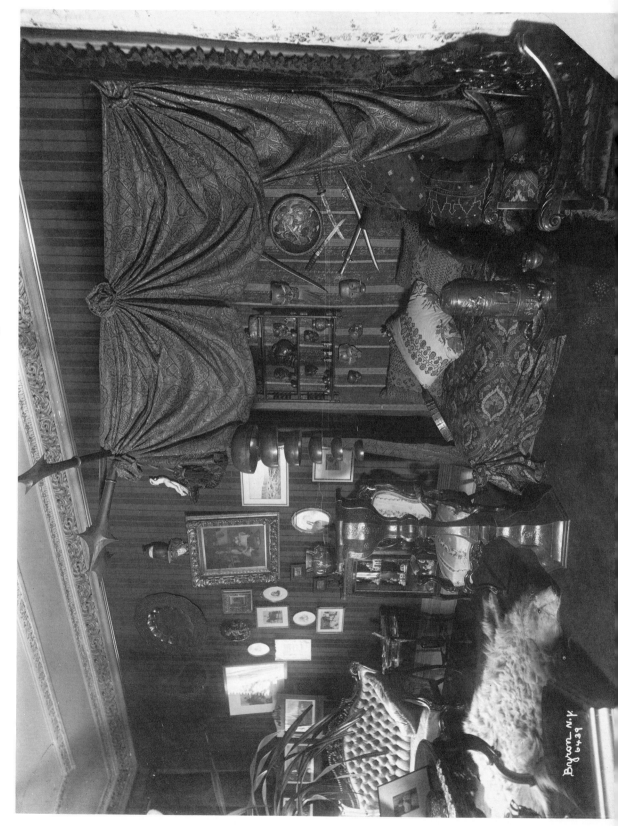

34. ABOVE: Drawing Room in Mrs. Hughes's Home (1899).
35. Turkish Corner in Mrs. Hughes's Drawing Room (1899).

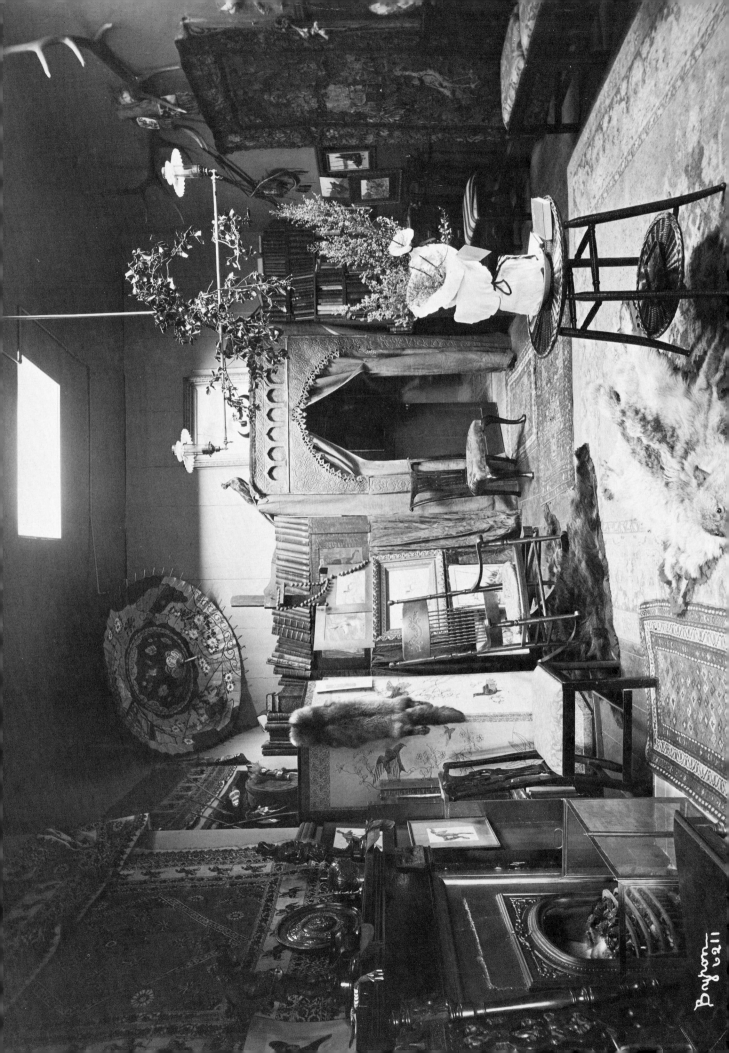

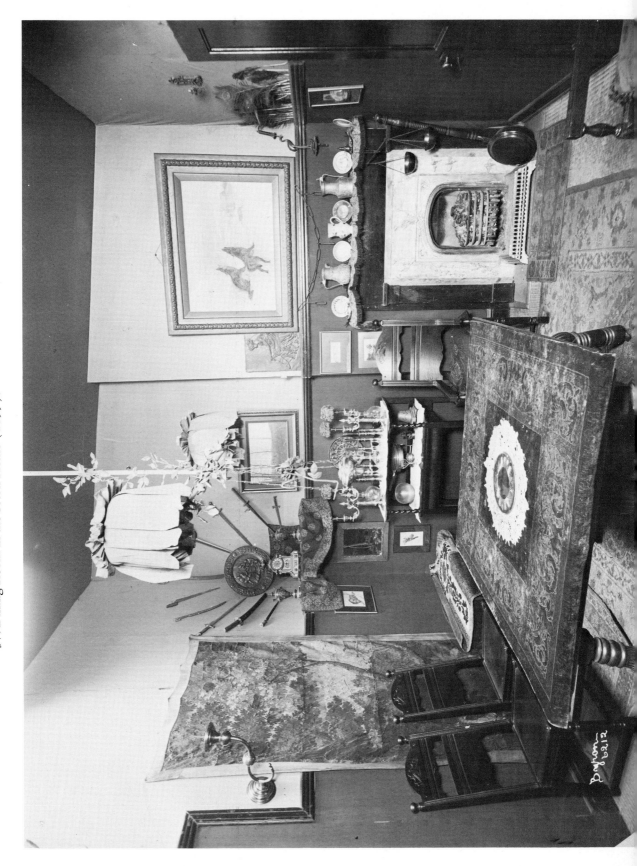

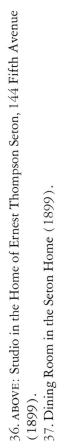

36. ABOVE: Studio in the Home of Ernest Thompson Seton, 144 Fifth Avenue (1899).
37. Dining Room in the Seton Home (1899).

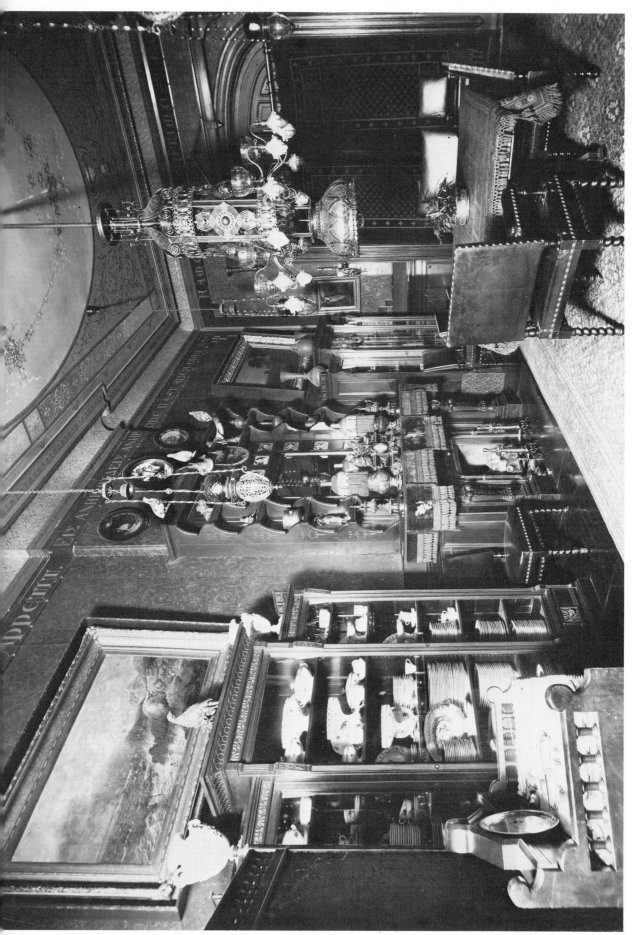

38. Dining Room in the Residence of Chauncey Mitchell Depew, 27 West 54th Street (1899).

39. BELOW: Library in the Depew Residence (1899).

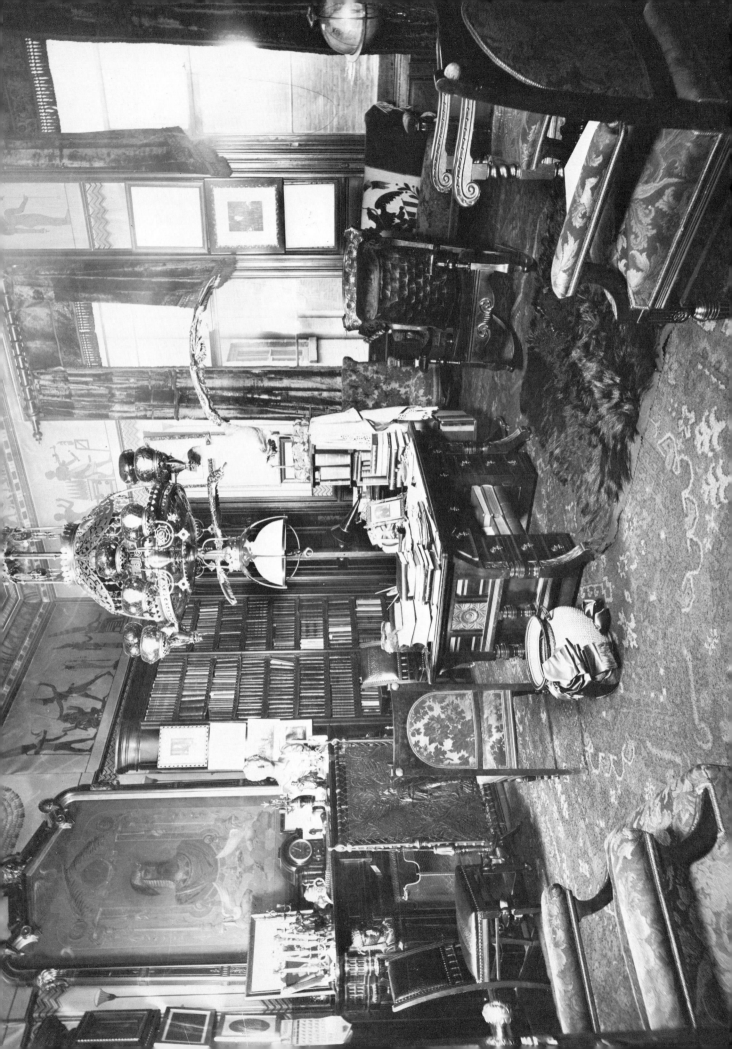

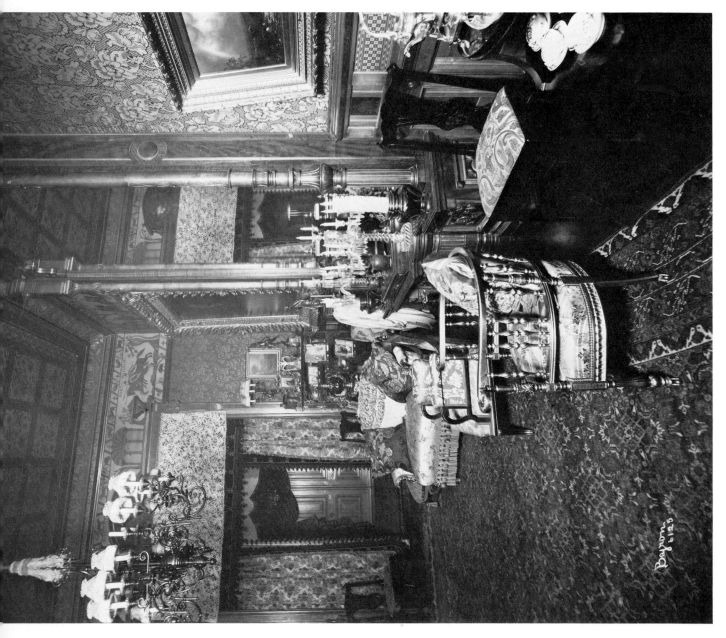

40. LEFT: Drawing Room in the Depew Residence (1899).

41. BELOW: Bedroom in the Depew Residence (1899).

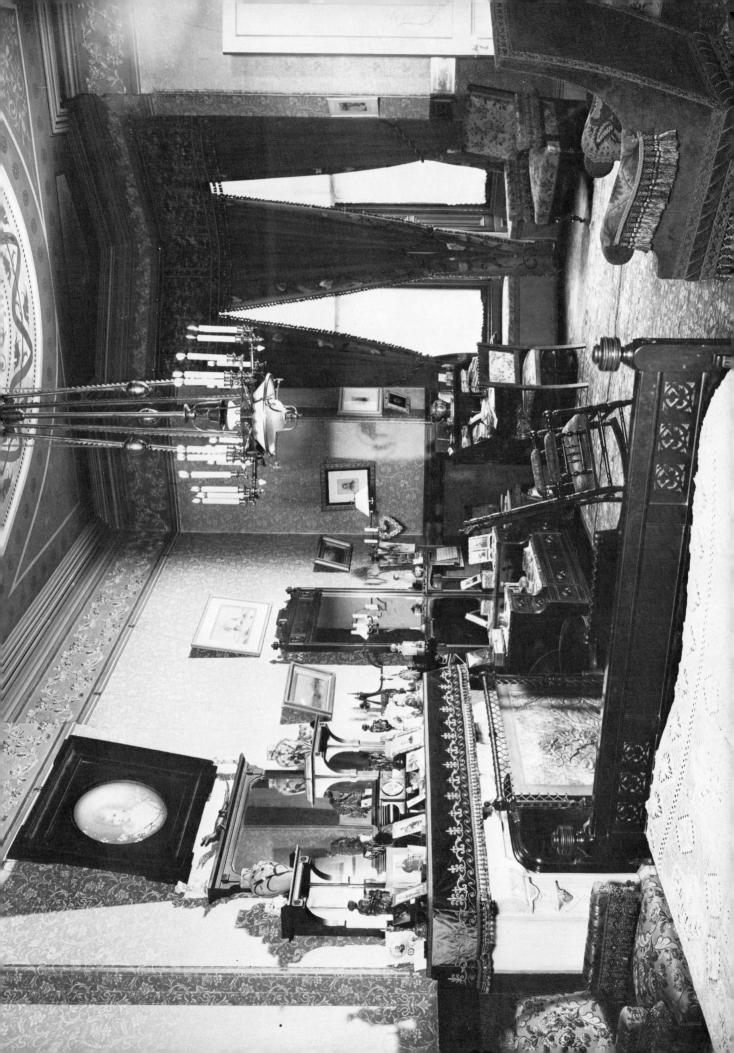

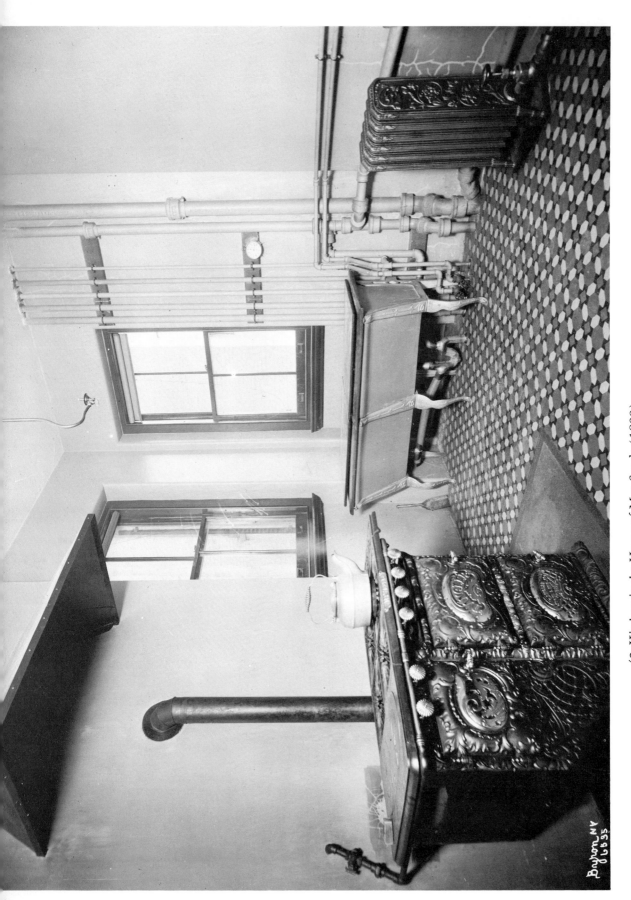

42. Kitchen in the Home of Mrs. Sands (1899).
43. BELOW: Kitchen in the Home of Mrs. Theodore Sutro, 320 West 102nd Street (1899).

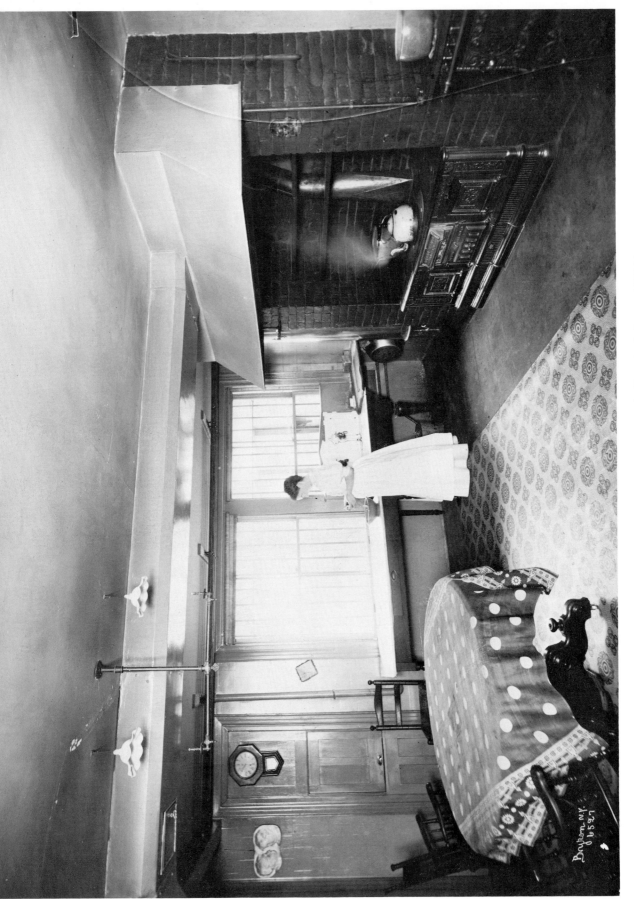

44. Kitchen in the Home of Mrs. Burton Harrison, 43 East 29th Street (1899).

45. BELOW: Kitchen in the Home of Mrs. F. L. Loring, 811 Fifth Avenue (1899).

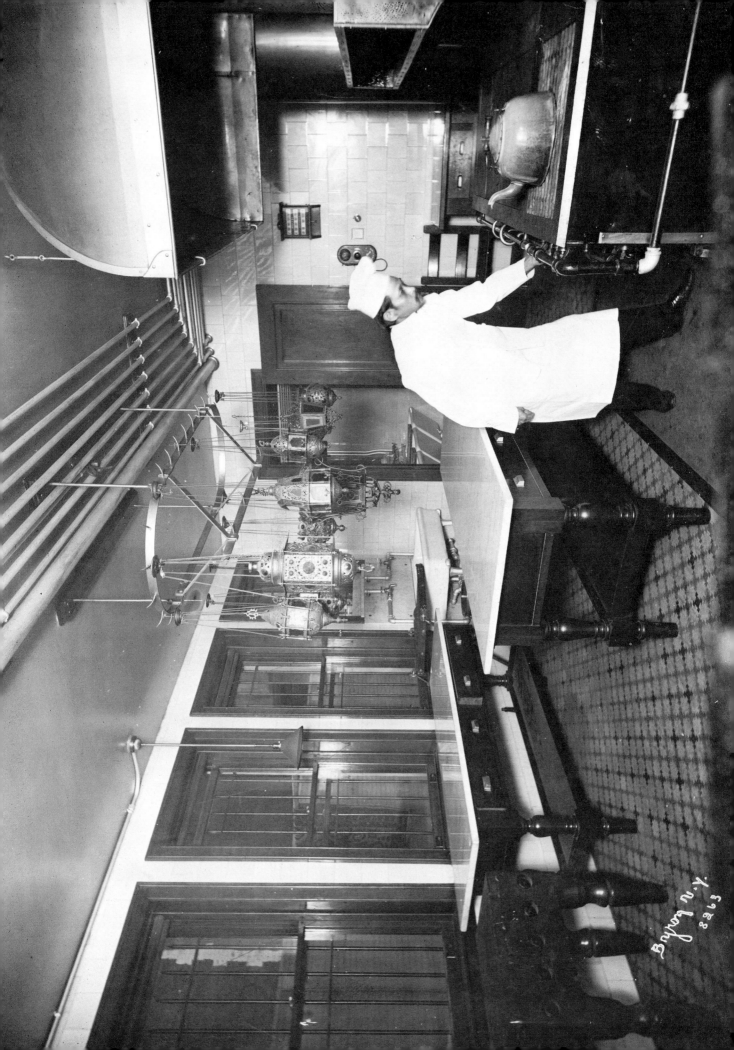

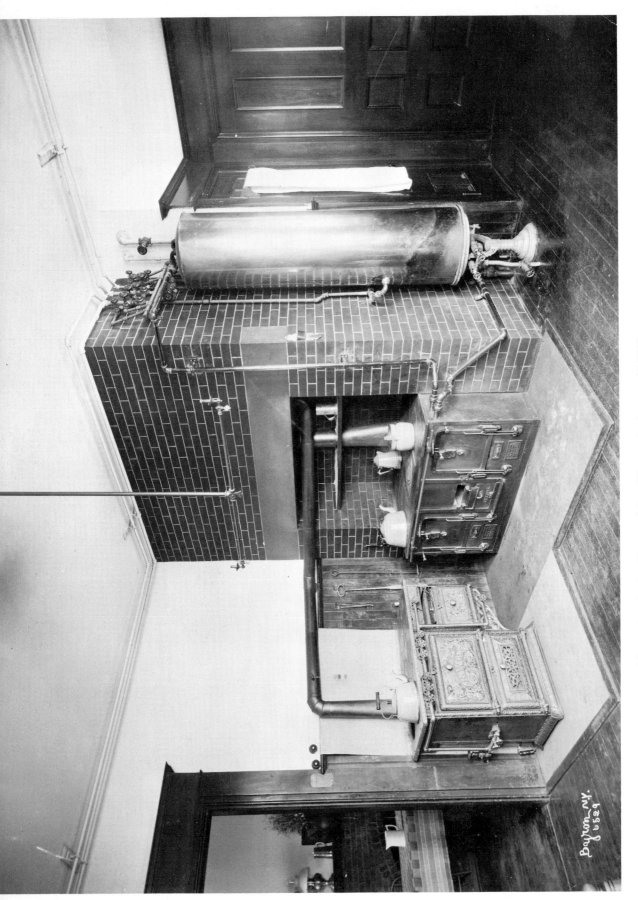

46. Kitchen in the Home of Dr. Warner Irvington (1899).

47. BELOW: Parlor in the Home of Frederick Wallingford Whitridge, 16 East 11th Street (1900).

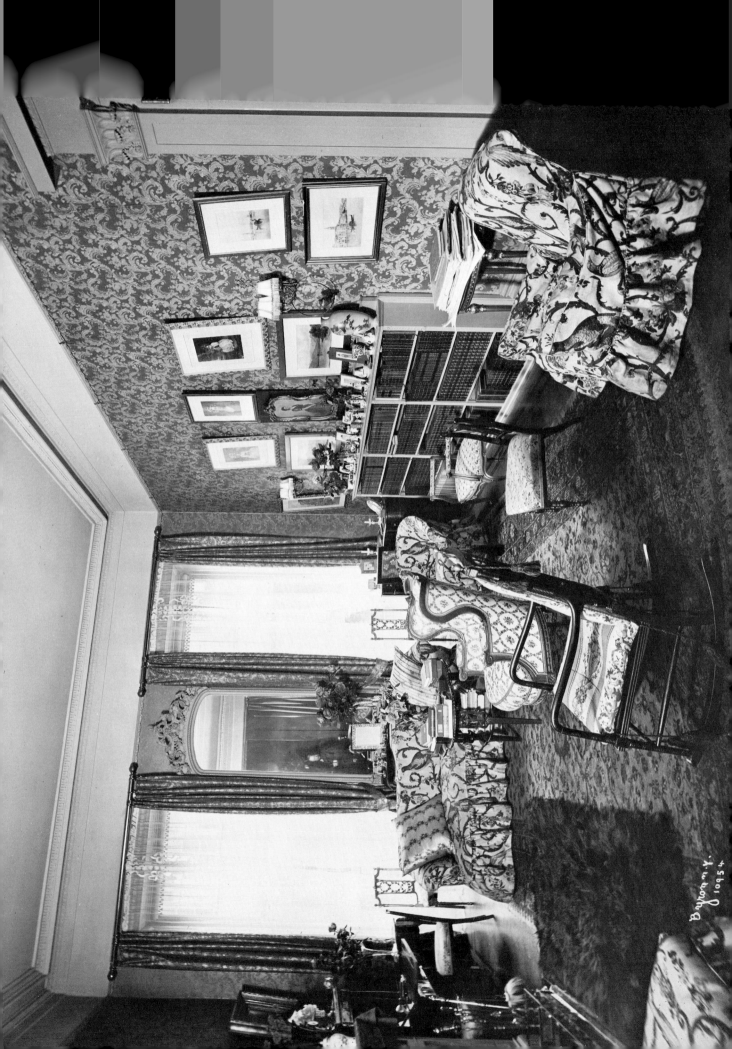

Bayonne N.Y. 1095

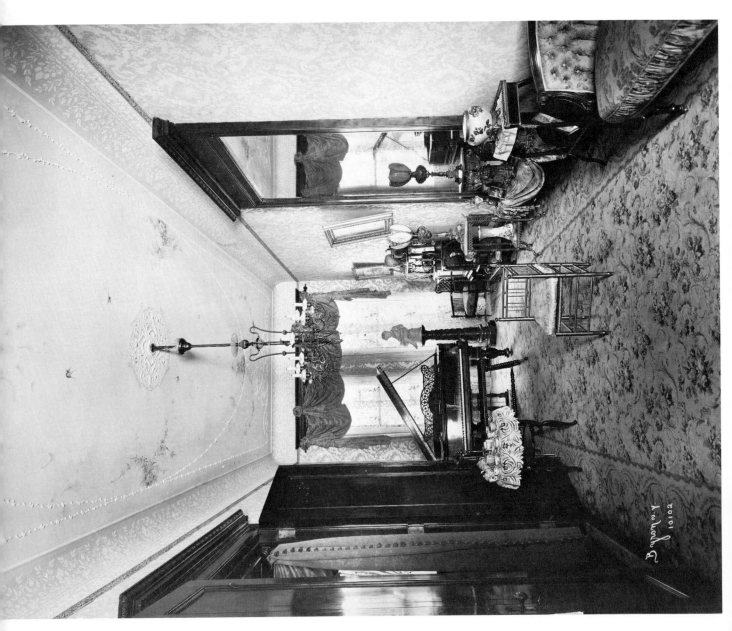

48. Music Room in the Oliver M. Farrand House (238 West 113th Street (1900).

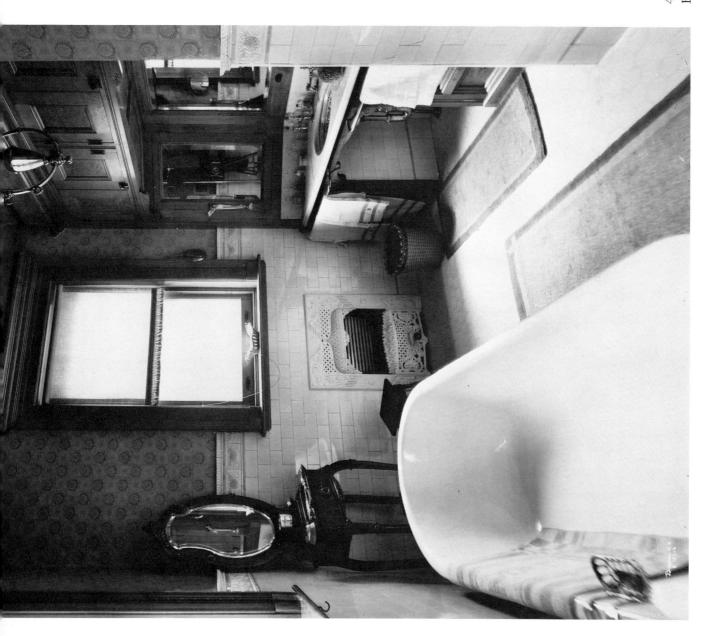

49. Bathroom in the Home of Edward Brandus, 16 West 88th Street (1902).

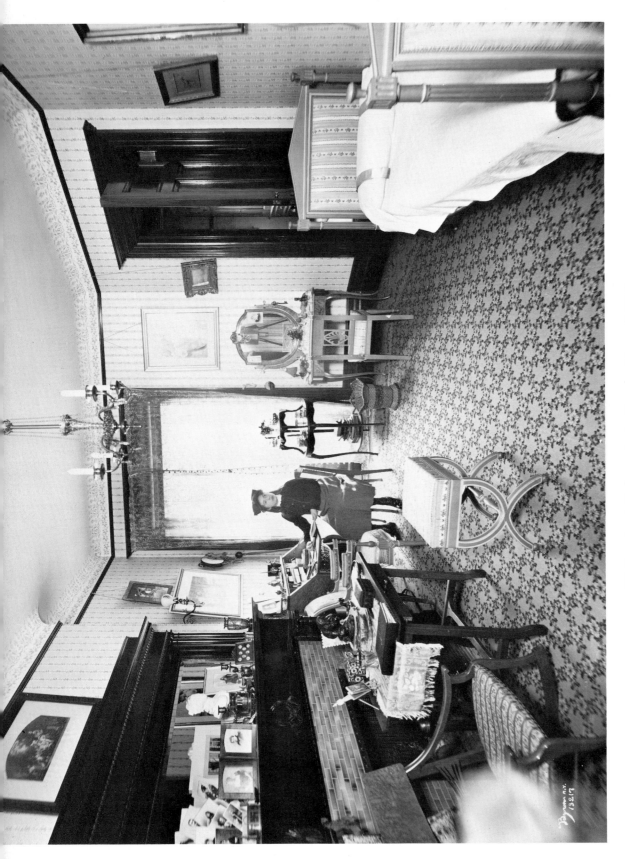

50. Daughter's Bedroom in the Brandus Home (1902).
51. BELOW: Upper Hall in the Brandus Home (1902).

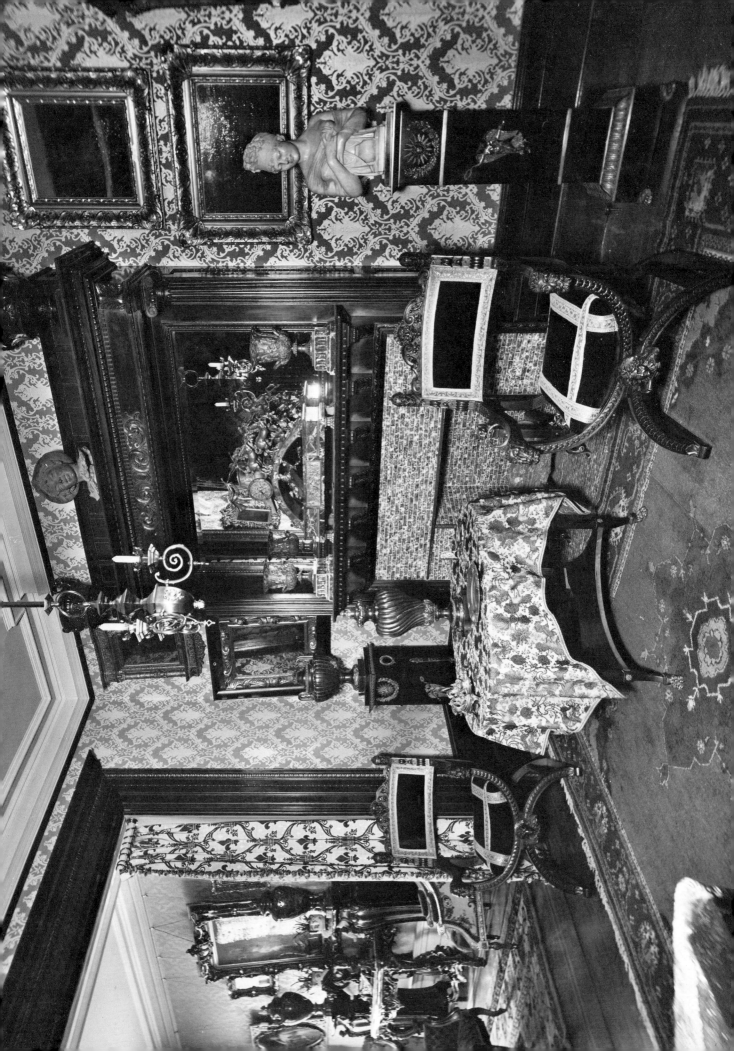

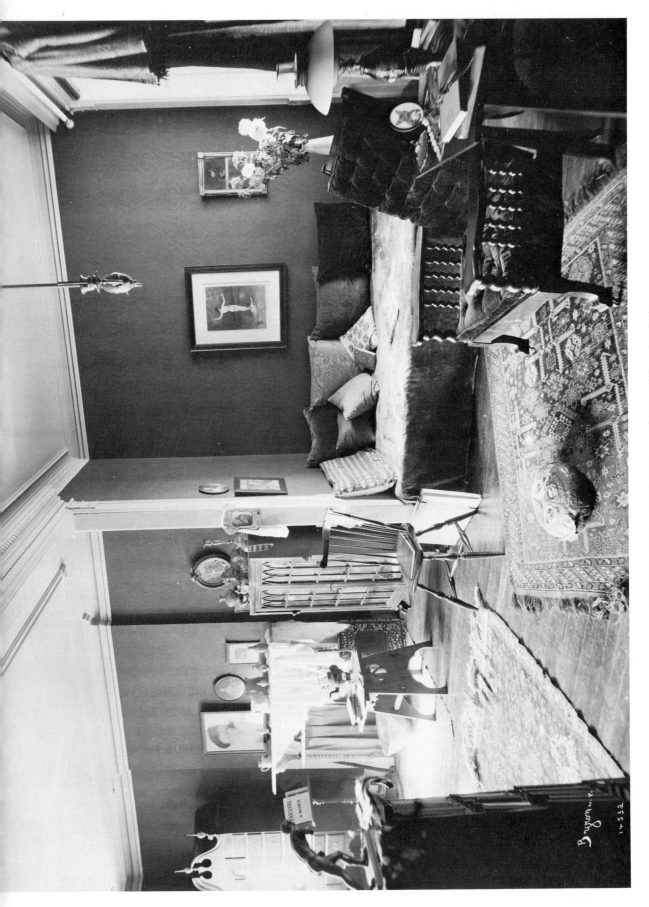

52. Living Room in the Home of Mrs. Elliott (1902).
53. BELOW: Bedroom in Mrs. Elliott's Home (1902).

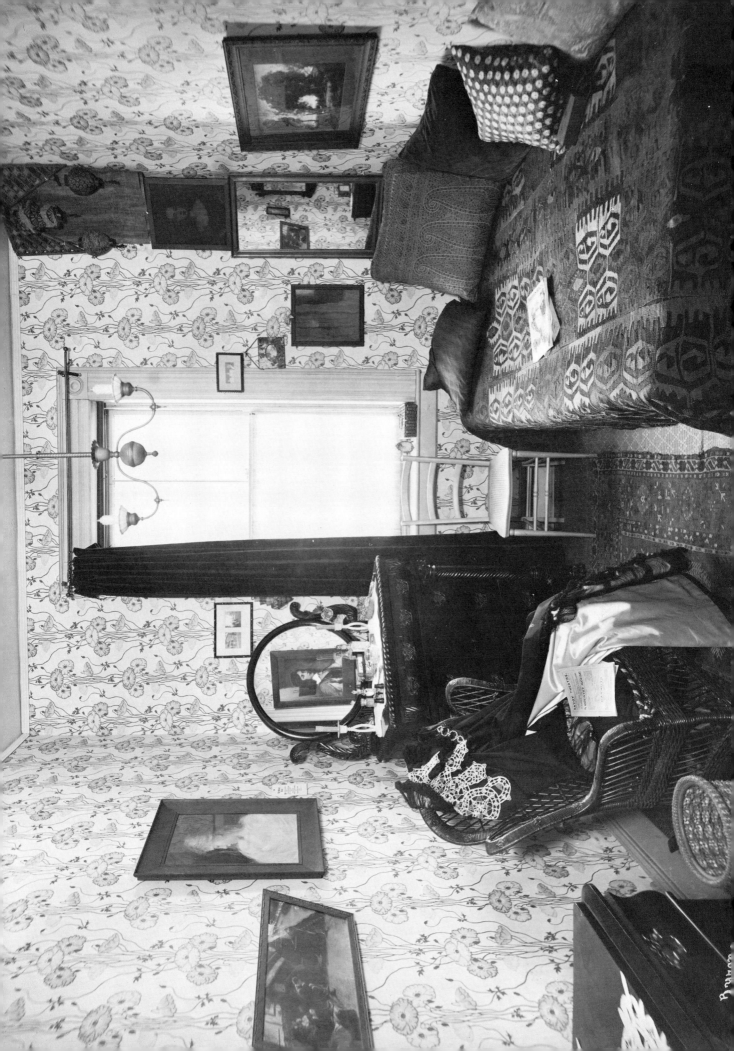

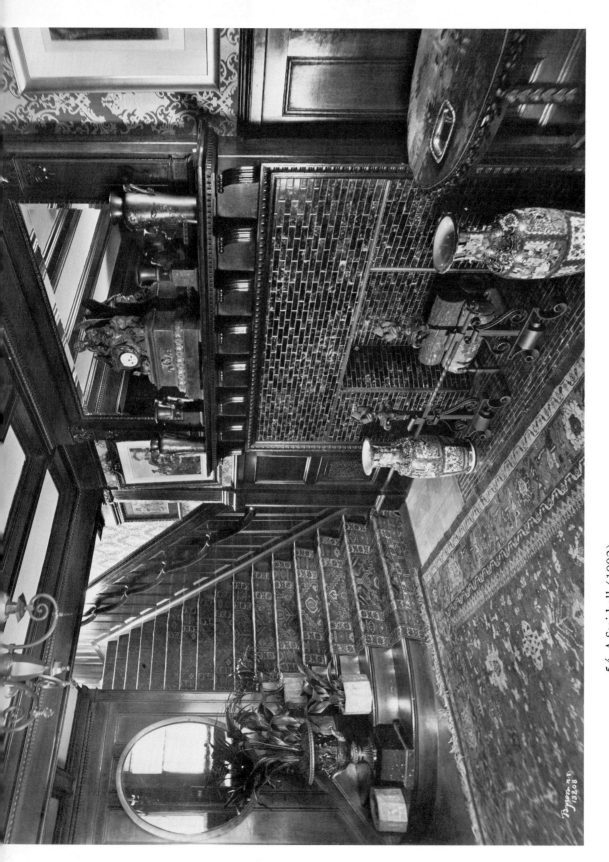

54. A Stairhall (1902).

55. BELOW: Dining Room in the Home of H. Ziegler, 18 East 54th Street (1902).

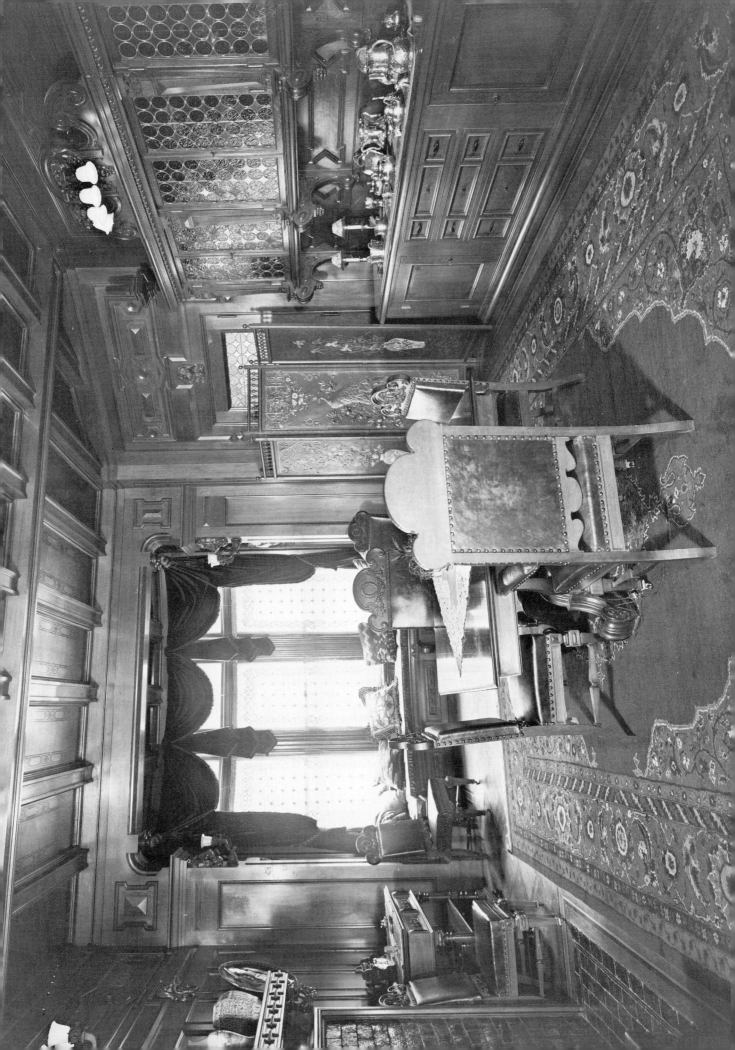

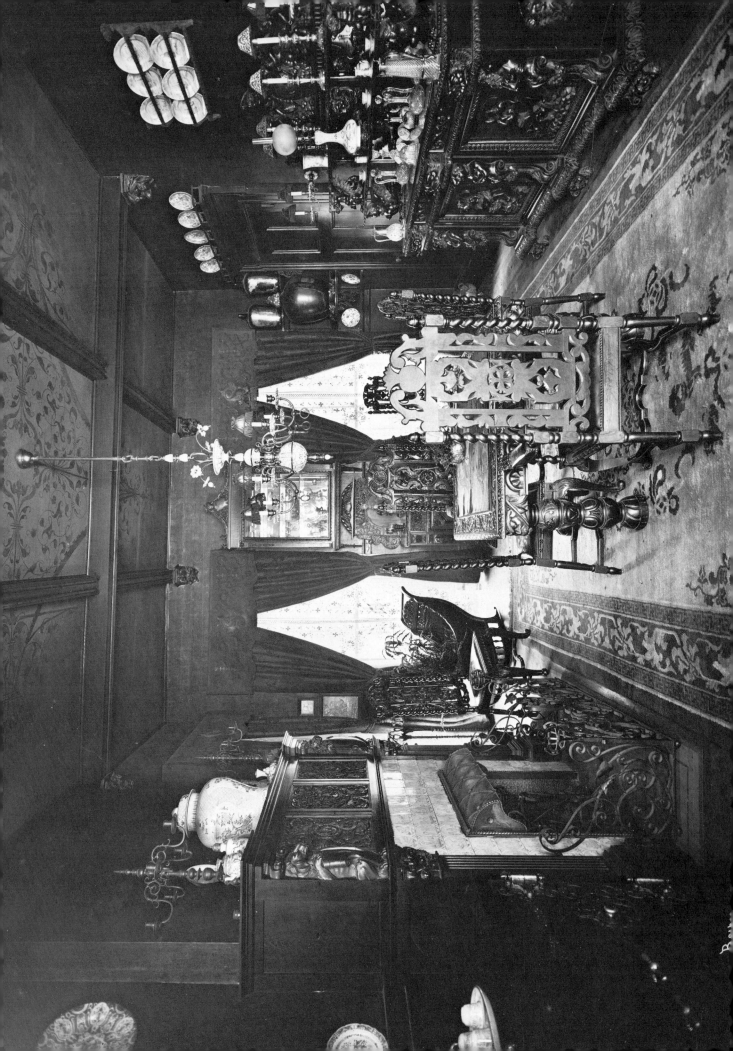

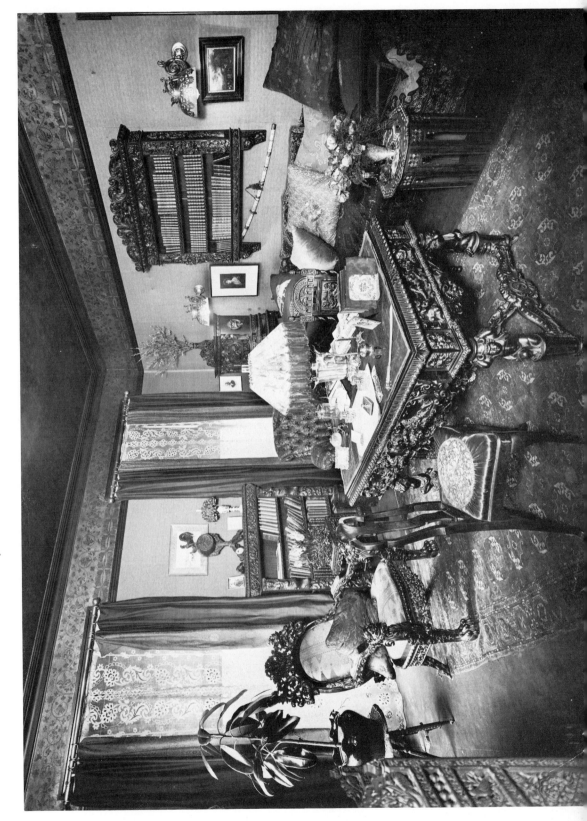

56. ABOVE: Dining Room in the Home of Mrs. R. E. Schroeder (1903).
57. Library in Mrs. Schroeder's Home (1903).

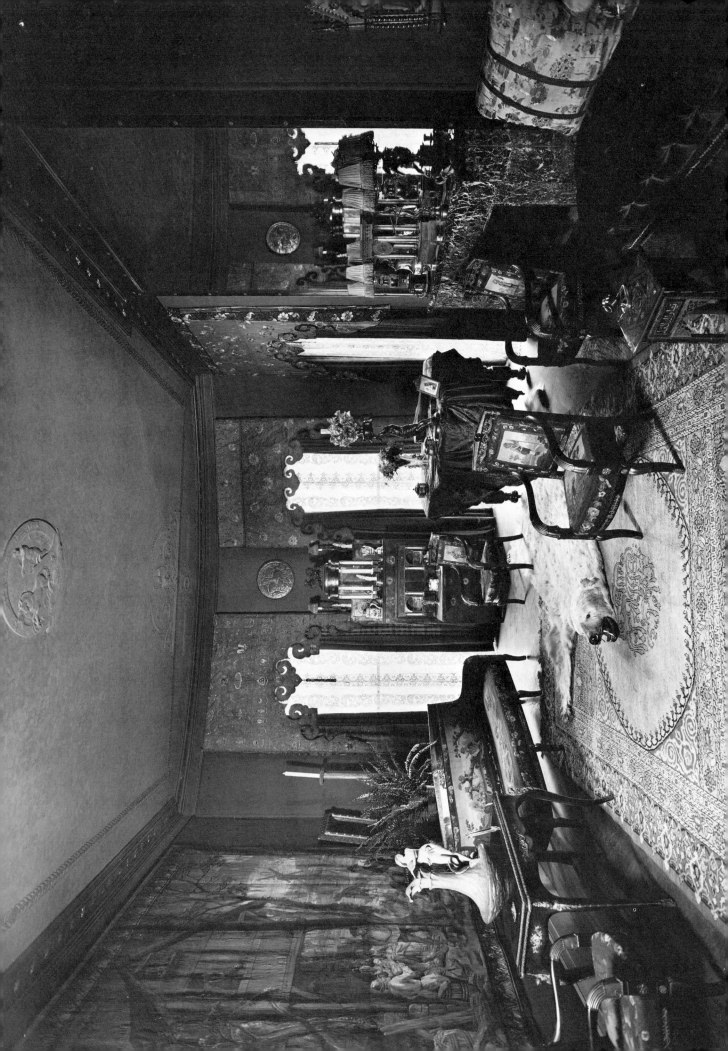

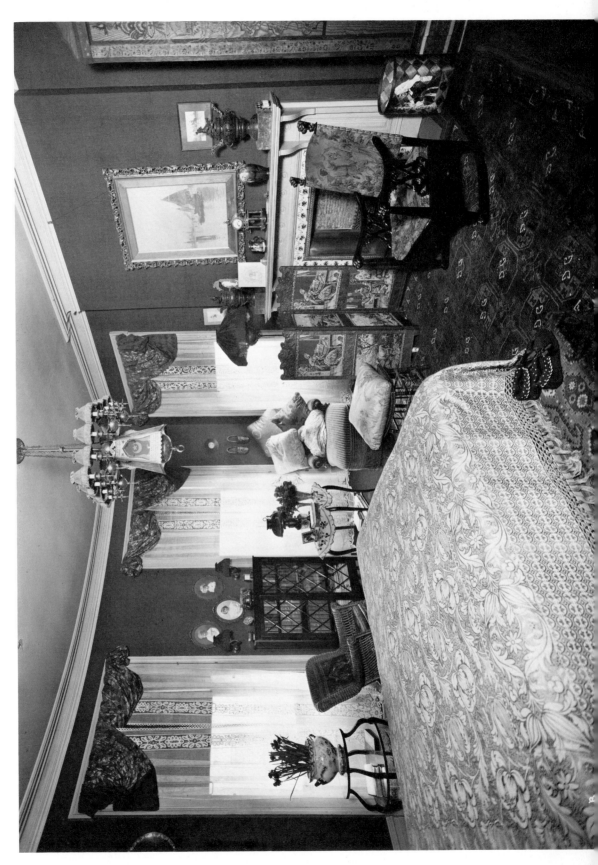

58. ABOVE: Drawing Room in Mrs. Schroeder's Home (1903).
59. Bedroom in Mrs. Schroeder's Home (1902).

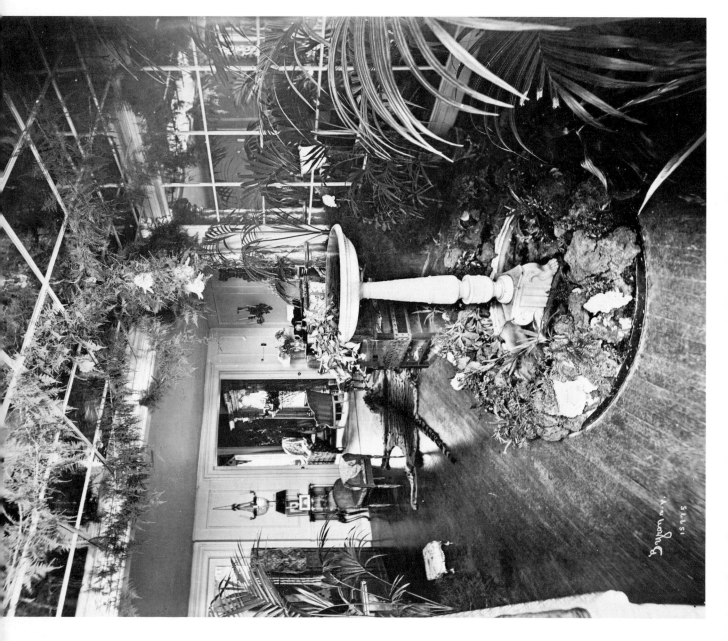

60. LEFT: Conservatory in the Home of
Miss N. Munroe, 36 West 59th Street
(1903).

61. BELOW: Bachelor Apartment of Mr.
Fox the Tailor (1903–04).

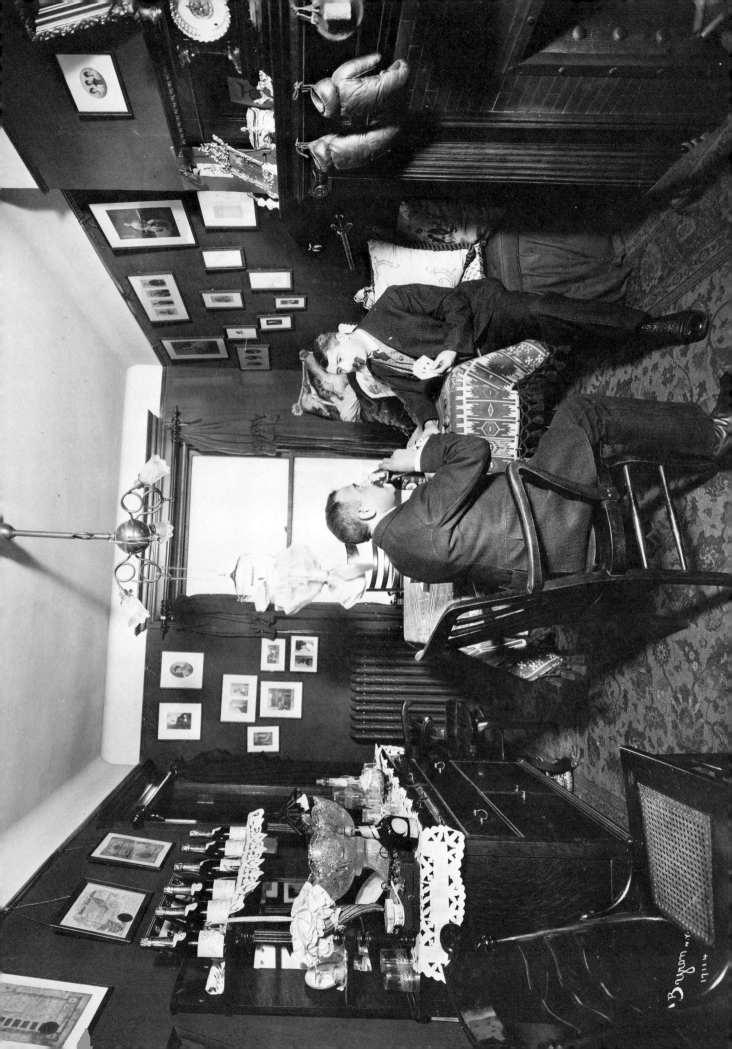

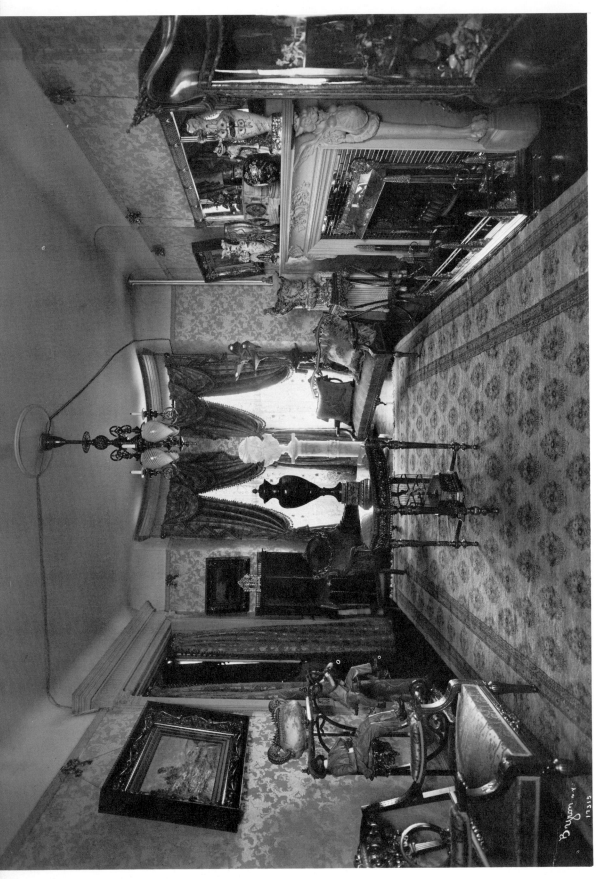

62. Drawing Room in the Joseph M. Weber House, 136 Madison Avenue (1904).

63. BELOW: Reception Room in the Weber House (1904).

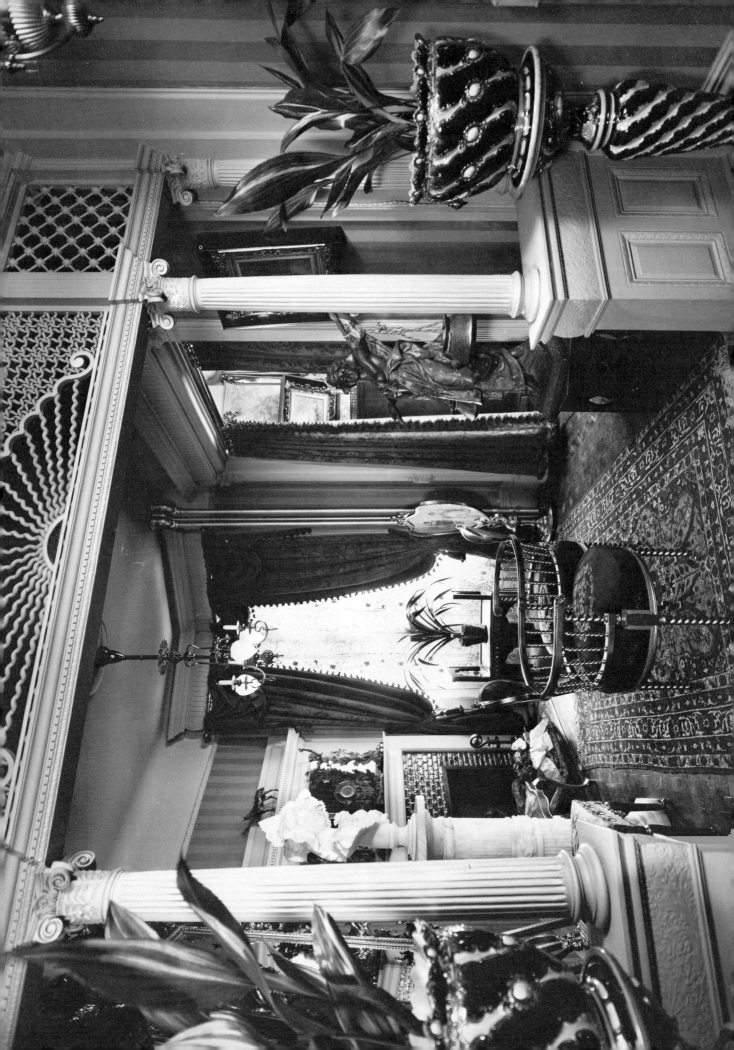

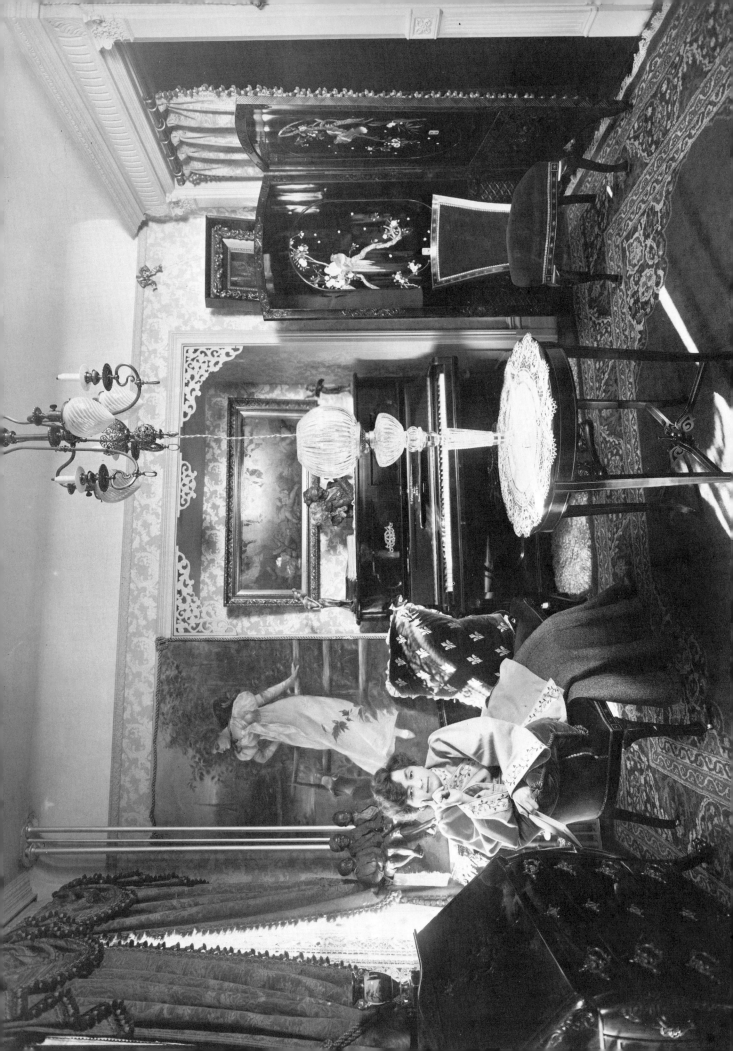

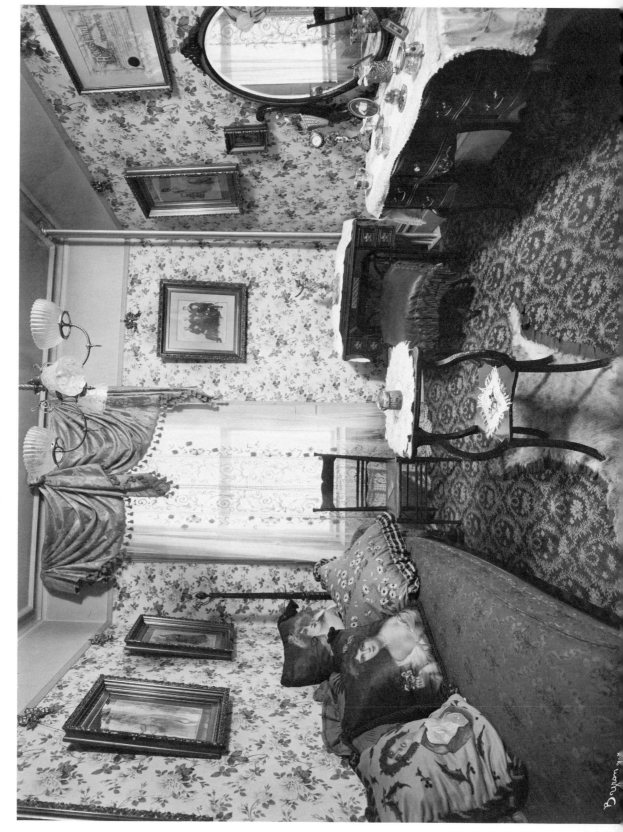

64. ABOVE: Music Room in the Weber House (1904).
65. Dressing Room in the Weber House (1904).

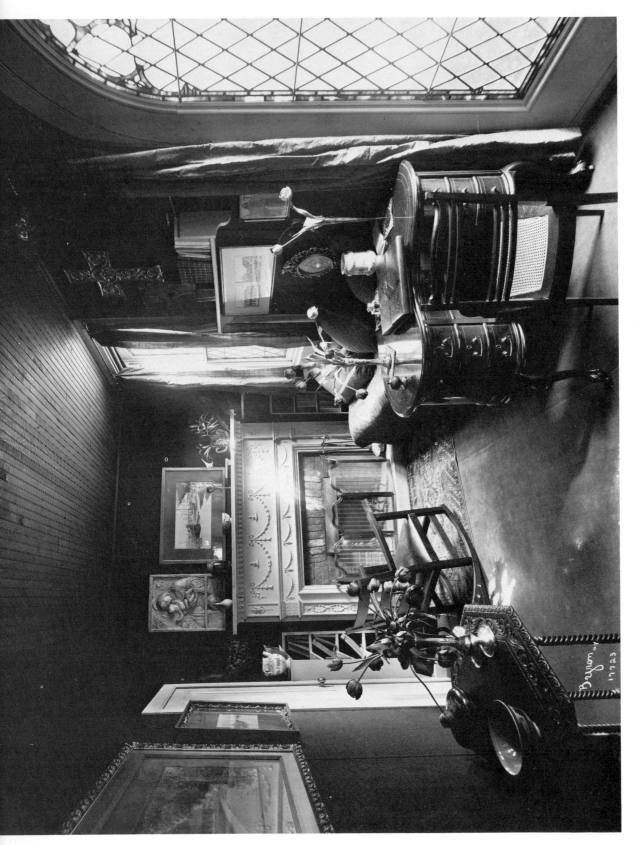

66. Room in the Studio-Home of F. Berkeley Smith (1904).
67. BELOW: Another Room in the Studio-Home of F. Berkeley Smith (1904).

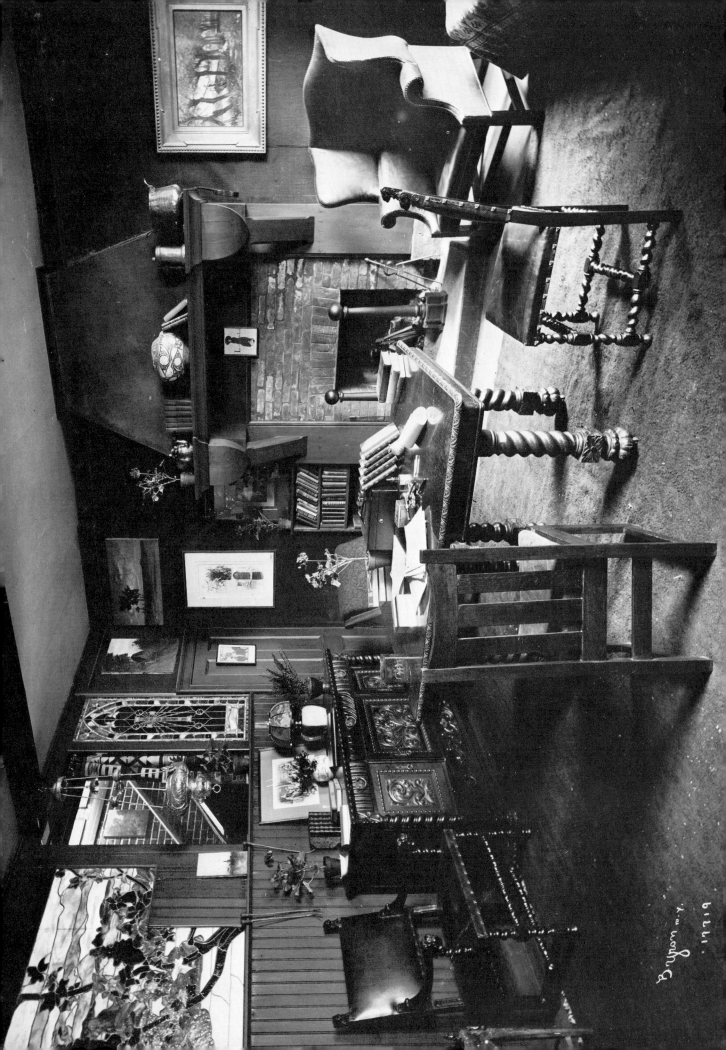

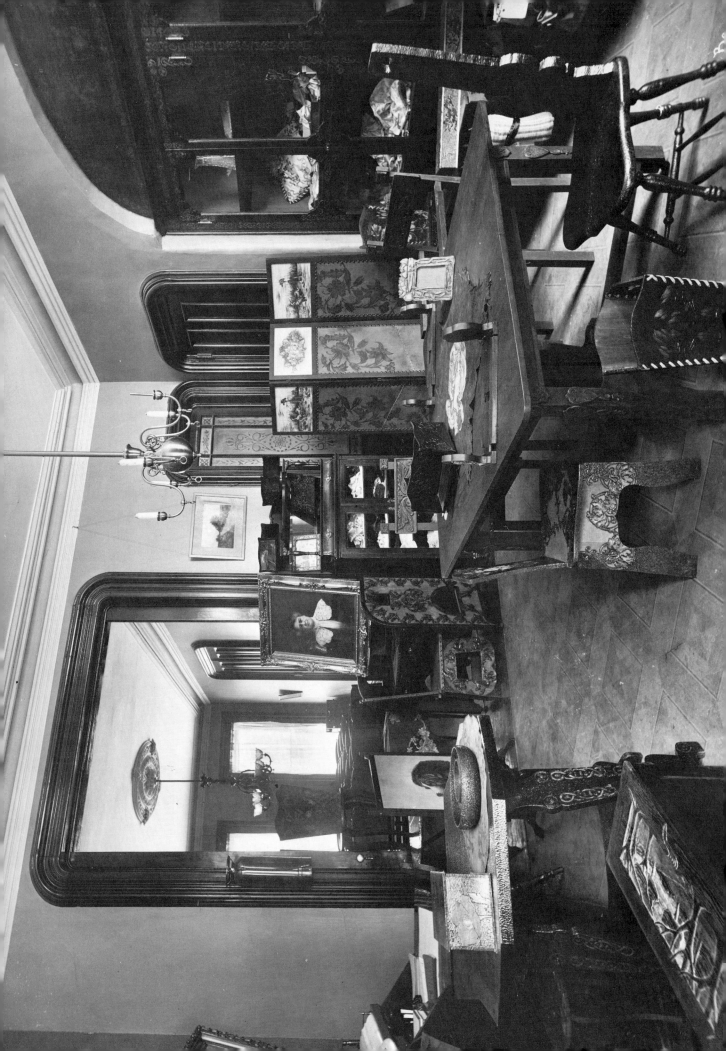

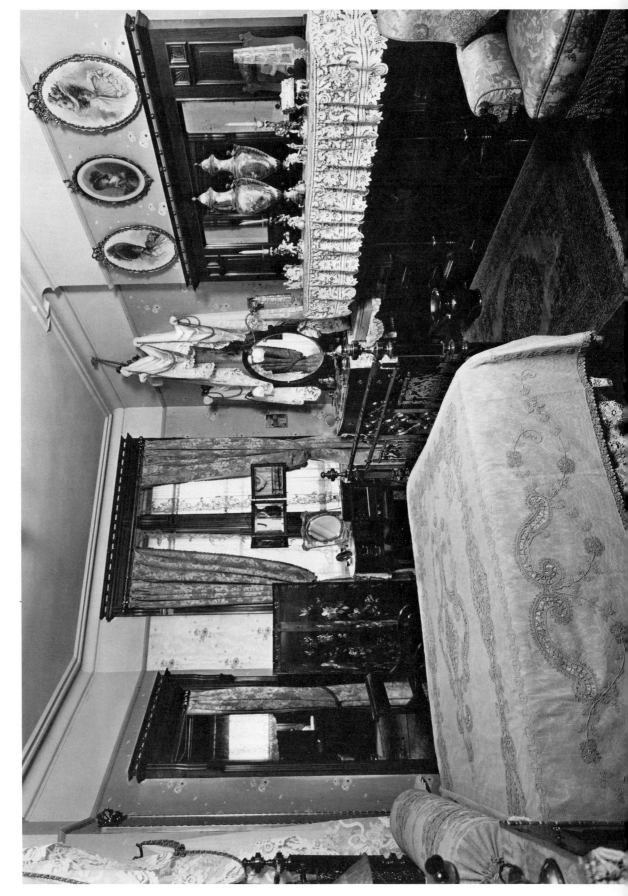

68. ABOVE: A Club Room (1904).
69. A Bedroom (1904).

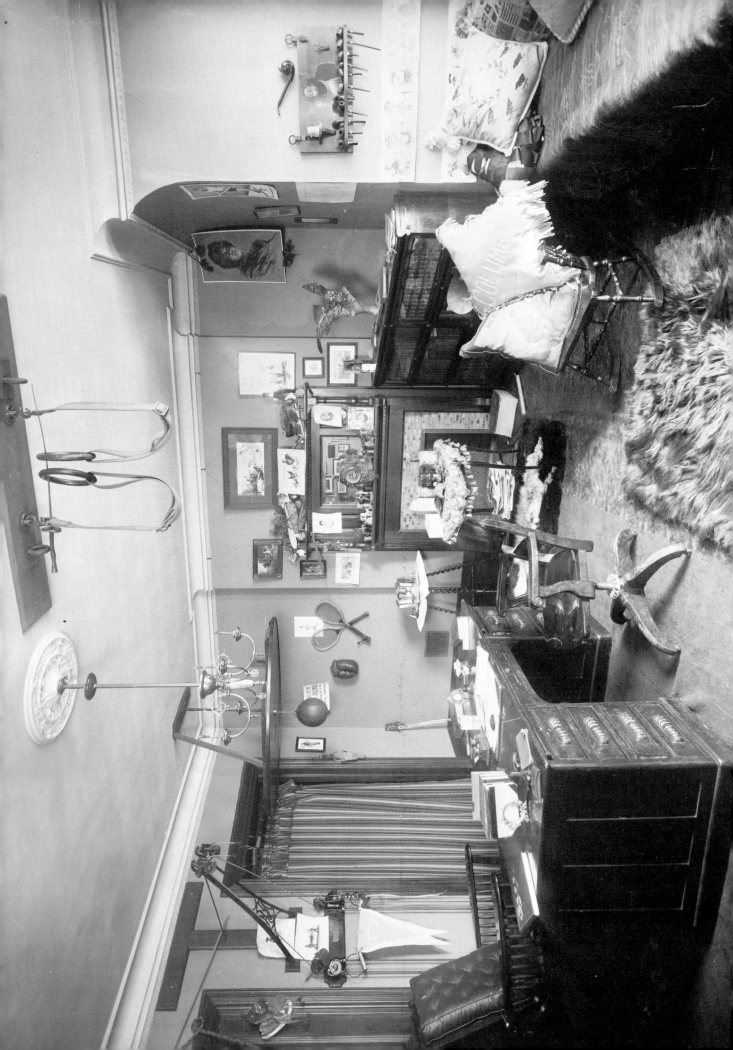

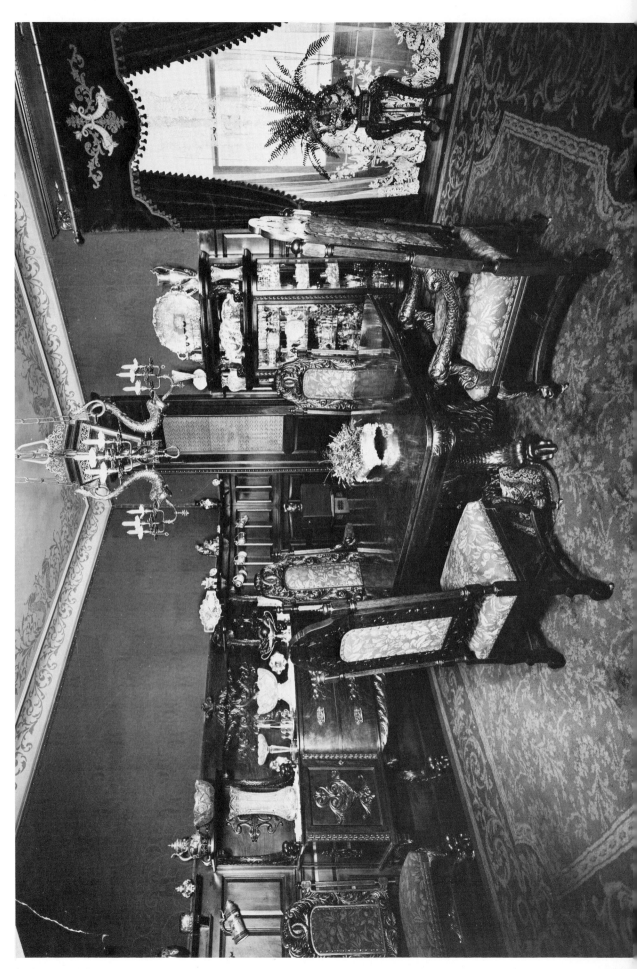

70. ABOVE: Den in the Home of Arthur J. Joseph (1905).
71. Dining Room in the Home of Arthur J. Joseph (1905).

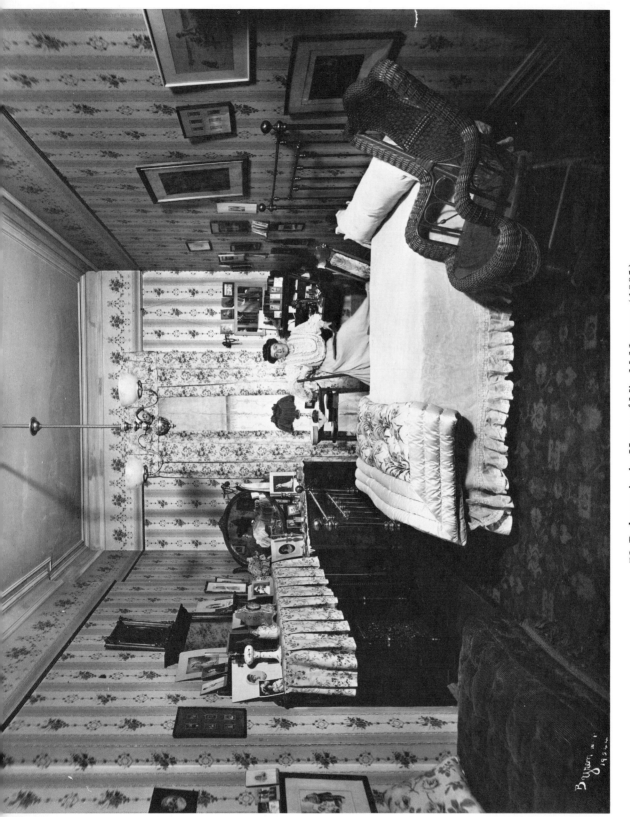

72. Bedroom in the Home of Miss McNamara (1905).
73. BELOW: A Bedroom (1905).

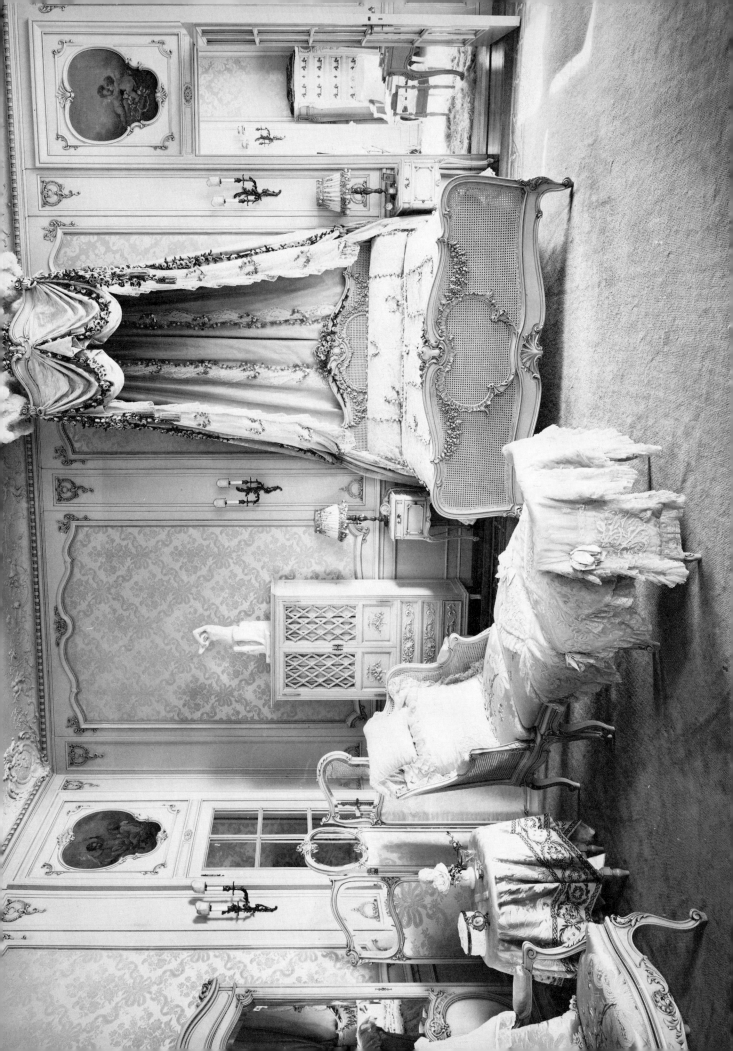

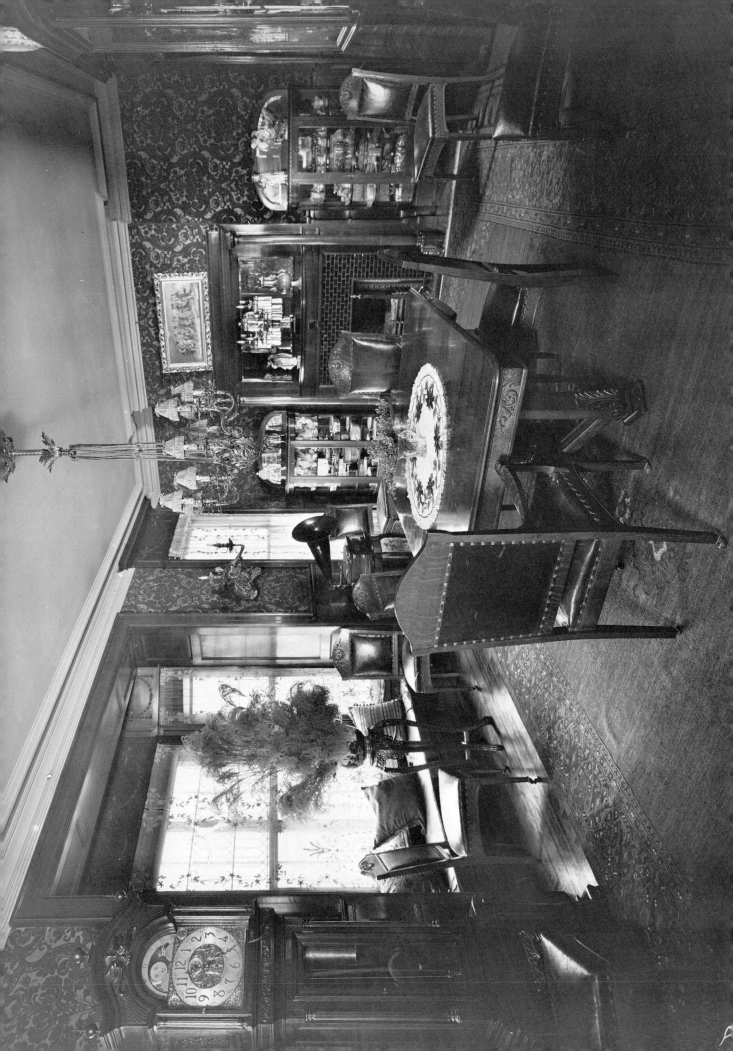

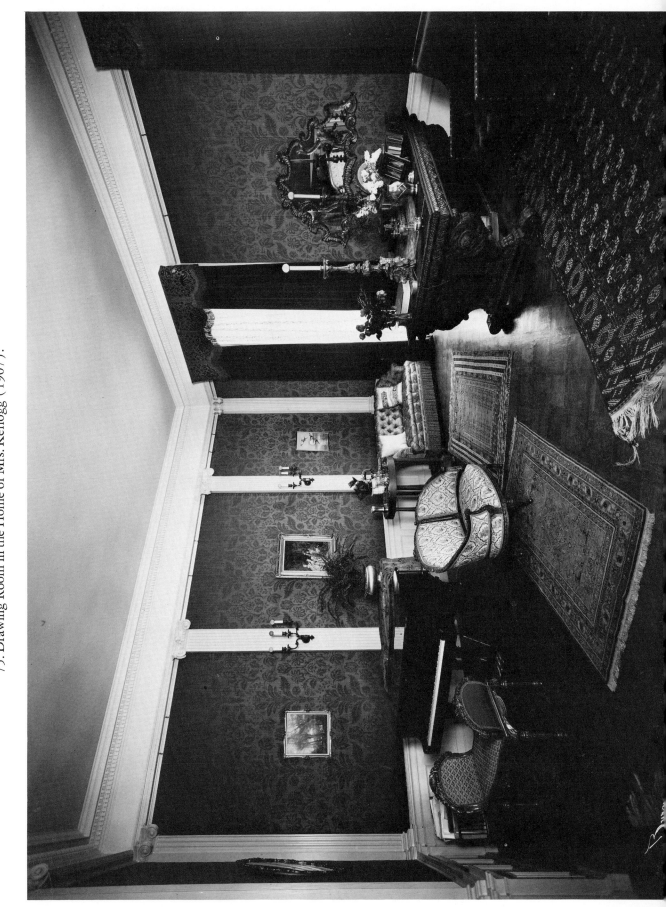

74. ABOVE: Dining Room in the Home of Leonard J. Busby, 135 Central Park
West (1907).
75. Drawing Room in the Home of Mrs. Kellogg (1907).

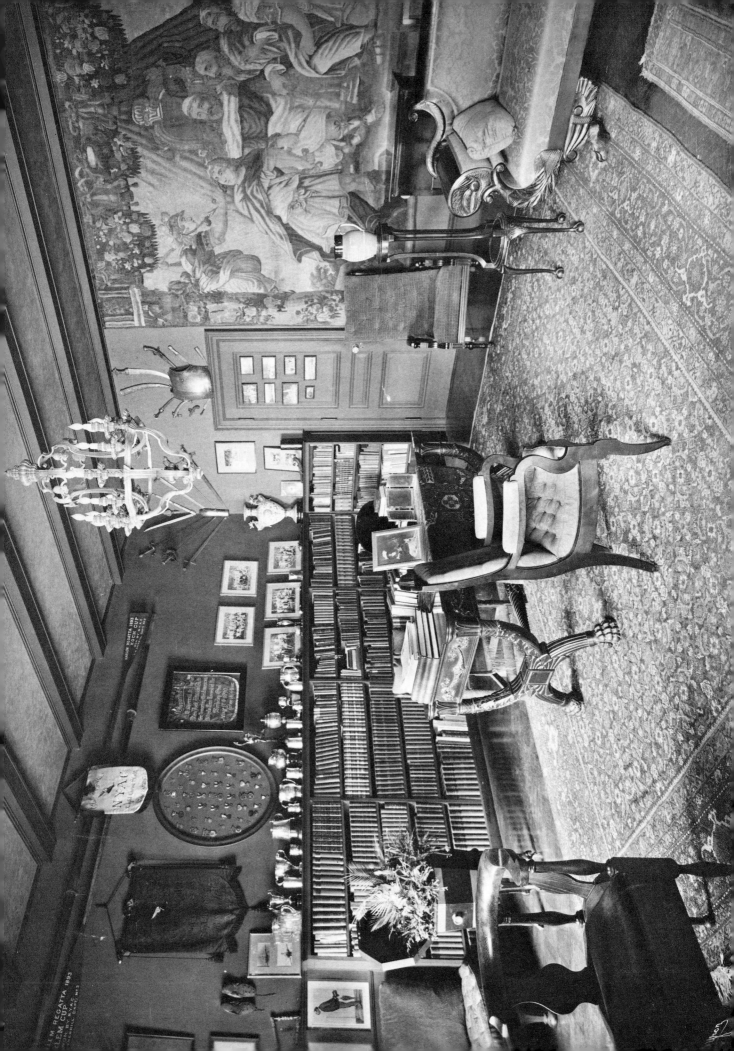

76. ABOVE: Library in the Home of
Charles Hitchcock Sherrill, 20 East 65th
Street (1909).

77. LEFT: Bathroom in the Home of Mrs.
Helen Terry Potter, New Rochelle (1909).

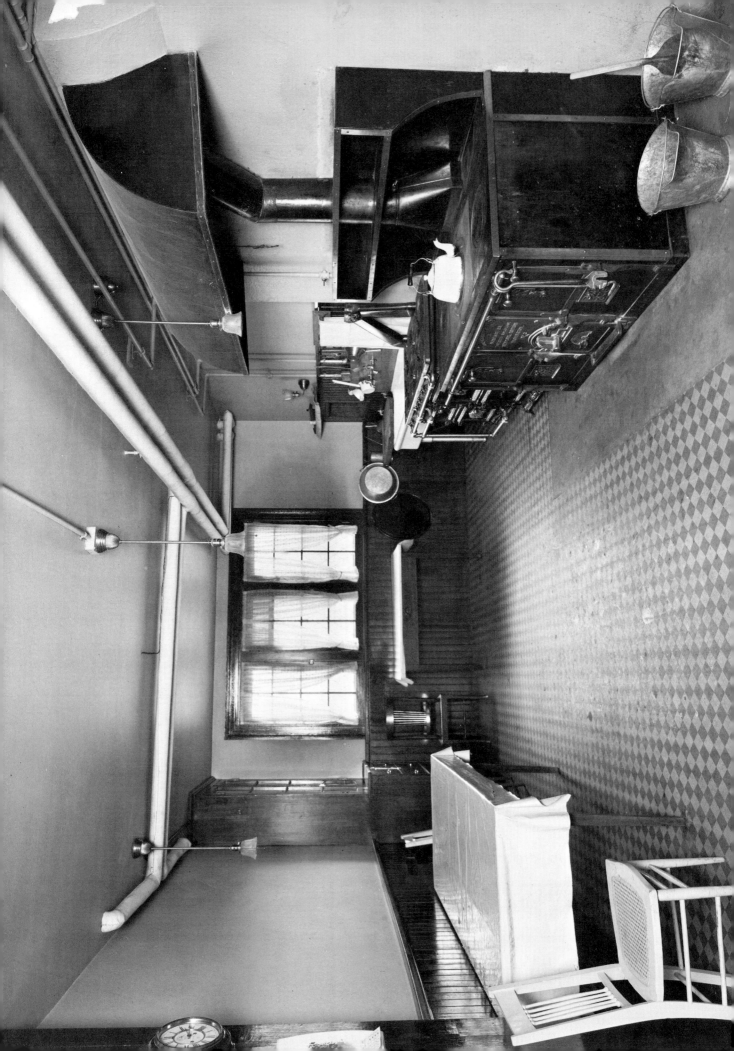

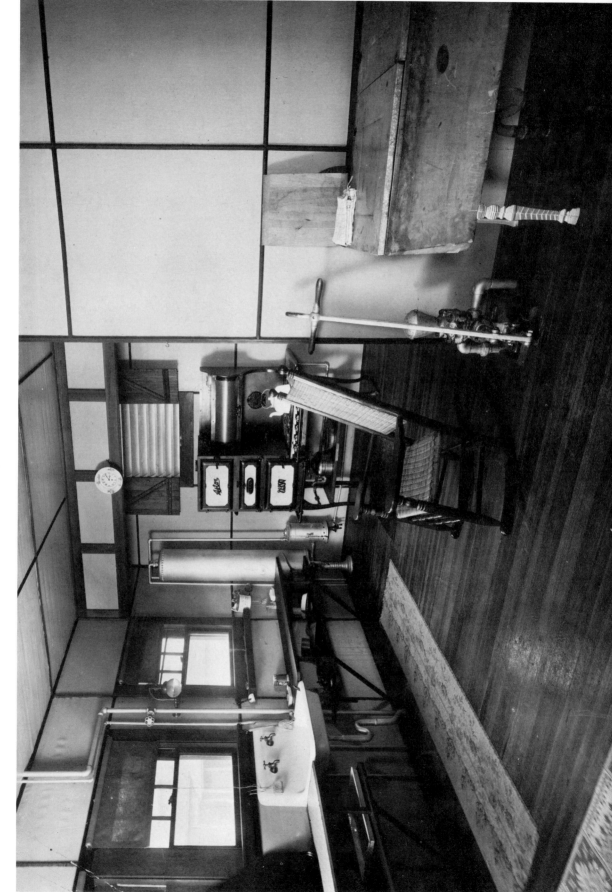

78. ABOVE: Kitchen in Mrs. Potter's Home (1909).
79. A Kitchen (1914).

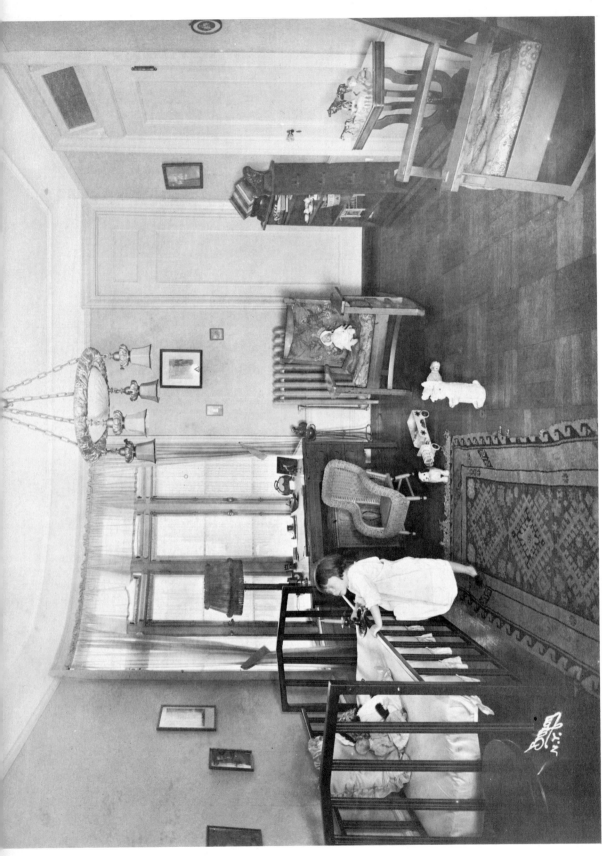

80. Nursery in the Home of A. C. Cronin (ca. 1915).

81. BELOW: Student's Room (Miss Newcomb's) at Barnard College, Broadway above 116th Street (1901).

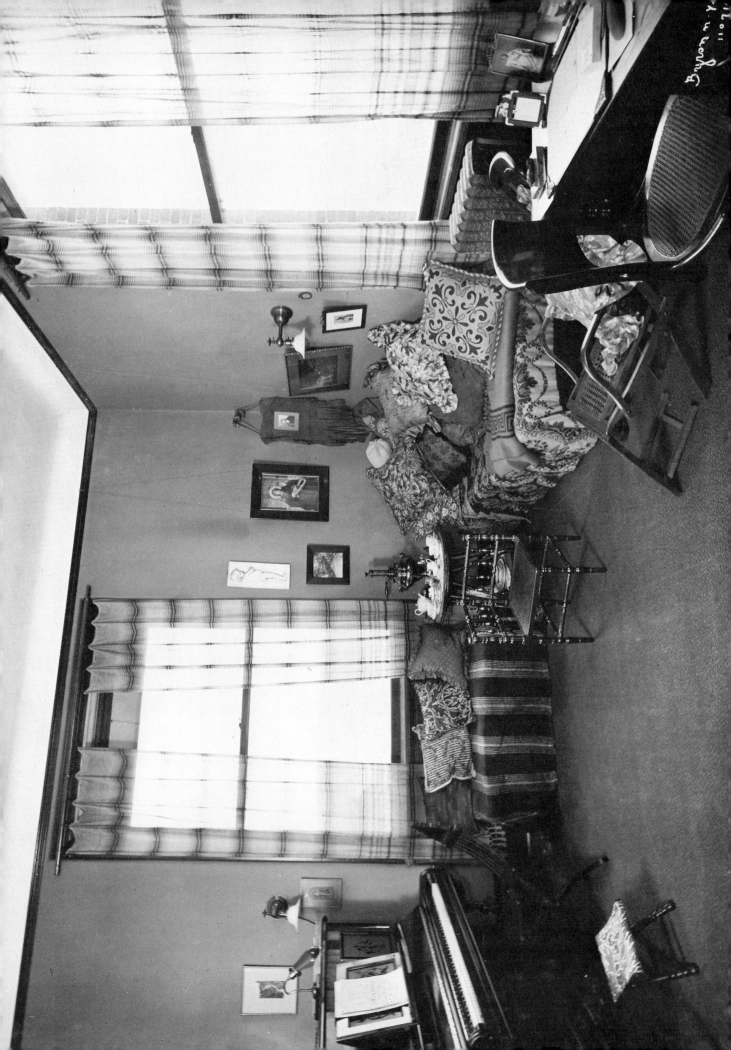

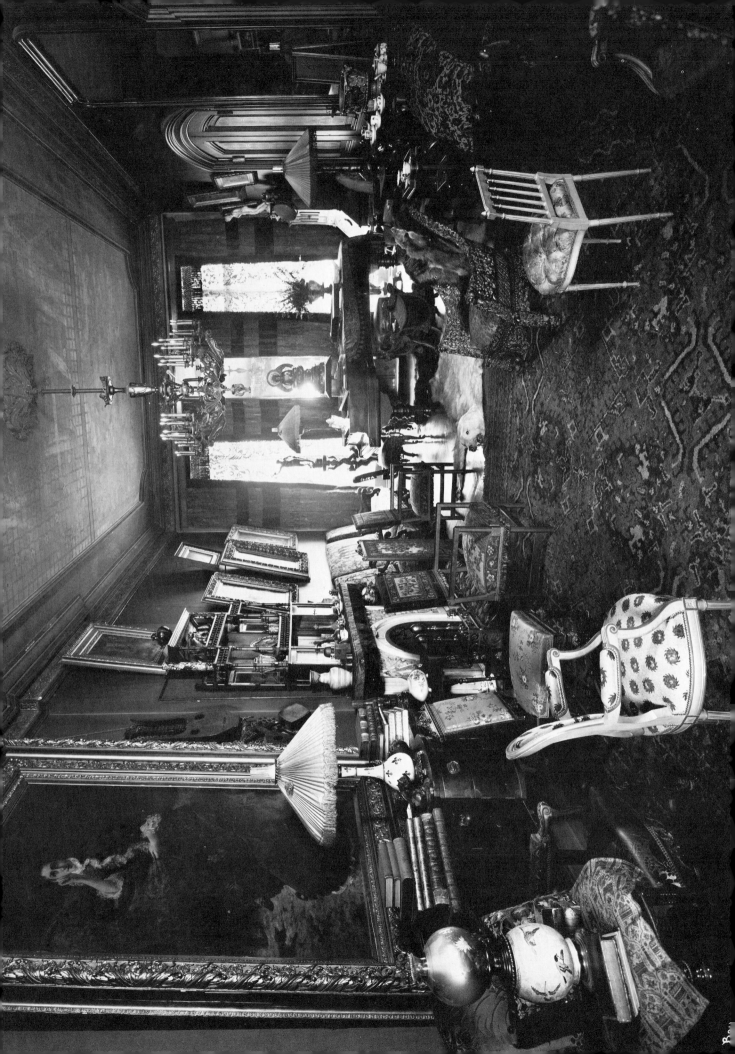

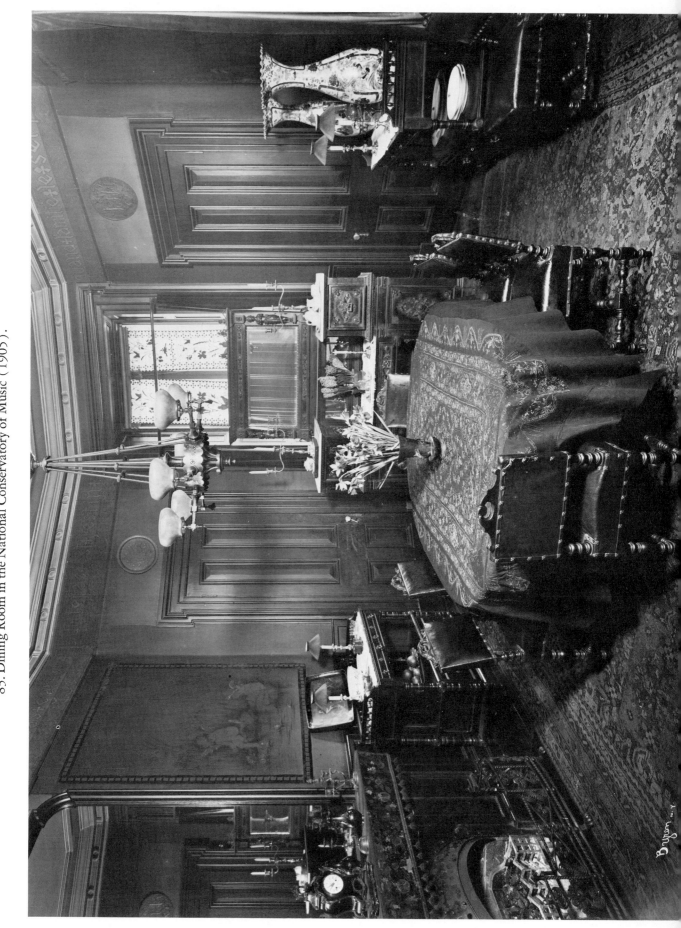

82. ABOVE: Drawing Room in the National Conservatory of Music, 49 West 25th Street (1905).

83. Dining Room in the National Conservatory of Music (1905).

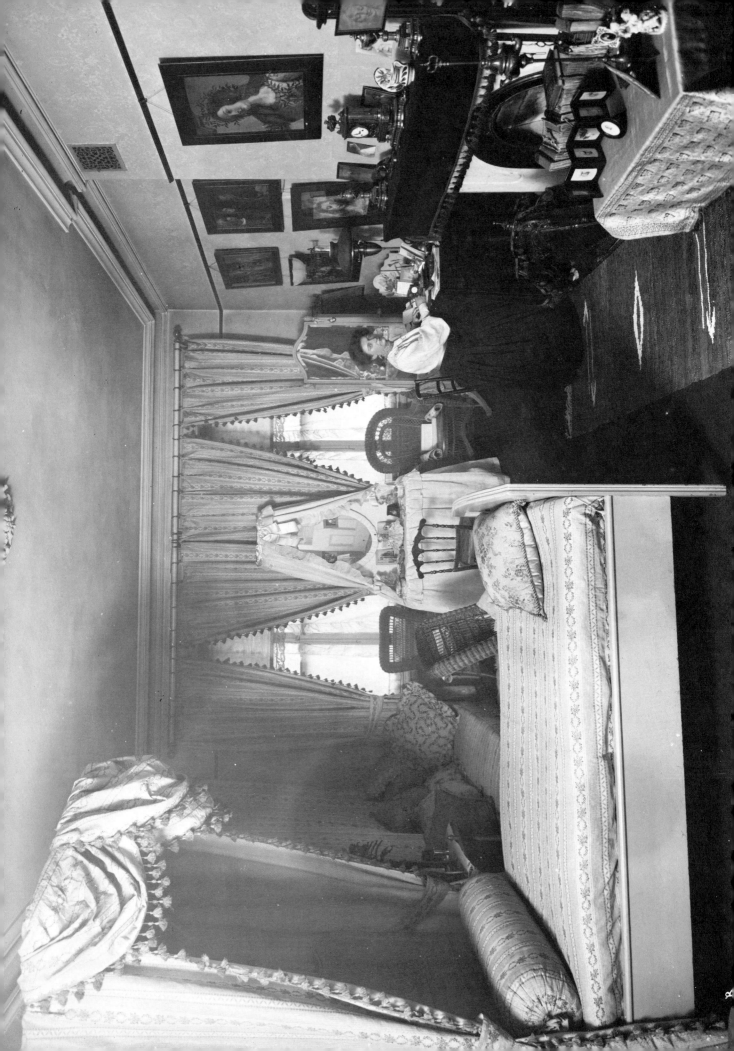

84. ABOVE: A Bedroom in the National Conservatory of Music (1905).
85. Lounge of the Lawyer's Club, Broadway between Pine and Cedar Streets (1901).

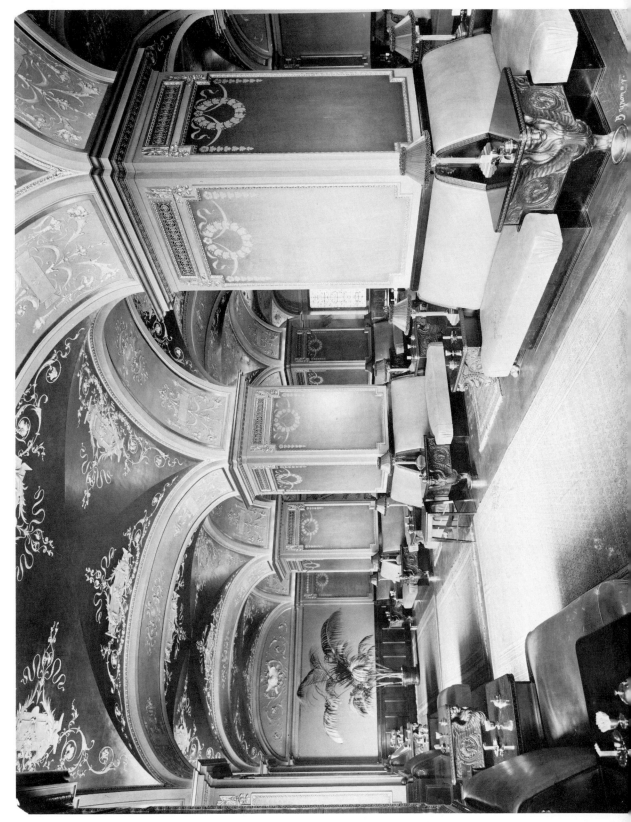

86. LEFT: Entrance to the Hotel Marie Antoinette, Broadway at 66th Street (1896).

87. BELOW: A Room in the Hotel Marie Antoinette (1896).

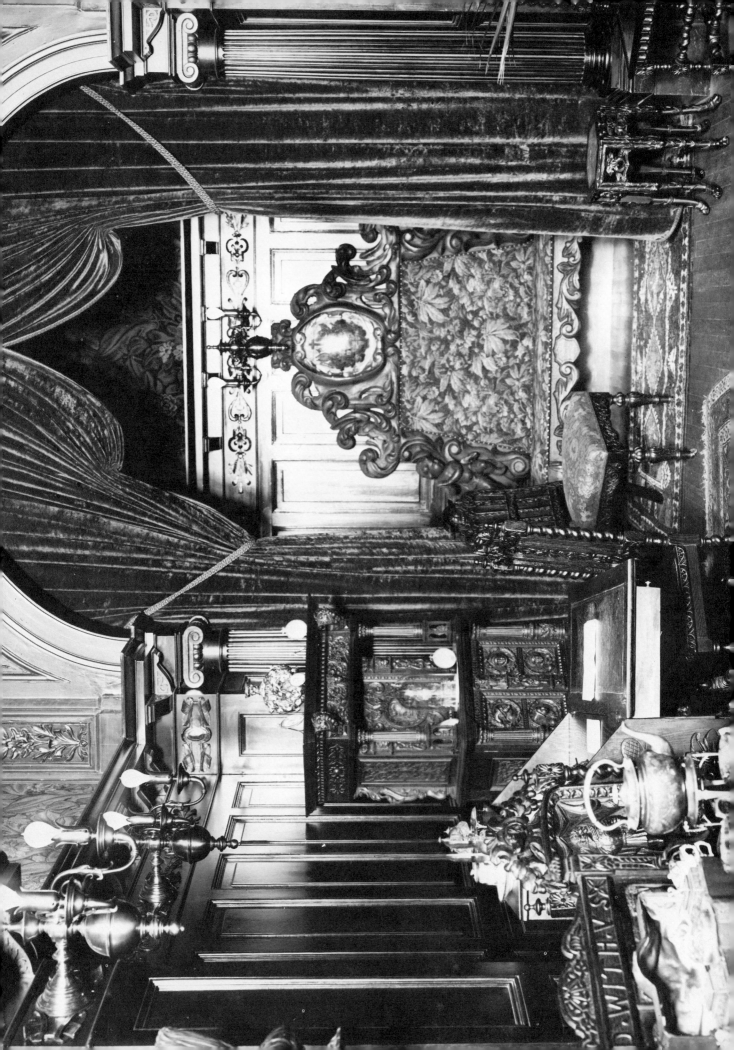

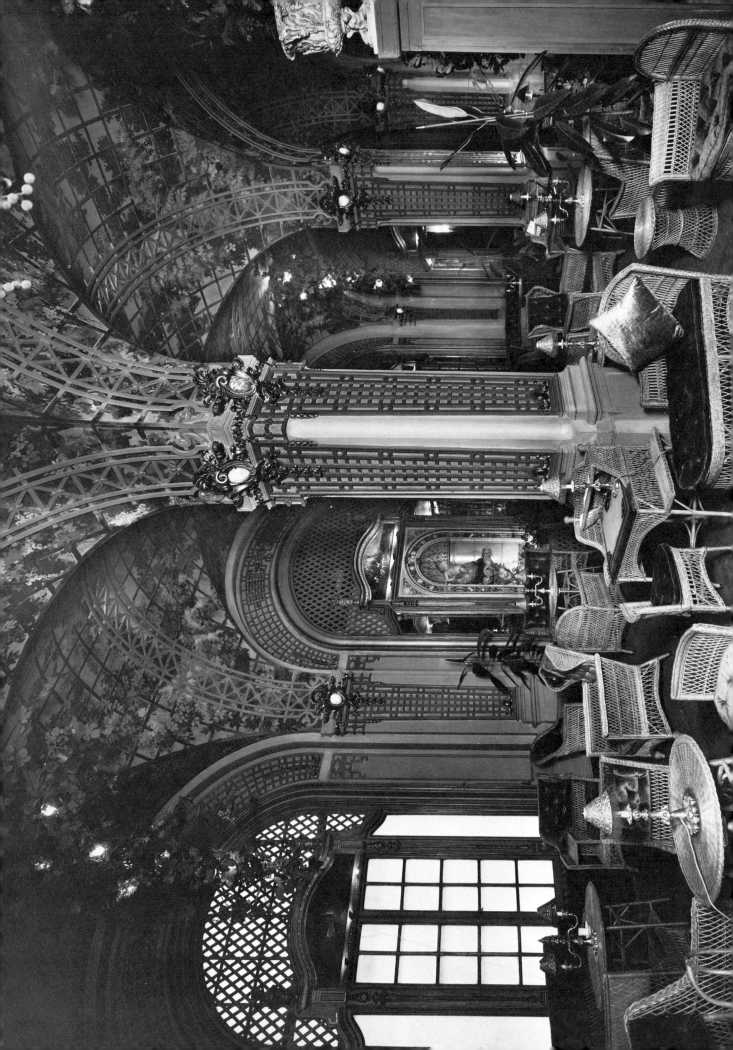

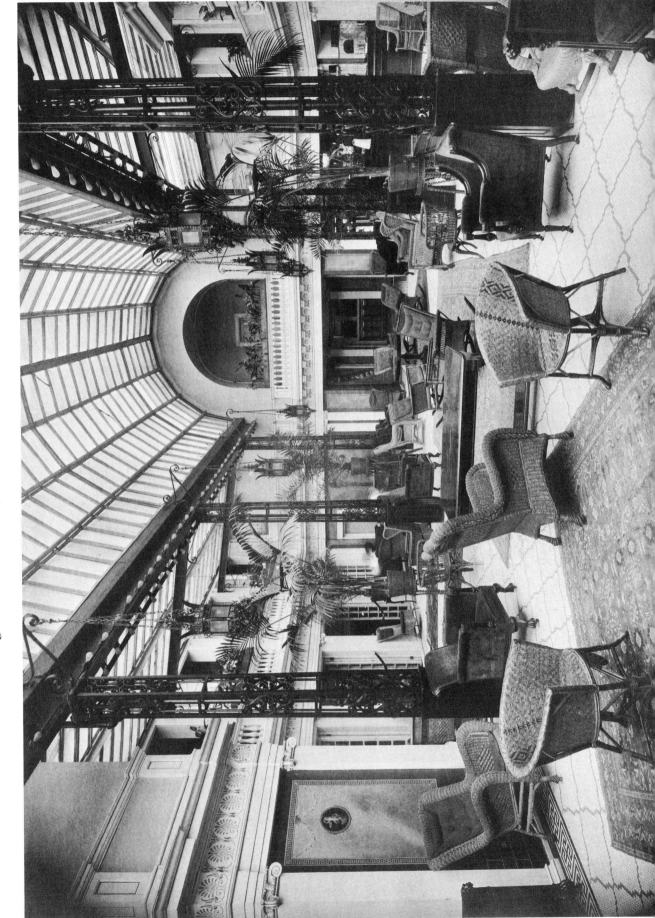

88. ABOVE: Tea Room in the Hotel Prince George, 14 East 28th Street (1905).
89. Lounge in the Hotel Endicott, Columbus Avenue and 81st Street (1908).

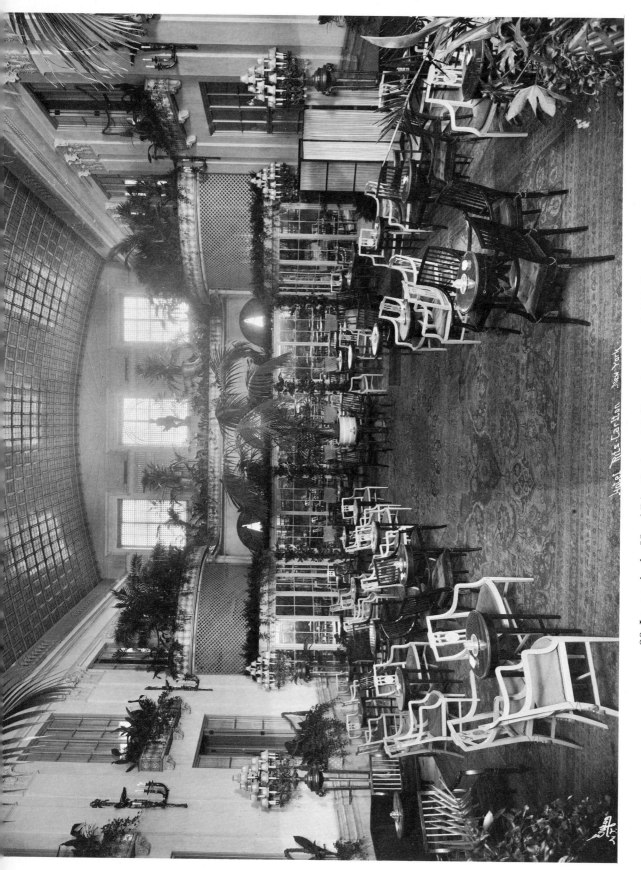

90. Lounge in the Hotel Ritz-Carlton, Madison Avenue and 46th Street (ca. 1911).

91. BELOW: Auto Show in the Ballroom of the Hotel Astor, Broadway at 44th Street (1914).

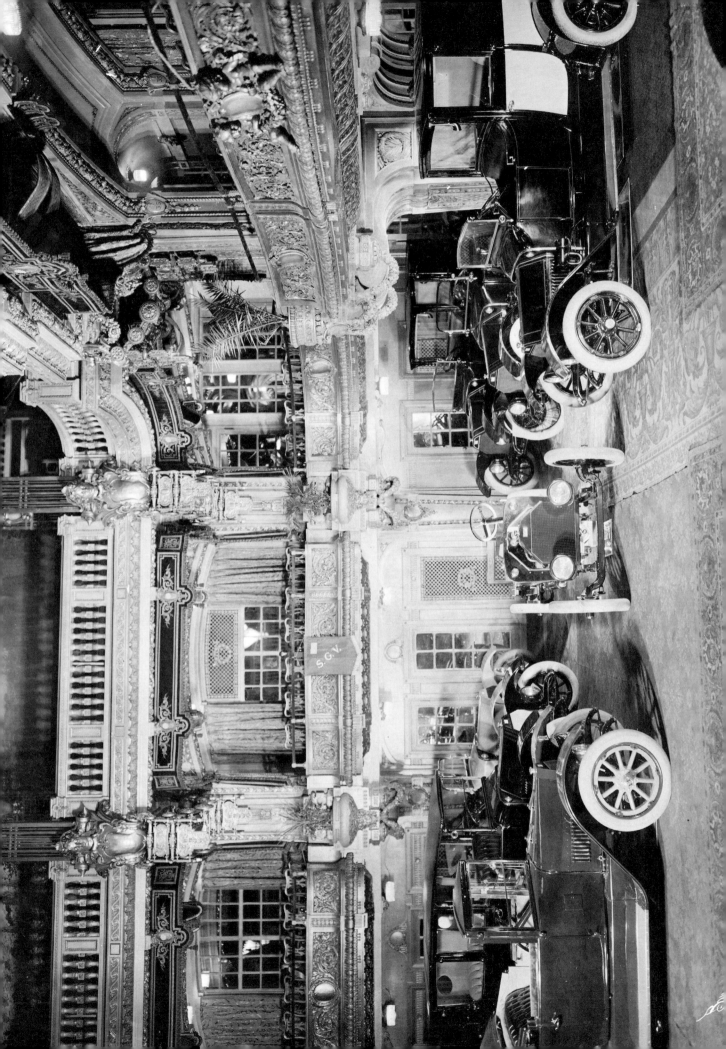

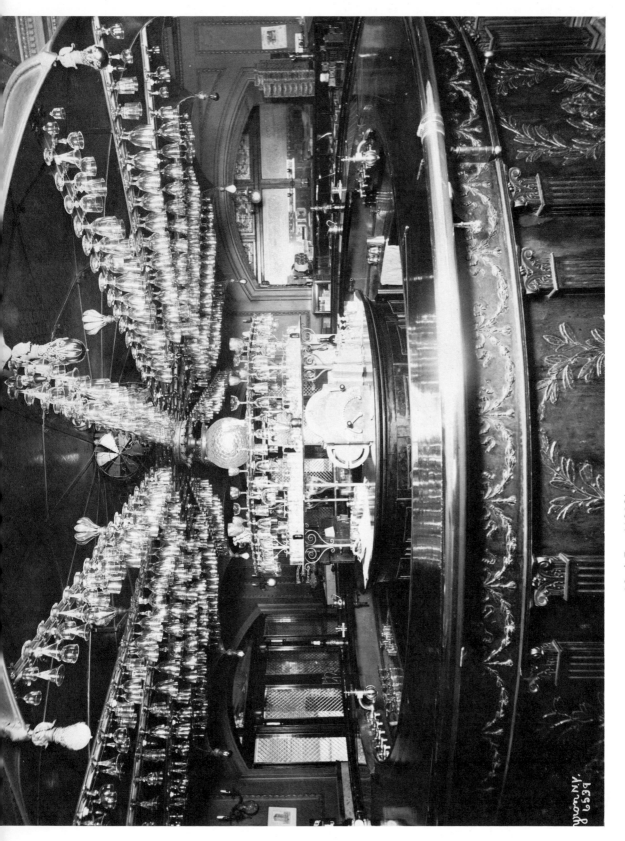

92. A Bar (1898).

93. BELOW: Bar of the Café Savarin, 120 Broadway (1901).

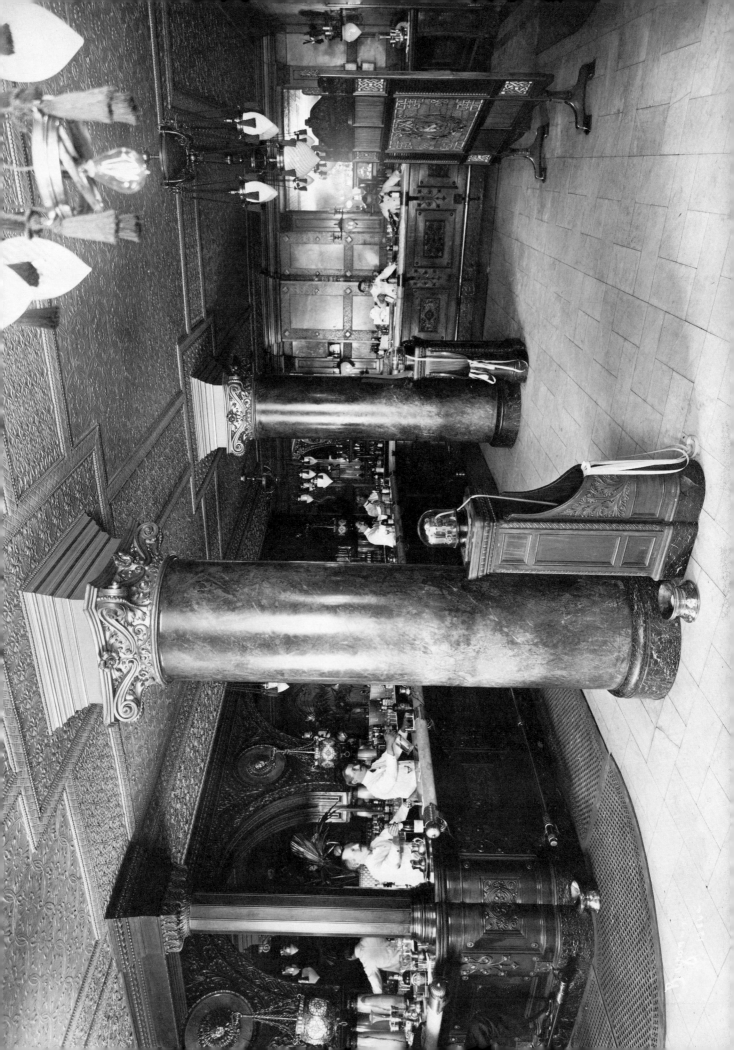

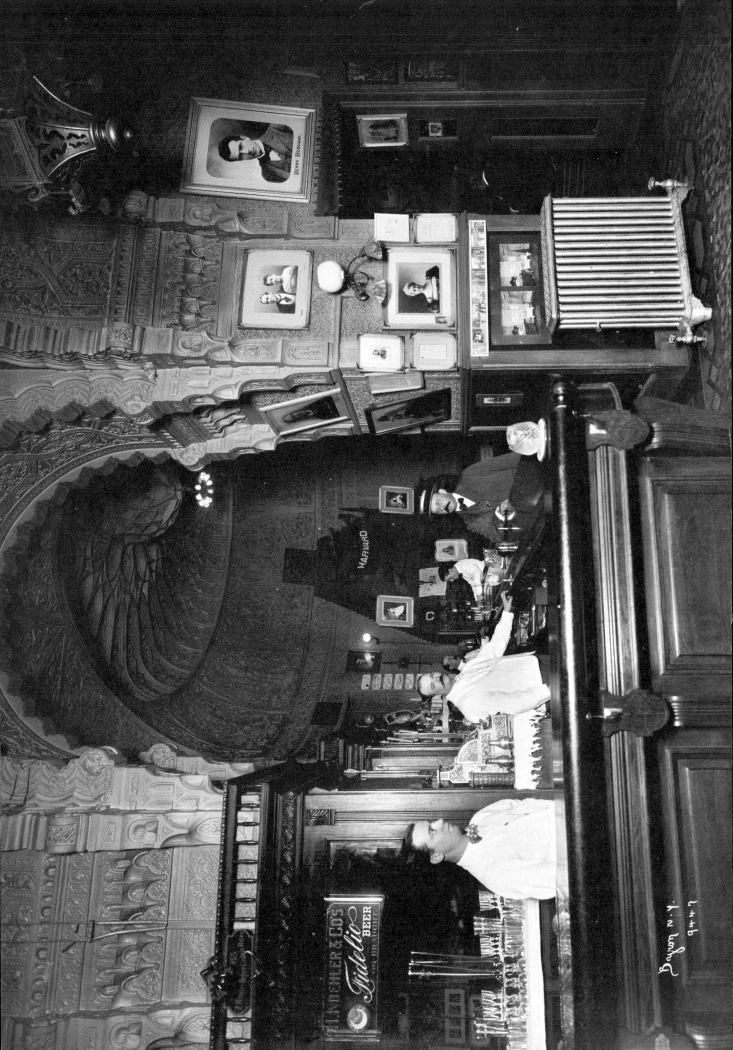

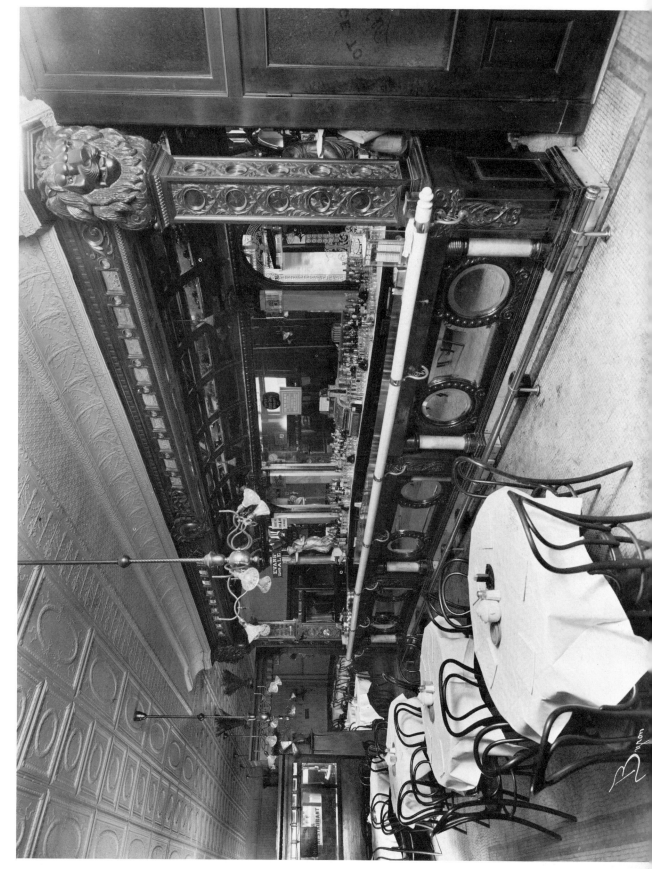

94. ABOVE: Bar and Café of the Casino Theatre, Broadway and 39th Street (1900).
95. Fritz's Café, 124 Chambers Street (1906).

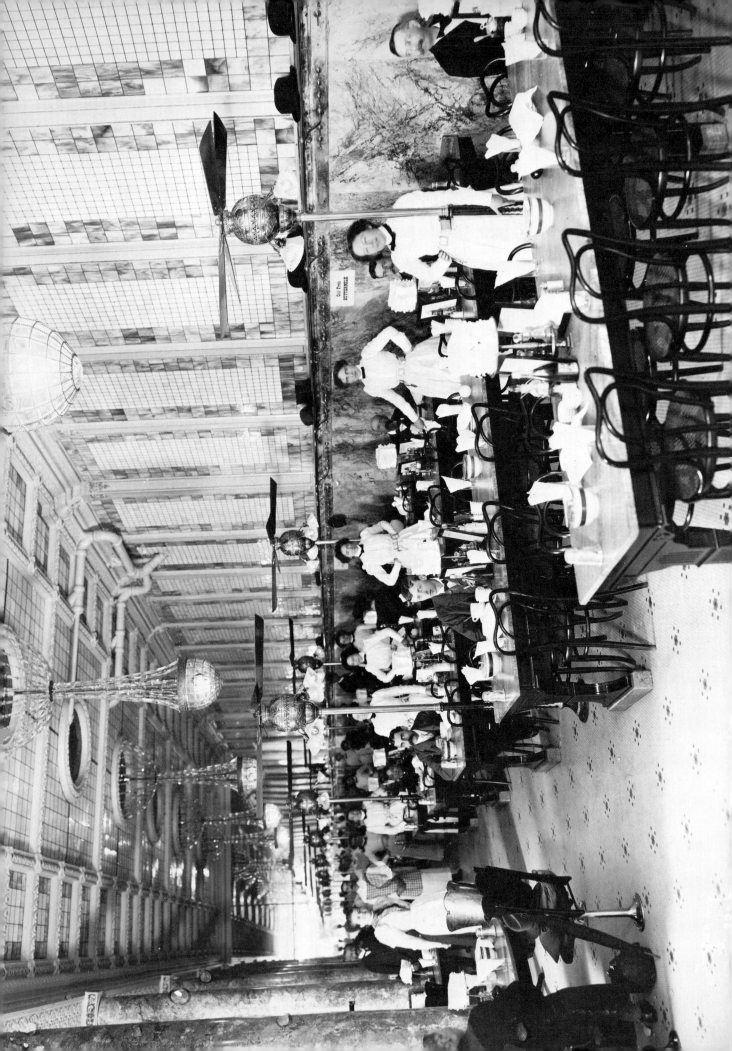

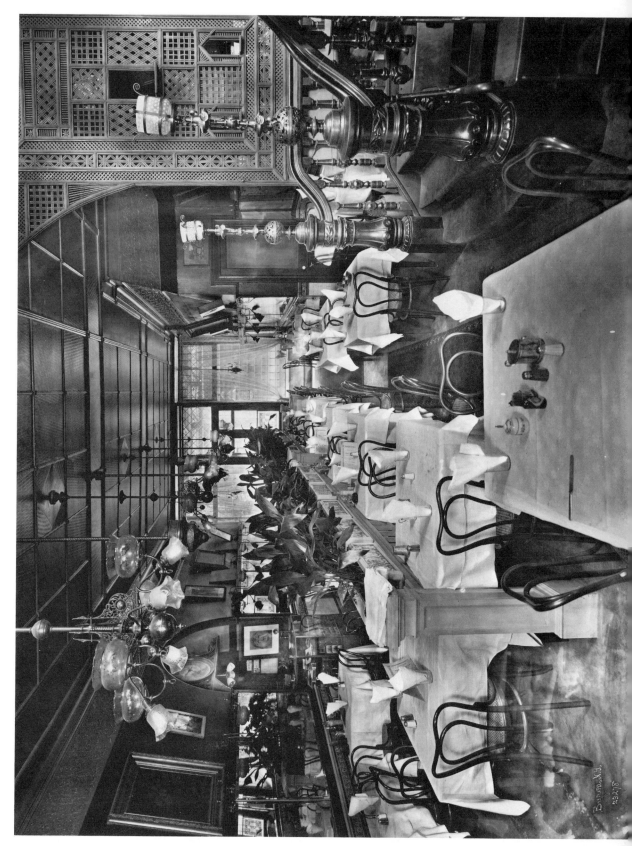

96. ABOVE: A Childs Restaurant (perhaps the one at 47 East 42nd Street; 1900).
97. The O'Neill and Bristol Oyster and Chop House, 364 Sixth Avenue (1906).

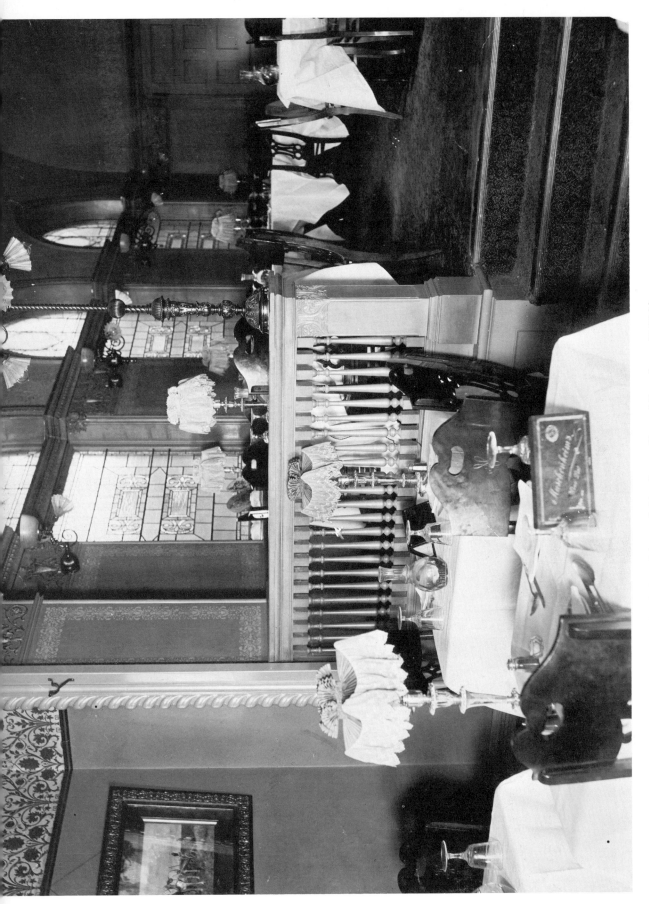

98. Muschenheim's "Arena," 31st Street, East of Broadway (1900).
99. BELOW: The Green Teapot Tea Room, 330 Lexington Avenue (1906).

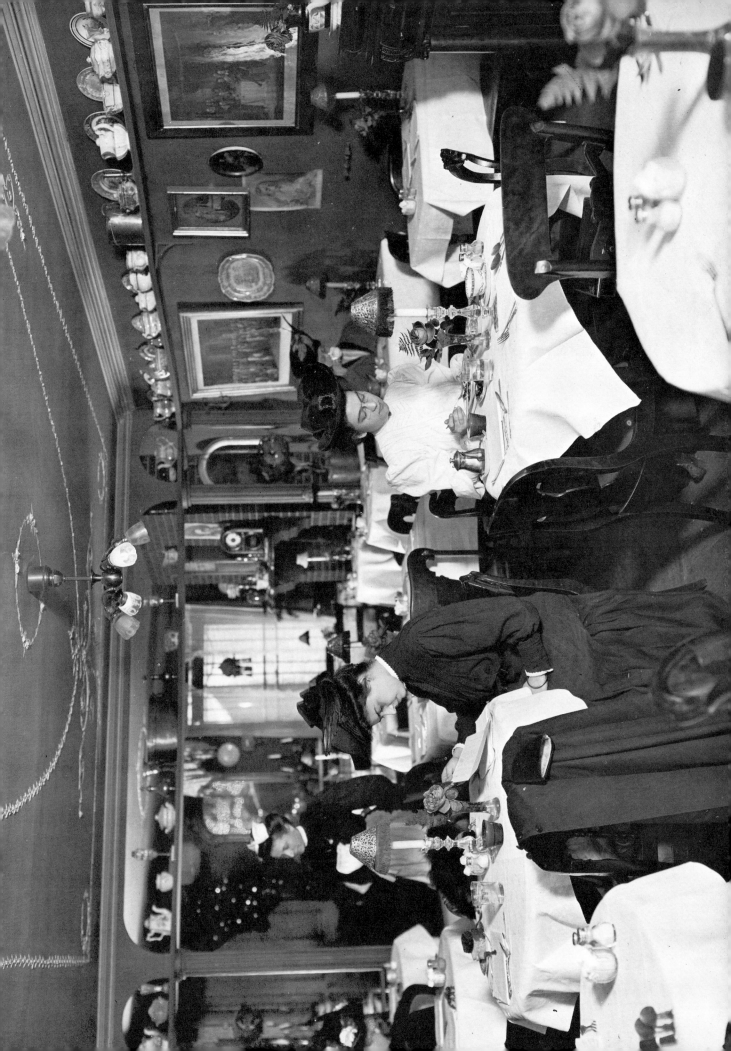

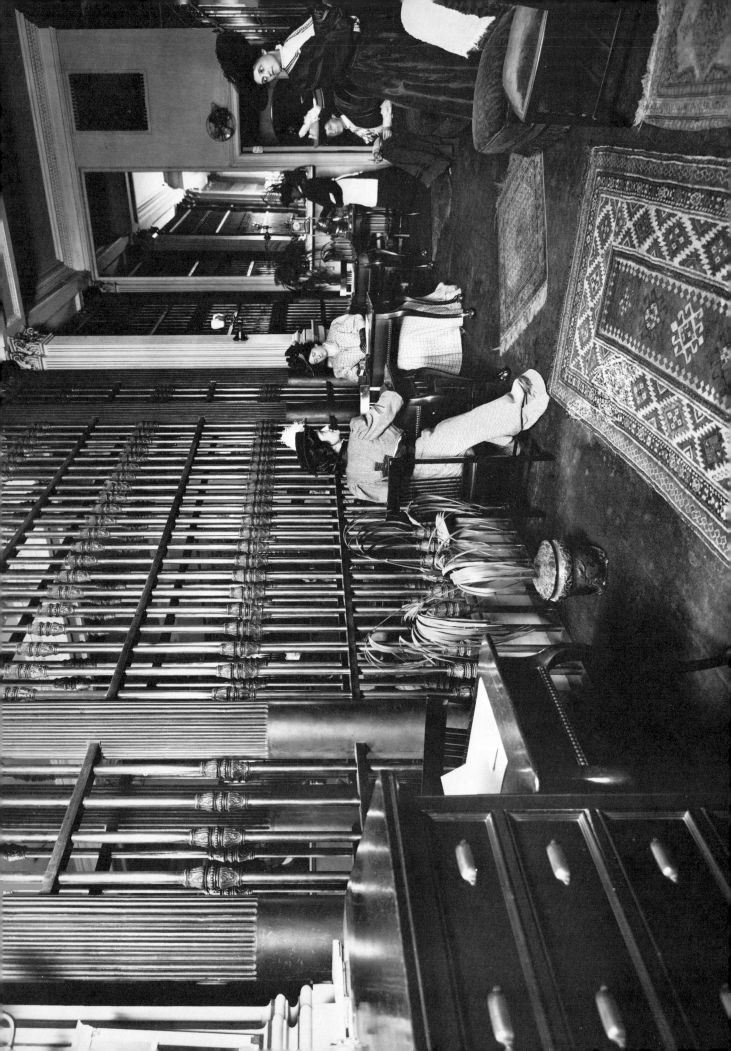

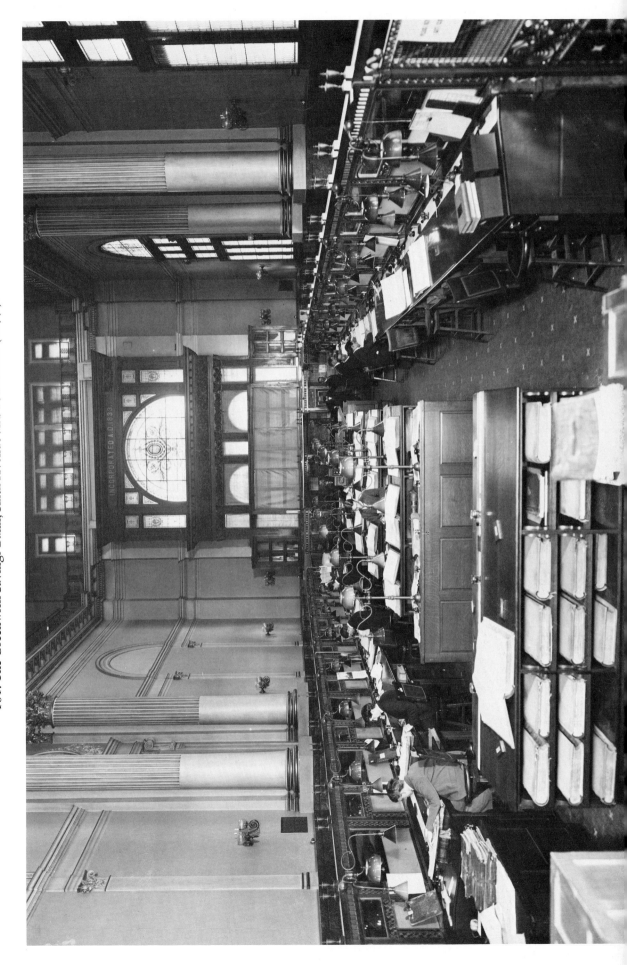

100. ABOVE: Ladies' Department of the New Amsterdam National Bank, 1411 Broadway at 39th Street (1906).

101. The Greenwich Savings Bank, Sixth Avenue and 16th Street (1899).

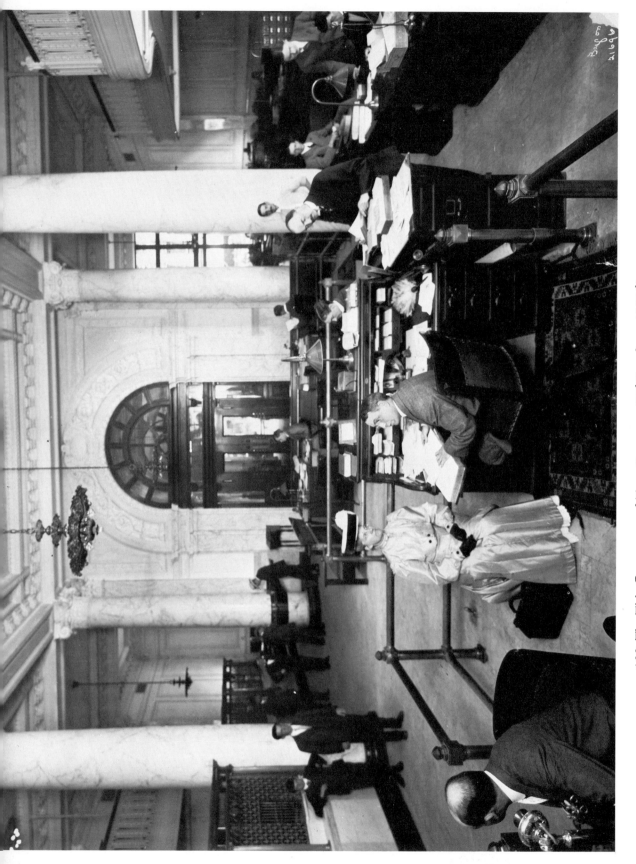

102. The Title Guarantee and Trust Company, 176 Broadway (1916).

103. BELOW: Aeolian Music Hall, 42nd Street between Fifth and Sixth Avenues (ca. 1912–13).

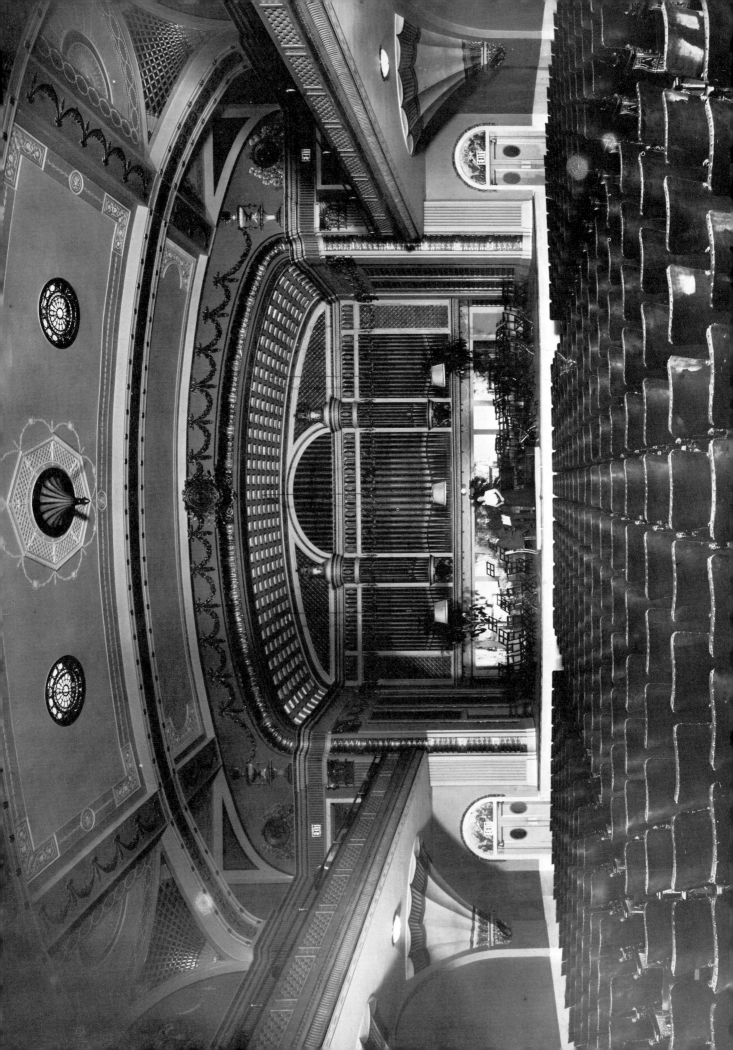

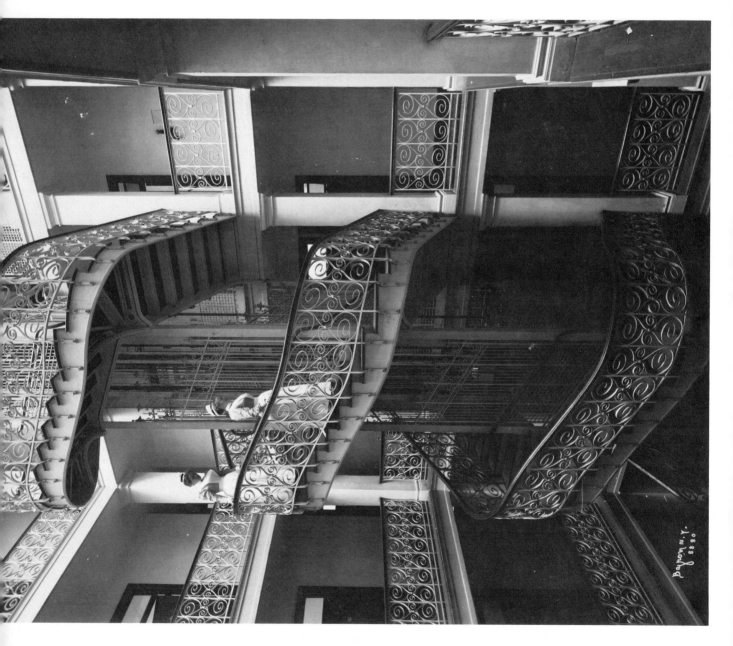

104. LEFT: Staircase Well in the Vanderbilt Pavilion of St. Luke's Hospital, Amsterdam Avenue at 114th Street (1899).
105. BELOW: The Jerry McAuley Mission (1897).

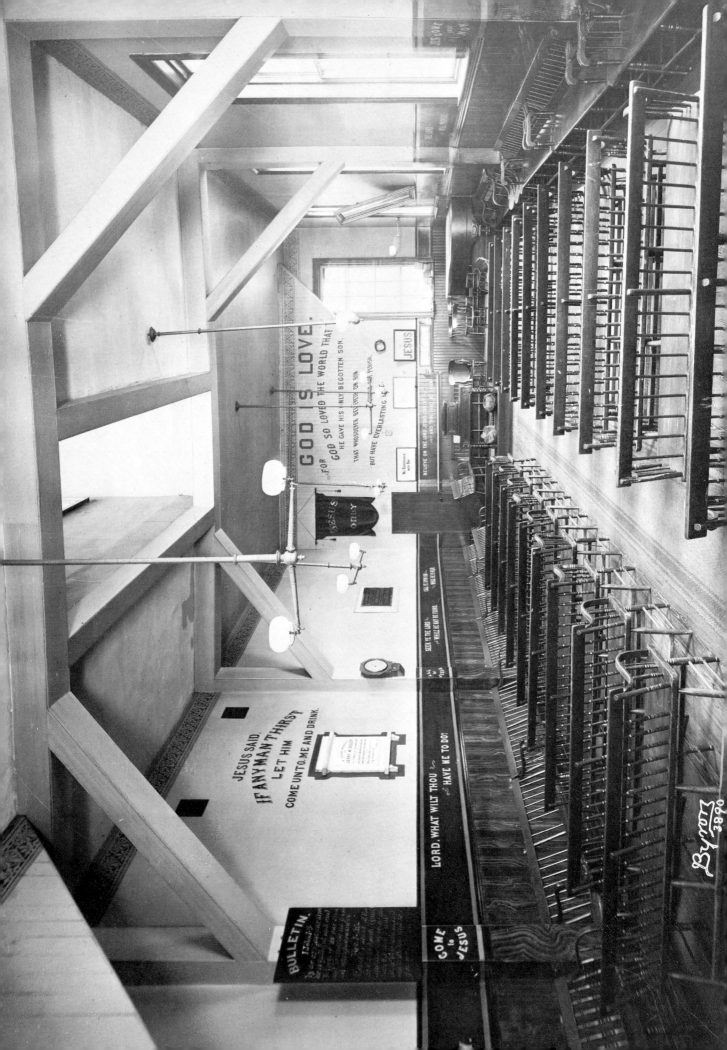

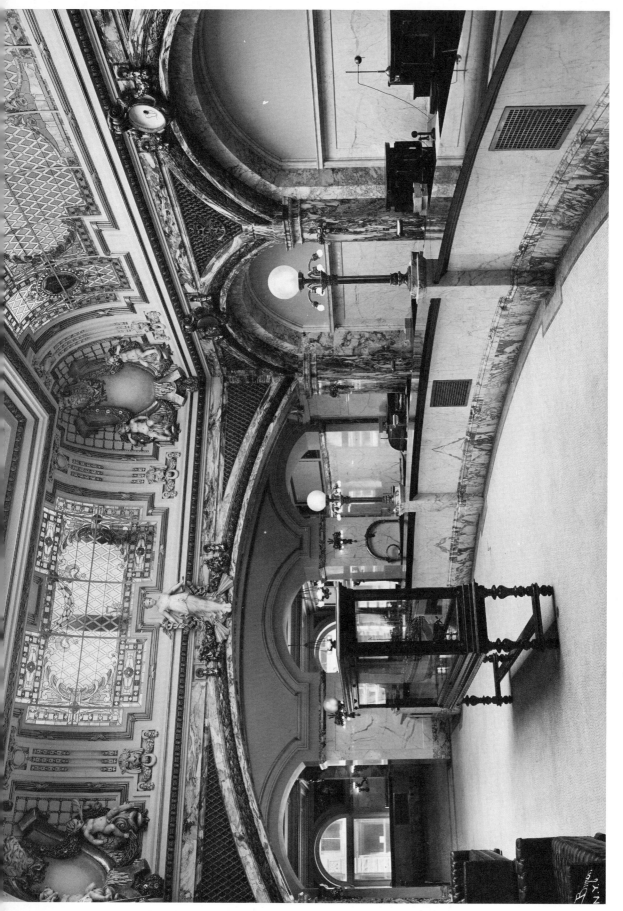

106. The New York Office of the Hamburg-American Line, 45 Broadway (1908).
107. BELOW: The New York Office of Thomas Cook and Sons, 245 Broadway (1906).

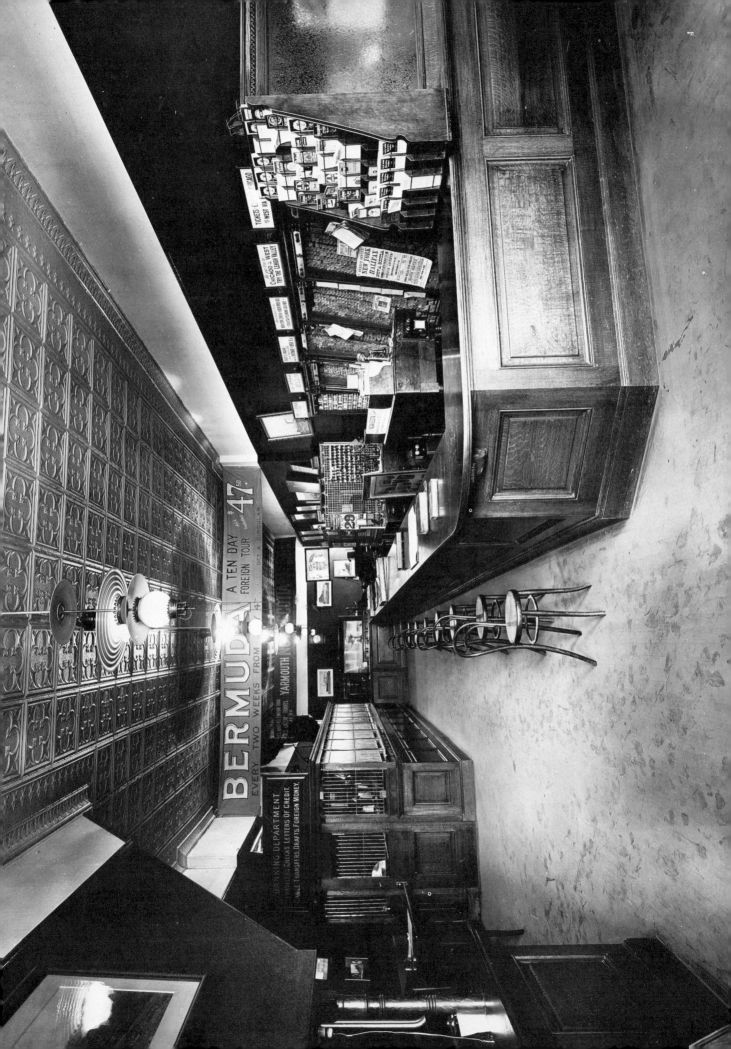

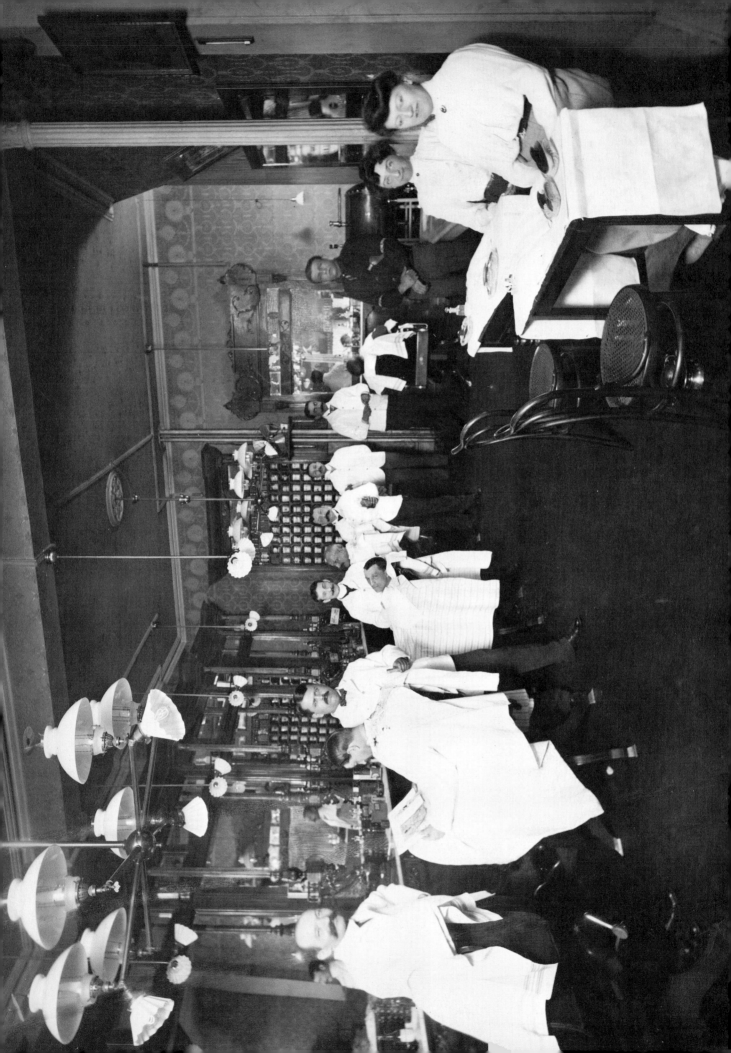

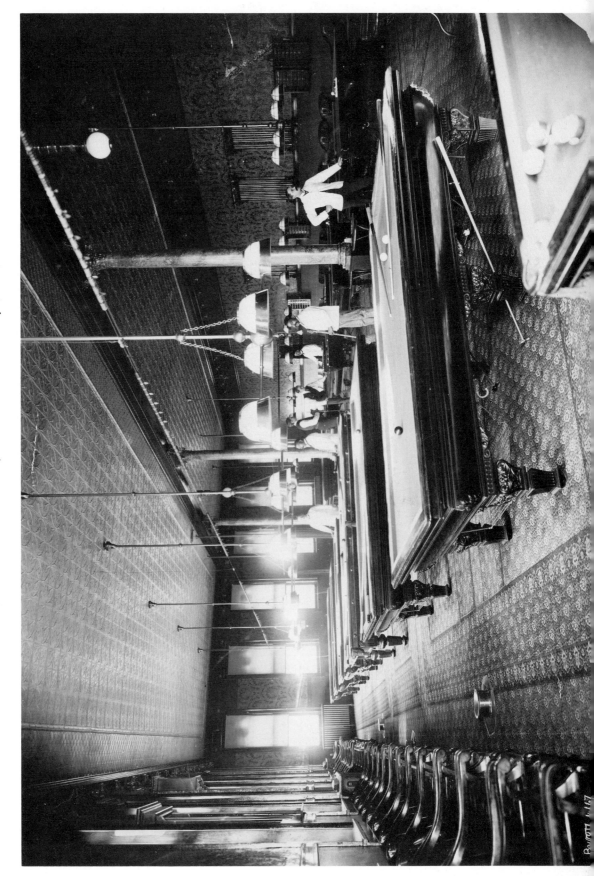

108. ABOVE: A Barber Shop (1903).
109. The Ives Billiard Parlor, 42nd Street and Broadway (1897).

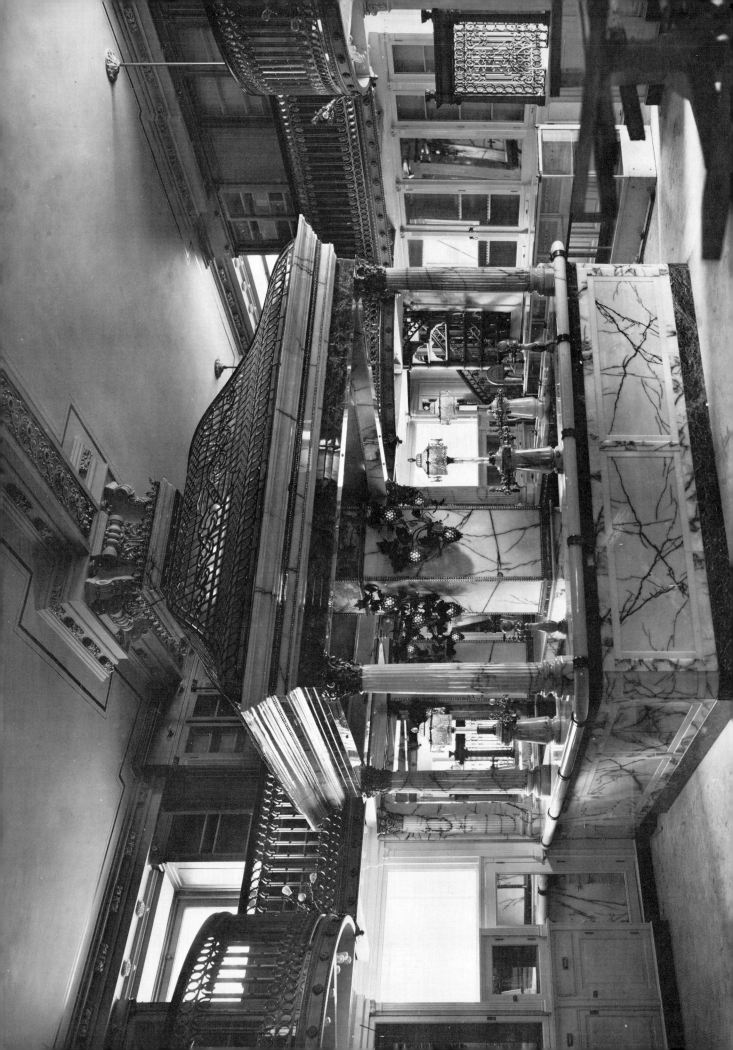

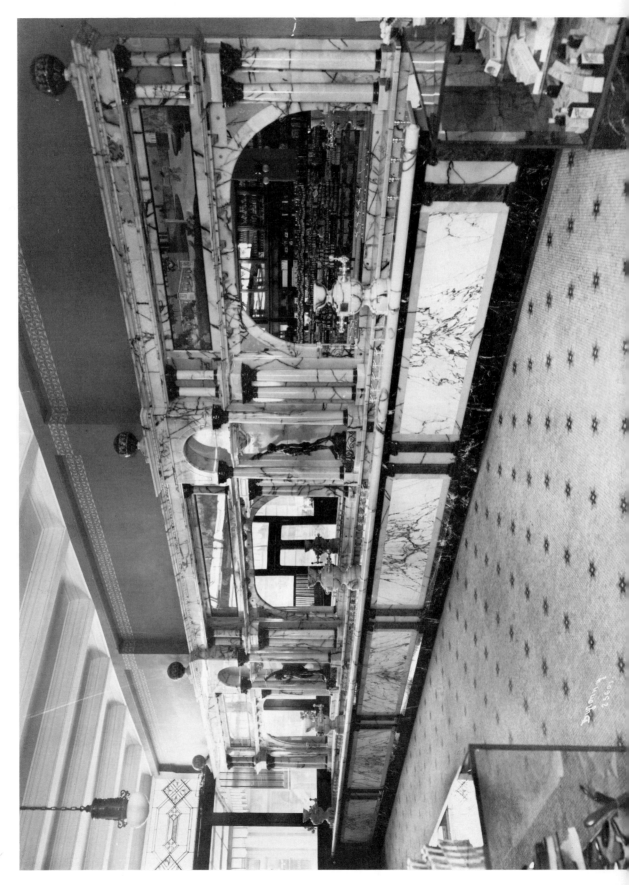

110. ABOVE: Soda Fountain in a Hegeman and Company Drugstore (1907).
111. The Riker's Drugstore at 23rd Street and Sixth Avenue (1908).

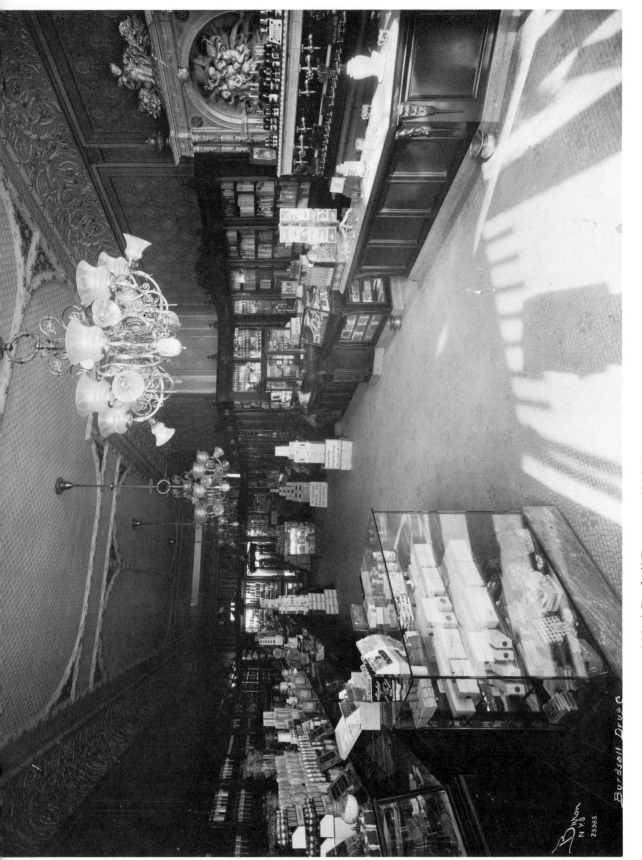

112. A Burdsell Drugstore (1907).

113. BELOW: A Corner of the Abraham and Straus Department Store, Fulton Street, Brooklyn (1907).

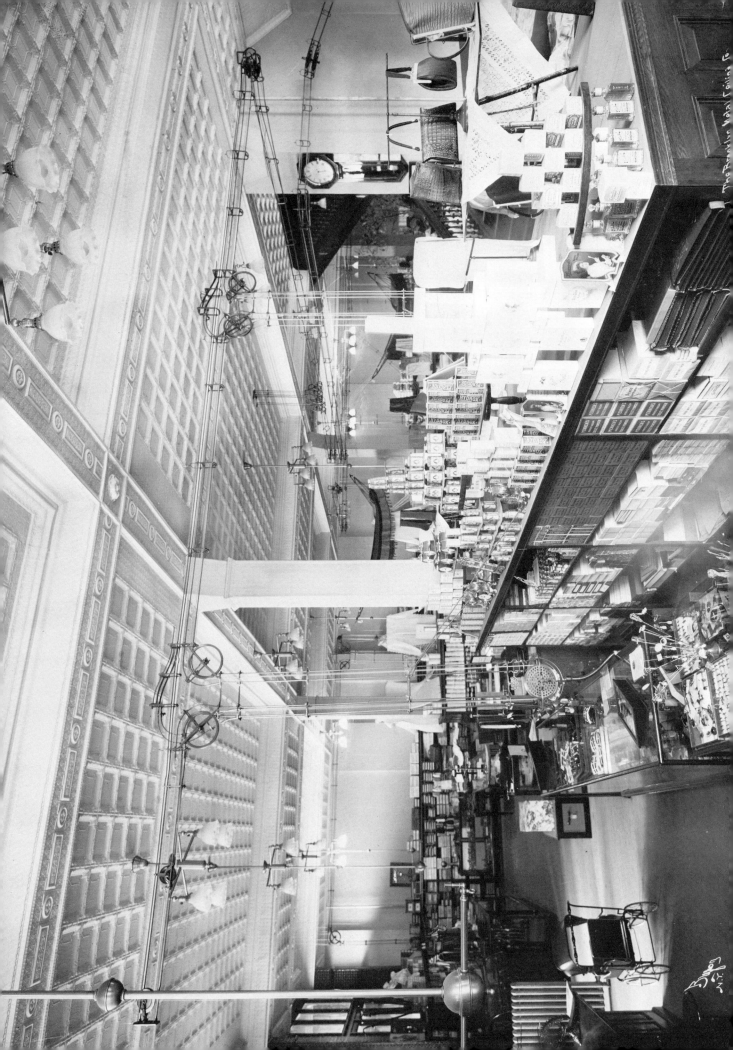

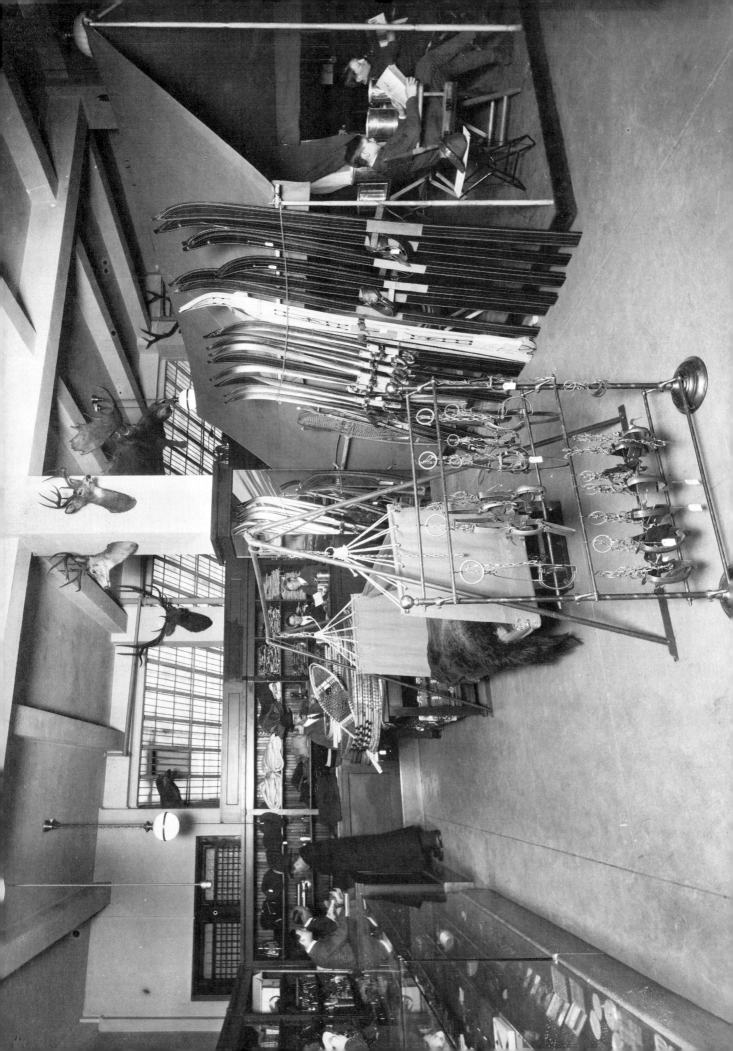

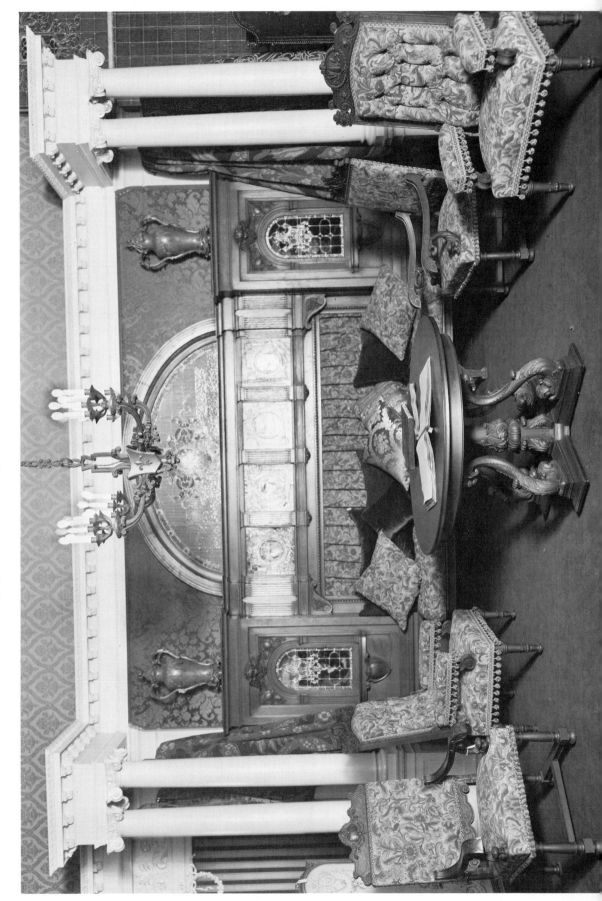

114. ABOVE: Abercrombie and Fitch Store, 55 West 36th Street (1912).
115. A Display Area in the W. & J. Sloane Store, 884 Broadway (1902).

116. The Music Department of Siegel-Cooper Company, Sixth Avenue between 18th and 19th Streets (1899).
117. BELOW: Food Counter in R. H. Macy's Department Store, Herald Square (1902).

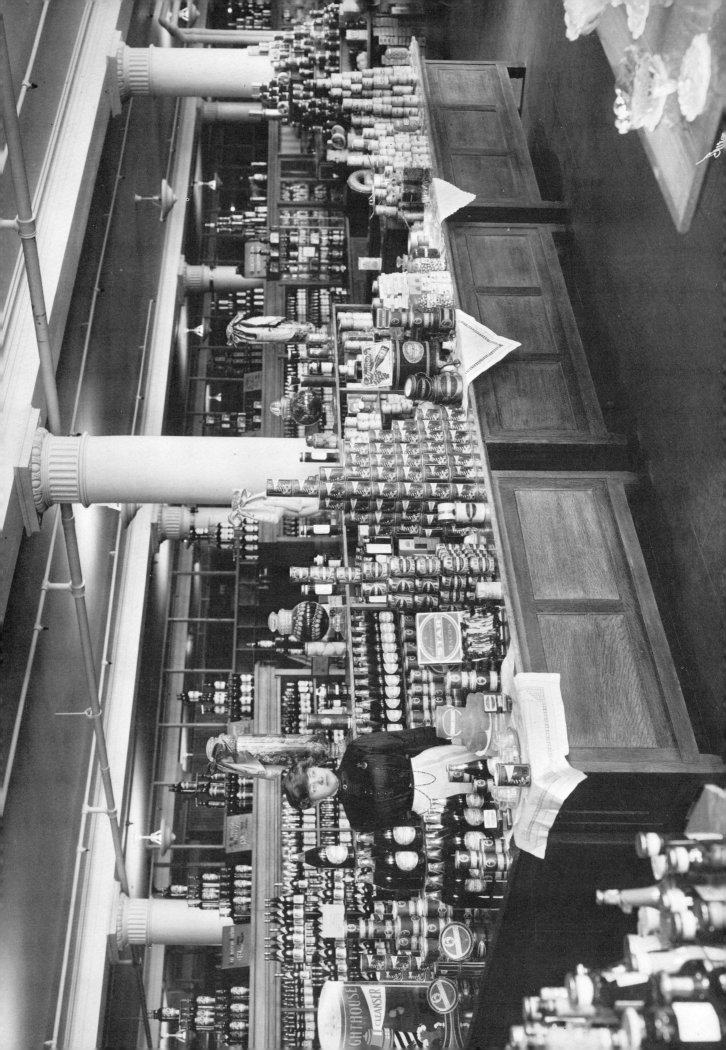

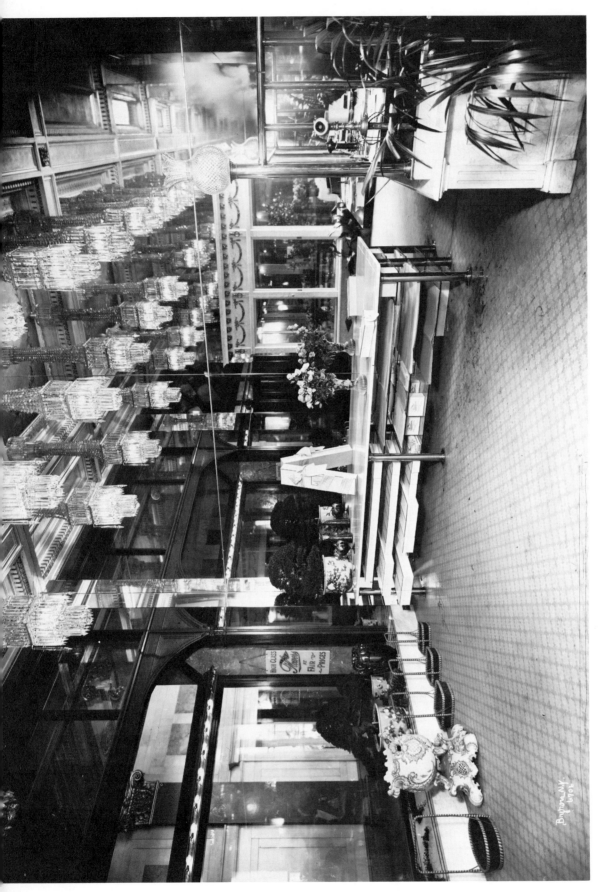

118. The Store of Joseph Fleischman, Florist, 71 Broadway (ca. 1899).
119. BELOW: Henry Maillard's Retail Confectionery and Ladies' Lunch
Establishment, 1099 Broadway at 24th Street (1902).

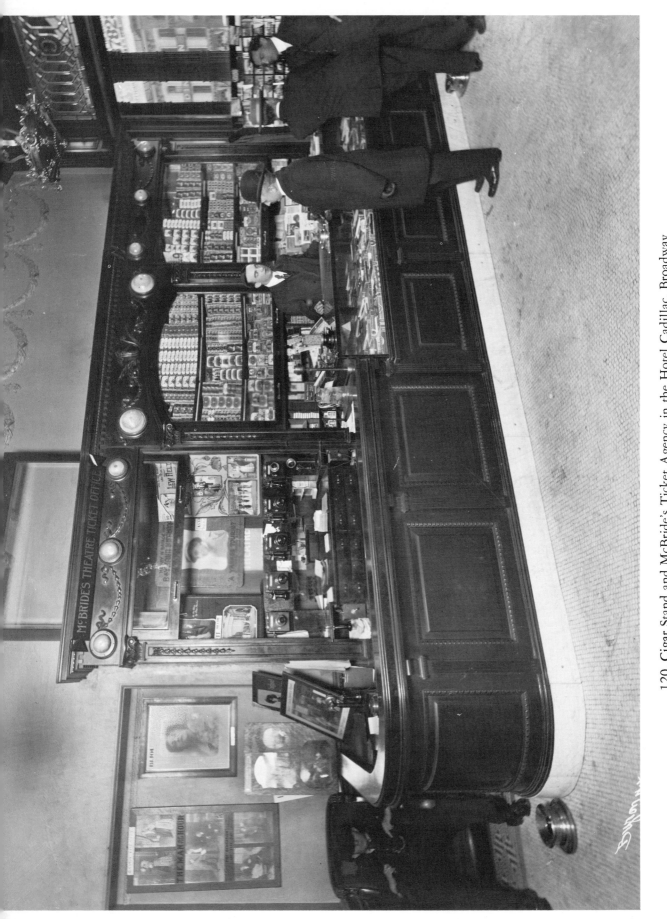

120. Cigar Stand and McBride's Ticket Agency in the Hotel Cadillac, Broadway at 43rd Street (1907).

121. BELOW: Moe Levy and Company, Clothiers, Walker Street (1908).

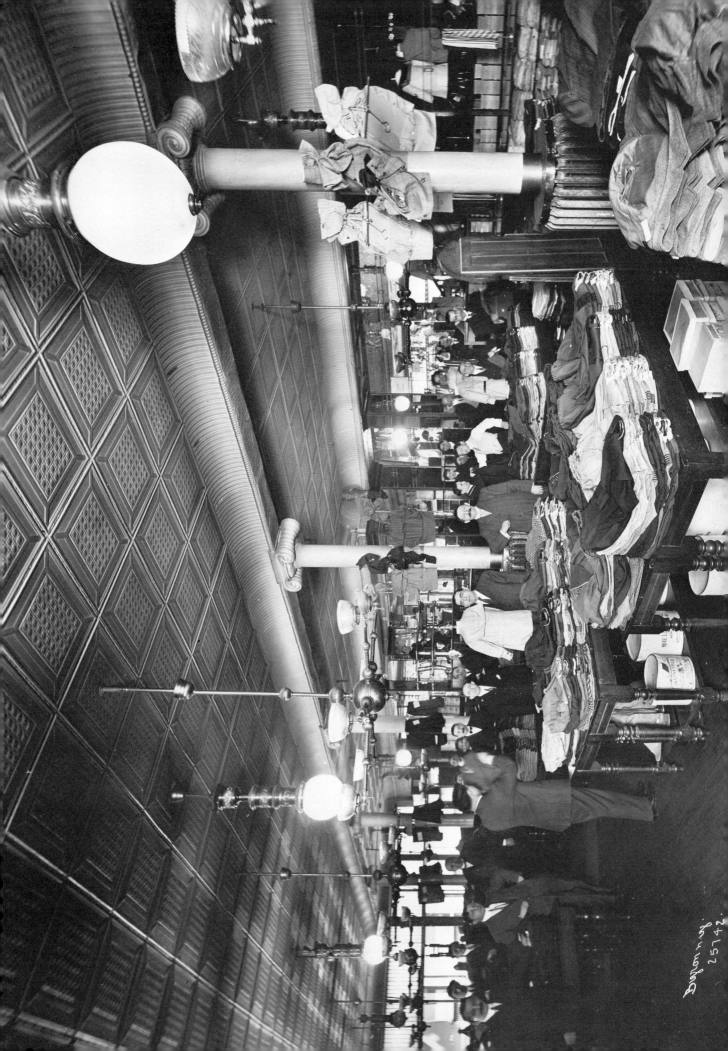

122. LEFT: Simpson, Crawford and Simpson Company, Sixth Avenue between 19th and 20th Streets (1904).

123. BELOW: An Art Gallery or Auction Room (1905).

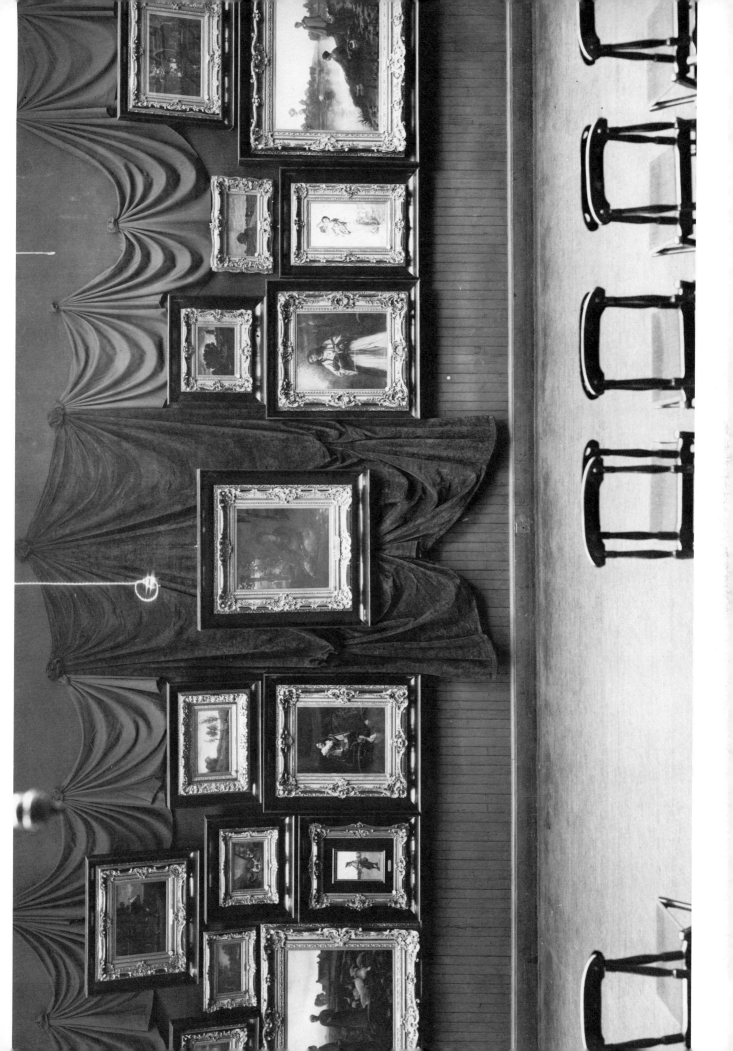

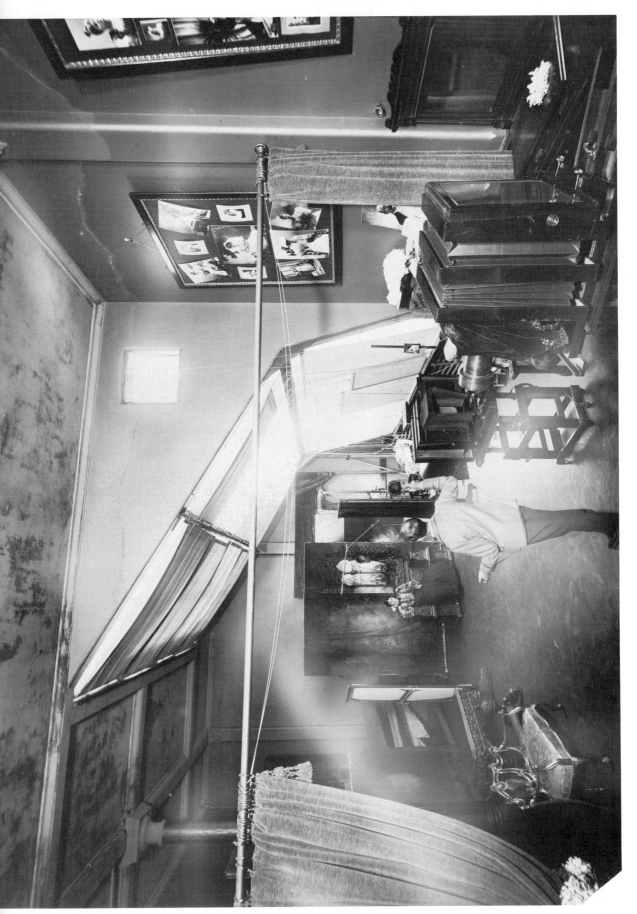

124. A Portrait Photographer's Studio (ca. 1893).

125. BELOW: The Bookkeeping and Exchange Department of *The New York Dramatic Mirror*, 1432 Broadway at 40th Street (1898).

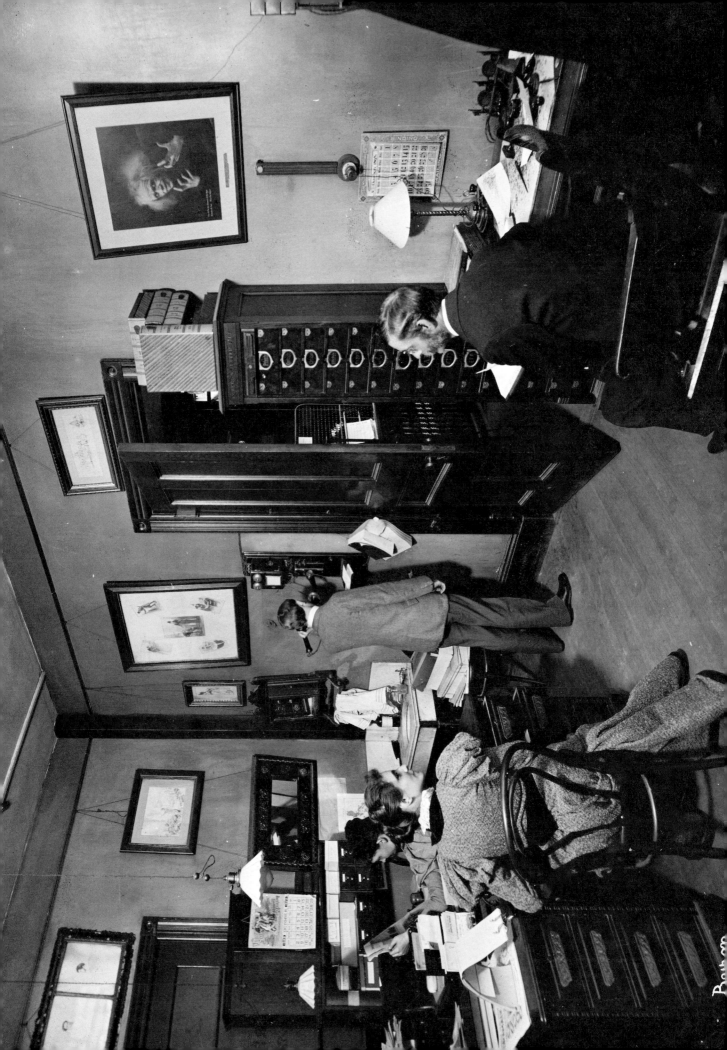

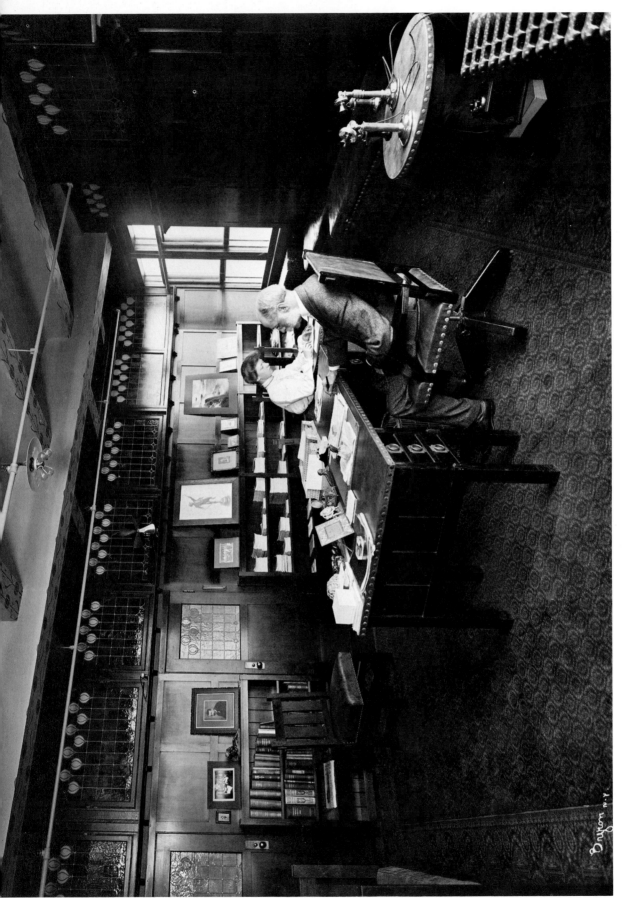

126. Office of The Butterick Publishing Company, 161 Sixth Avenue (1904).

127. BELOW: Office of *Success* Magazine, 32 Waverly Place (1902).

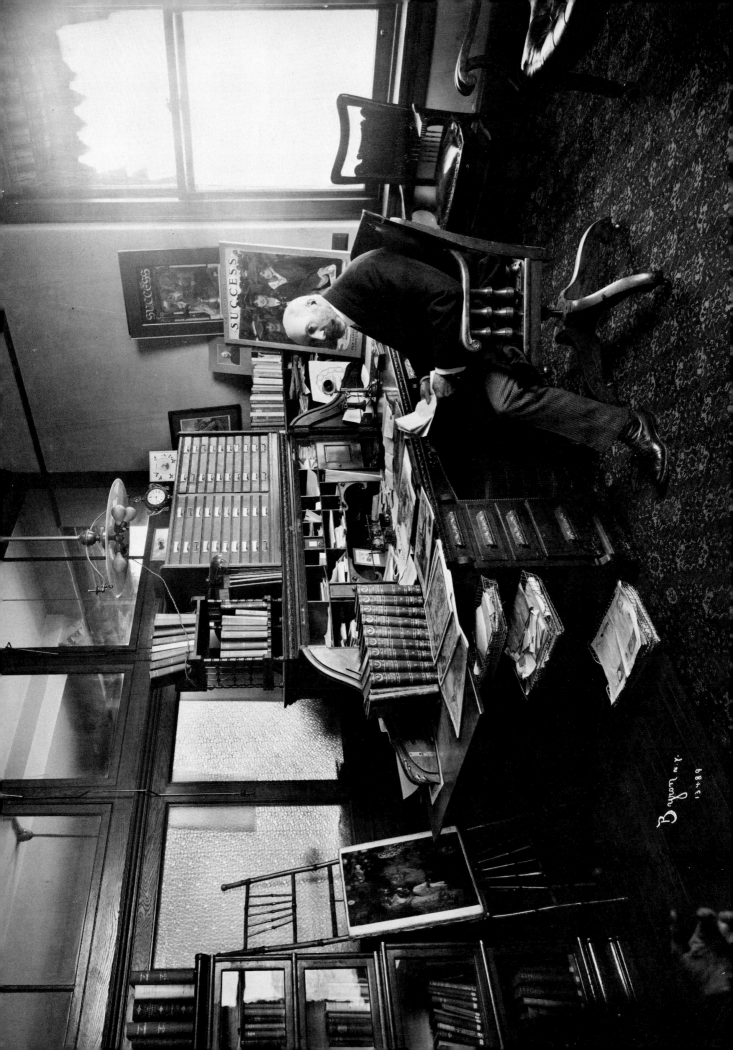

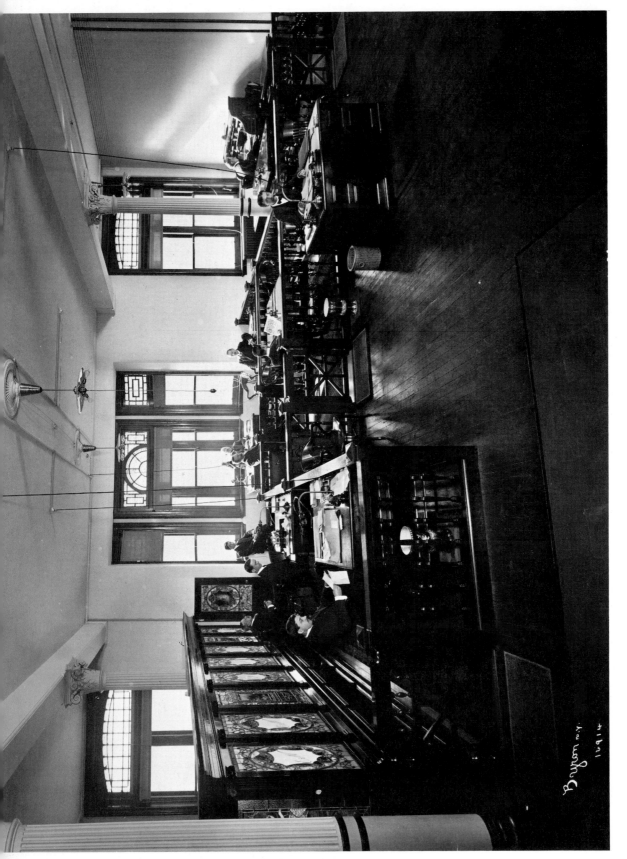

128. Office of Earl and Wilson Collar Manufacturers, 33 East 17th Street (1903).
129. BELOW: Office of the American Type Founders Company, 2 Duane Street (1902).

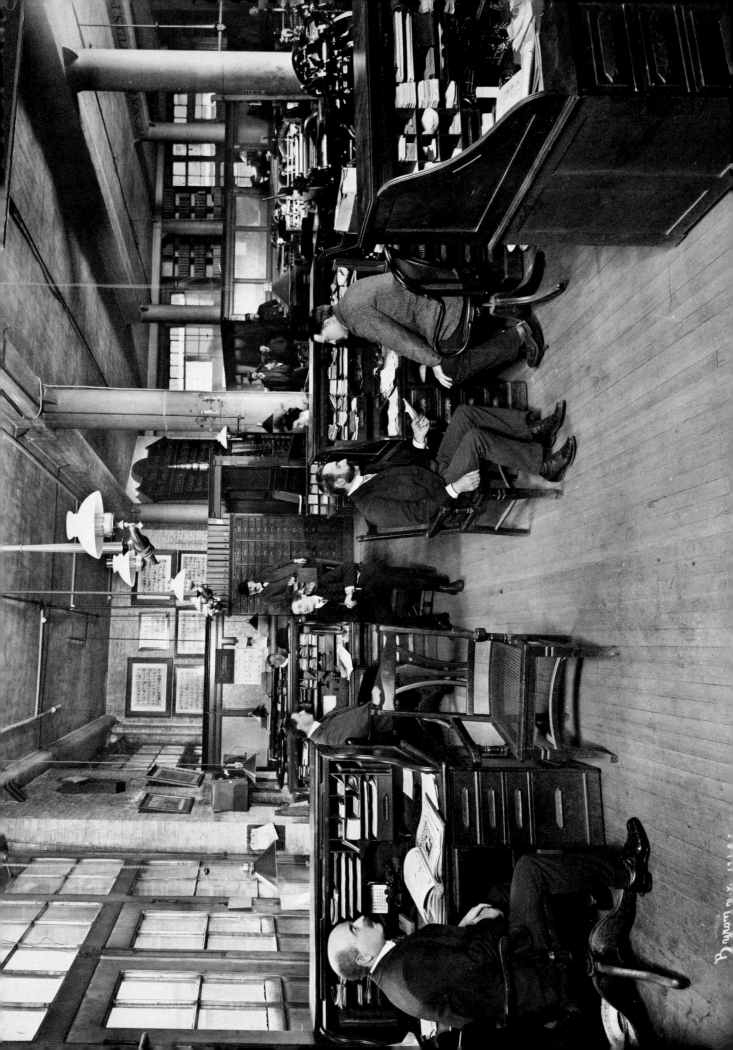

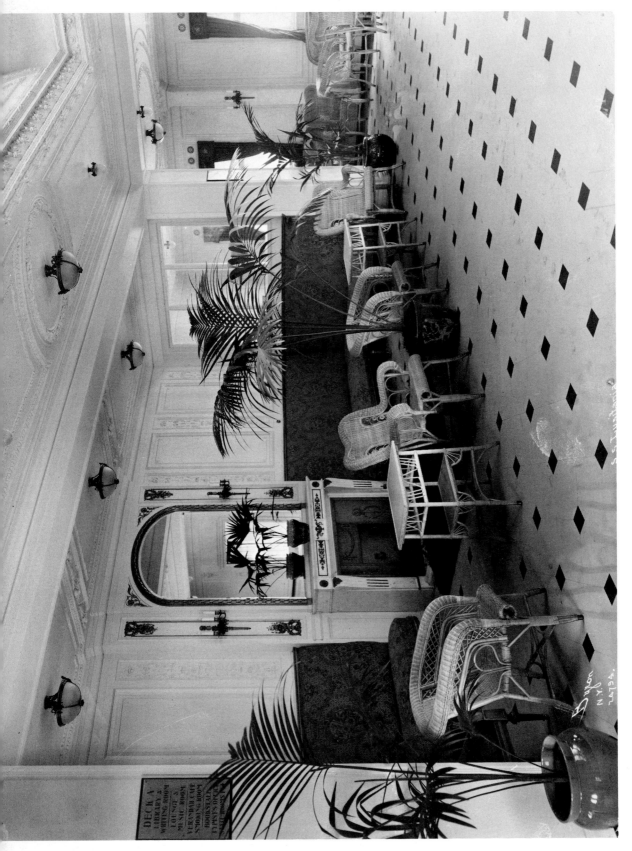

130. A Lounge on Deck A of the *S. S. Lusitania* (1907).
131. BELOW: Deck A Dining Salon on the *Lusitania* (1907).

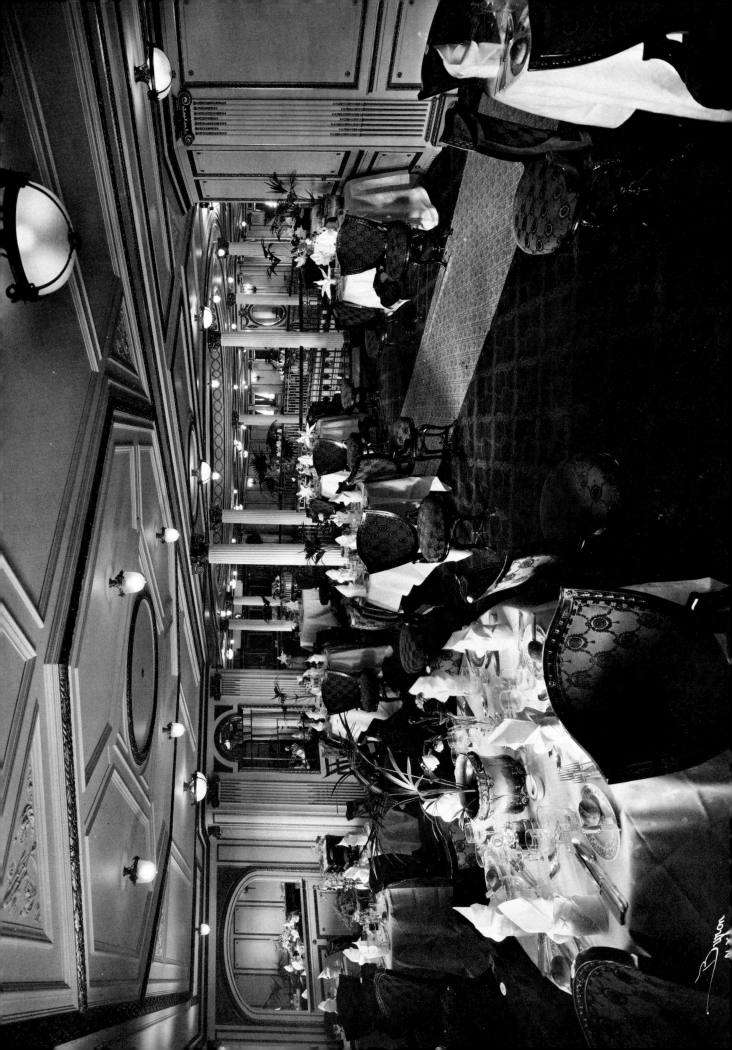

Notes to the Plates

1. DRAWING-ROOM ORIEL AT LYNDHURST, TARRYTOWN (1893). Farthest afield from New York City and the earliest photograph in the present album, this shows a detail of the original castellated house designed by Alexander J. Davis and built for William Paulding in 1838, enlarged by the same architect for George Merritt in 1865, and acquired by Jay Gould in 1880. In 1893 it was the country home of his daughter Helen, and shows minor updated changes in the decoration. Beneath polychromed Christian-style vaulting disport the divine pagan lovers Cupid and Psyche (relic of the Merritt occupancy) in innocent whiteness (matching the entire room at the time of their installation), amidst more recent furnishings, the light softened by heavy silk portieres and Art Nouveau glass tympanums inserted in the windows. Lyndhurst was presented to the National Trust by Anna Gould, Duchess of Talleyrand-Périgord, in 1964, and is open as a museum.

2. ENTRANCE HALL, THEODORE AUGUSTUS HAVEMEYER HOUSE, MADISON AVENUE AT 38TH STREET (1893). Sustaining the graciousness of the *claire-voie* iron fence, paved courtyard and porte-cochère preceding it, in the recent redecoration by Richard Morris Hunt, the white entrance hall of the Havemeyer residence reflected the granulated sweetening from which the owner's

fortune derived. In lunettes over the French doors are classic figures in bas-relief, and there is delicate modeling in the door frames and the frieze adjoining the beamed ceiling. Plush covers the gilded Baroque and Rococo furniture and a section of the floor. Under the grand staircase stands a damask-padded chaise, a useless object in this setting unless serving as a telephone booth. Palms and lilies prepare one for more exotic wonders to behold in the house.

3. CHINESE ROOM IN THE HAVEMEYER HOUSE (1893). The colorful interior is filled to overflowing with Far Eastern conceits. One wall is covered by a Chinese silk hanging sprinkled with flowers, birds, butterflies and fishes. Elsewhere the walls are articulated by lattices and pierced-carved frames. Peafowl, pheasants and water birds are featured in paintings and inlaid panels. The furniture is executed on a system of carved rectangles. The chairs, with claw feet and grotesque heads at the summit of the backs, are tufted in Chinese stone-blue or black silk. The cabinet overpowers the collection of mediocre porcelain on its shelves, and the ornate vase on the floor in back of the chair is remarkable only for its size. The mantel ornaments are miscellaneous, and include a panel mounted with carved snuff bottles directly over the fireplace. The tasseled pendants (upper left

corner) and the garments draped on the furniture were not originally made for display in this manner. Beneath so many Chinese products, the rug is Persian.

4. A CORNER OF THE PICTURE GALLERY, HAVEMEYER HOUSE (1893). After refurbishing the Havemeyer residence, Richard Morris Hunt designed the main pavilion of the Metropolitan Museum of Art. In the picture galleries of both it was intended that the paintings should be stacked on the walls from waist level to ceiling. The partial concealment of the nakedness of the bronze figure by palms and a strategically trained vine is no accident. The placing of furniture and a lamp on the table between the spectator and the paintings would indicate that during the late Victorian period art was to be acquired abundantly but observed sparingly.

5. DINING ROOM IN THE HAVEMEYER HOUSE (1893). Seven Byron photographs illustrated the article on Mrs. Theodore A. Havemeyer, "At Home and in Society," in the 24 January 1895 issue of Once a Week magazine. The dining room was among them. Its ceiling interlacing, wall paneling, Gobelin tapestry, velvet-covered table and chairs, lace-covered sideboard with porcelain garniture and frill-shaded lamps, and shelves of the carved buffet resplendent with tableware constituted the ideal setting for 1890s feasting. The triptych screen, combining a medieval manuscript madonna with Adamesque framing ornaments and pierced Rococo consoles on the side-panel extremities, is a triumph of the Eclectic spirit.

6. DRAWING ROOM OF THE ALBERT STEVENS HOUSE, 13 EAST 9TH STREET (1894). The exuberance of fin-de-siècle decoration has sought to override the restrained Greek Revival details of a house built a half-century earlier. The piered doorway, of the order of the Tower of the Winds (Athens), leading to the adjoining room, may be seen reflected in the mirror to the right. Window enframements are draped to oblivion, and the ceiling is dropped (as they say) by a picture mold, below which the wall is embellished by various flowered wallpapers. Similar patterns in chintz cover the chairs. No flat horizontal surface, above floor level, is available for placing an additional object.

7. SMOKING ROOM IN THE STEVENS HOUSE (1894). The small classic side chair and pilastered marble mantel (alas, draped!) are proper mementoes of the original period of the building. A Kazak prayer rug overlaps the hearth and the Bokhara-type carpet, and facing the fireplace is a Morris chair with adjustable back. A square library table and a somewhat Art Nouveau side table hold the residue of knickknacks not on the mantel or adjoining bookshelves. Sporting prints suspended from the picture mold and a few minor silver trophies mingled below denote the masculinity of the den.

8. PARLOR IN THE HOME OF MRS. LEONI (1894). Mrs. Leoni must have been her own decorator, delighting in festooning her piano, lamps, mantel (shelves at both levels), doorways and windows in the same manner as she bedecked herself. Her furnishings are altogether heterogeneous: brass lamp stand, spindle dos-à-dos (non-conversation) chair, imitation bamboo corner chair, tufted gondola armchair, tables of several kinds, rattan stool by the piano and rush-seated stool in the foreground, and cushions for lolling on the floor. Christmas decorations (wreaths at the window and holly on the chandelier) are incidental to the year-round embellishments.

9. A DRAWING ROOM (1894). The interior contains Watteauesque murals, Rococo mantel ornaments, a gilded griffin, an Empire armchair, a Louis XVI table and fringe-skirted satin Turkish seats, yet it has a thrown-together look because of framed paintings and a mirror hanging on the door and lack of carpeting. The brass table and frilly lamps relate to Mrs. Leoni's style of decorating. These, the lace doily and Eastlake valance on the mantel shelf and the East Indian flowering tree of life on the wall through the doorway are less out of place than the hunting-lodge bearskin rug before the sofa.

10. ART GALLERY AND BALLROOM IN MRS. WILLIAM B. ASTOR'S MANSION, 350 FIFTH AVENUE (1893–94). The Astors moved into the four-storied, red-brick town house in 1856, and in this great crimson-and-gold addition Mrs. Astor held the annual ball for the Four Hundred on the third Monday evening in January. A scintillating crystal chandelier and causeuse formed the focus of the cubic volume, and gilt-framed paintings covered every square inch of wall between the dado and

the springing of the coved ceiling. The rug is a Hamadan runner. Mrs. Astor ceased to entertain here at the death of her husband in 1892, giving only a farewell dinner in her home on 2 February 1895, preceding its replacement by the "hyphen" section of the Waldorf-Astoria Hotel. The hostelry was razed for the construction of the Empire State Building in 1931. Many of the paintings shown in the view above survive in the Ringling Museum at Sarasota, Florida.

11. SLUM DWELLING (1896). The only photograph of a slum flat in this collection (Byron took others) shows the same practice of clutter exhibited in opulent homes. In place of exotic silk robes hung up, as in the Havemeyer Chinese room (Plate 3), here are garments worn every day. The arabesque pattern on the wallpaper and the spool bed are designs that have filtered down to those of meagre income. The room served as kitchen and chamber, and probably as parlor as well. A colander on the wall over the stove suggests a diet staple of pasta. The inhabitants of these restricted quarters react self-consciously in various ways to the photographer's flash.

12. STAIRHALL IN THE BLAKELY HALL HOUSE, 11 WEST 45TH STREET (1896). The premium on New York land forced even a substantial publisher of periodicals (*Standard Weekly* and *Metropolitan Monthly*) like Blakely Hall to reside on a narrow lot. The reception room, seen through the arch to the left, shares space with the entrance corridor. Placing the stairhall in the middle of the house enabled it to open directly into front and back rooms. A sturdy newel post in the foreground, in wood, reflects buxom forms developed for outside stairs in cast iron. An alcove opposite has closets on either side. The lamp resembles milady's bonnet perched on a hall tree.

13. RECEPTION ROOM IN THE HALL HOUSE (1896). The front room glimpsed in the preceding plate is a grotto of draperies. On the ceiling is a Tibetan hanging with *dorje* (thunderbolt) motif and characteristic string imbrication ending in tassels at the far end. A Near Eastern kilim borders the portieres to the hall doorway (right). On the small square table adjoining is an East Indian spread with metallic designs. Other textiles are flowered and of Western manufacture. The curved divan has scatter cushions in place of a back, and in front is an inlaid Turkish table holding cordial glasses. A larger octagonal table in the lower left corner displays a Japanese tea set, and other Japanese porcelains accent the mirror valance over the fireplace. A sword with bone handle and scabbard is on the far side of the mirror, and two Oriental daggers are among the receptacles on the square table.

14. DINING ROOM IN THE HOME OF MRS. MAYER (1896). If the Hall reception room has the look of a temporary encampment tent, this middle-class dining room, laying stress on post-and-lintel members, appears contrastingly permanent. The pilastered door and window frames and piered sideboard, with sections of balustrade atop all three, the reduplicated shelves on twisted posts over the mantel, the consoled hanging étagère and the colonnetted table and chairs are substantially architectonic. Only the windows are masked. The entrance to the service quarters is partly concealed by a three-panel screen on which are depicted scantily draped figures in landscapes. The style of the room is Eastlake, with the exception of the Rococo-manner frieze and ceiling embossing, which tie in with the silver displayed on the sideboard.

15. SITTING ROOM IN THE HOME OF MISS FORD (1896). Miss Ford is an individualist, whose penchant for extremes is manifested in the dropped ceiling (picture molding) halfway down the wall, and whose furniture combines a bulky ottoman—which begins at the chimney breast on the left, turns the corner and spans the window wall—and wicker and spidery wood furniture. The equivalent today would be mixing inflated balloon and wire furniture. Fenestration is brought low by grilles and inner curtains, and the windows are connected by a mirror-and-hanging arrangement. The arts are represented by the piano, plaster casts of classical reliefs, and Japanese items on the mantel, including a small folding screen. A flexible pipe from the ceiling conducts gas to the table lamp, indicating that Miss Ford subscribes to the proposition of living dangerously.

16. RELAXING IN THE PARLOR (1897). This and the following plate show posed models representing young women of high and low degree. The damsel of the privileged class is snared by the laxity of too much luxury. She lounges among symbols of entertainments musical, literary and dramatic (the photo profile cut off by the top of

the picture is of Henry Irving). Her hand resting on the open book shows that even reading fails to interest her. The palmetto in the cachepot in front of the window stands on a strutted-framework stool with dipping seat based on an Egyptian archetype of the XVIIIth Dynasty. Photographs hanging on the wall were not considered good taste in the late Victorian period, but Byron used this opportunity to promote rectification.

17. EATING BREAKFAST BY CANDLE LIGHT (1897). The destitute counterpart is apathetic from total lack of enjoyment in her life, as she muses over her frugal meal before reporting at the plant for another hard day's grind. The apron is the badge of earning her own livelihood. She turns her back on what solace might be derived from religion, as her more fortunate sister momentarily eschews the arts. This trumped-up poverty scene may be compared to the reality in Plate 11. Though the spool table here matches the bed in the slum room, the floor is bare and there is a simulated disarray on the walls, the expression of melancholy assumed by the inmate falls far short of the true mask of privation (despite a forced smile) worn by lifelong residents of the ghetto.

18. A STAIRHALL LIBRARY (1897). This multi-purpose room of the end of the nineteenth century recalled the medieval hall and was part of the "Queen Anne" style. Especially characteristic is the staircase, which rises straight ahead, several steps to a landing, then turns into a long flight ascending to one side. In the fore part of this hall an attempt has been made at achieving bilateral symmetry by placing the ornate square table in the center and balancing the pair of inlaid Empire pier cabinets and upholstered chairs right and left. Bookcases in the angle of the stairway and opposite, and two small desks, each with lamp, make the raised platform a study area. The visible personal effects are meant to remain in place, except on the front table, which is the catchall for smoking equipment, a deer-foot letter opener, and incoming reading matter.

19. LIBRARY IN THE HOME OF ELSIE DE WOLFE AND ELISABETH MARBURY, 122 EAST 17TH STREET (1898). The house at the corner of Irving Place, said to have been once the residence of the Knickerbocker historian and raconteur of Catskill legends after whom that street was named, was taken over by the actress Elsie de Wolfe and the literary agent Elisabeth Marbury in 1887. They dwelt in mauve-decade gloom for about ten years, then Miss de Wolfe turned the house into an ivory (colored) tower. A few pieces, such as the rattan stands (already light in color) and the mahogany Chippendale writing table, evaded her modernizing brush. The seventeenth-century fire-screen figures also retained their pristine somberness. Thespian photographs scattered about recall the denizens' vocational interests. Miss de Wolfe entered upon a new career in 1905, when Stanford White called upon her to decorate the Colony Club at 120–124 Madison Avenue. This launched ivory as a Gotham interior vogue, which flourished until replaced by the antiseptic white that followed the blackouts of World War II.

20. STUDY IN THE HOME OF JOHN DANIEL CRIMMINS, 40 EAST 68TH STREET (1898). Just off the Fifth Avenue parade of millionaires' mansions lived J. D. Crimmins, a major contractor of public works and a parks commissioner when the city's recreation areas still received proper horticultural care. The leaded, crinkled-glass screen, the adequate electric lighting, the two desks (that in the corner for a secretary) and the straight-backed chairs for conferences give a business-like atmosphere, whereas the fireplace, the framed engravings and mezzotints, the tufted lounge to the left and the Kashan rug lend domestic touches to the proprietor's retreat. The room is both the consequence and means of successful enterprise.

21. DRAWING ROOM IN THE CRIMMINS HOME (1898). As in the study, the masculine mood dominates the Crimmins drawing room. The great scale of the mantel, the module wall panels in pomegranate design, the windows in the curved-front bay, the ponderous Turkish chairs placed for individual reflection rather than conversation, the plain carpeting and the velvet upholstery and curtains far outweigh the delicate Sheraton side chairs, the ebony piano, the flowered screen, the Japanese porcelain jars and the French bombé clock on the lower shelf over the fireplace. The feminine decorative pieces are supplemented by the marble sculpture to the left and the portrait in white in the far corner.

22. DRAWING ROOM IN THE HOME OF MISS DODD, 231 WEST 21ST STREET (1898). Symmetry and order are provided by a mid-nineteenth-

century room shell, with typical marble mantel and cornice, to which has been added a later frieze and an assemblage of miscellaneous furnishings. Between the windows is a Chinese cabinet for porcelains, and in the foreground is a bronze nymph on a grained marble pedestal in the shape of a Roman Ionic column. Seats are provided for persons of all ages: a straight, rush-bottom bamboo chair for the shy adolescent, a curvilinear love seat for the demonstrative maturescent and a cushioned rocker for the placid senescent. The grille, resembling a chain-link fence, over the draw portieres in the doorway, derives from the Japanese *ramma*.

23. LIBRARY IN MISS DODD'S HOME (1898). Miss Dodd believed that immaculate lace curtains at the windows gave the house a respectable appearance from the street. She also conceded that proper interior decoration began with flowered carpeting, here a quiet Tabriz-type of design as opposed to the swirling foliage in the parlor. She may have felt as well that every room should have a rocking chair. Her other seats are Belter scroll-back side chairs and a late Empire sofa. A small cast-iron stove stands before the mottled mantel in the Eastlake manner, and contemporary to these is the John Rogers plaster group *Coming to the Parson* (1870). Recent pieces are the parasol lamp with fringe, corner whatnot stand, Grand Rapids bookcase and twisted-legged table with lower shelf poised on the cross stretchers like a trapeze performer.

24. PARLOR IN THE HOME OF MRS. KRESS (1898). The lady's pensive stance in the curve of the grand piano betokens a staid late-Victorian ideology daily guarded by stern portraits of ancestors. She identifies with musical accomplishments on violin and pianoforte, the latter occupying a sizable portion of her living area. The shoulder decorations and small American flag are patriotic symbols reminding us that this was the year of the *Maine* disaster and the war with Spain in Cuba. On the easel atop the chest at the right is an illustrated folio edition (somewhat Art Nouveau) of Poe's *The Raven*.

25. SITTING ROOM IN THE HOME OF MRS. HAUGHEY, MANHATTAN AVENUE AND 117TH STREET (1898). Below Washington Heights, on which was perched the new complex of Columbia University, and east of Morningside Park, residences and apartment houses were mushrooming at the end of the nineteenth century. Tenants kept up with the times by displaying Japanese screens and lacquered chairs, an ottoman, and a vitrine filled with bibelots and curios. Rooms retained their propriety and orderliness by having sliding curtains in front of recesses and bookshelves. Mrs. Haughey, clad in black, poses sidesaddle on her best curule armchair, her glance studiously avoiding the book held lightly in her hands. On the rear wall, to the left of the fireplace, are two American flags, and the third flag represents the Cuban liberation. It was devised by expatriates in New York City in 1849 and used during the American intervention, remaining as the national symbol throughout the U.S. military regime of four years; then it was adopted by the republic in 1902. Mrs. Haughey's widow's dress and medal may tell a sadder story of the war than Mrs. Kress's.

26. BALLROOM IN THE WILLIAM COLLINS WHITNEY HOUSE, 871 FIFTH AVENUE AT 68TH STREET (1899). This house was planned by William Schickel in 1880, built for Robert L. Stuart and occupied by his widow. Whitney had the interiors redesigned and the 63-foot-long ballroom (45-foot-high ceiling) constructed by McKim, Mead and White after purchasing the building in 1896. The Rococo room usually had its furniture arranged in groupings. Here, set up for a banquet, the indigenous Louis XV side chairs are alternated with Louis XIV aliens around the huge fern-decked and palm-shaded oblong table. The adjacent Meshed carpets have been brought in for the occasion.

27. DRAWING ROOM IN THE WHITNEY HOUSE (1899). Whitney's redecorating of the Fifth Avenue house was in the early Italian Renaissance style, with coffered ceilings, deep cornices and a good deal of carving on the woodwork and built-in cabinets. Brocade-covered seventeenth-century-type chairs are supplemented by plain overstuffed contemporary pieces for comfort. The Boston ferns and Areca palms and the ruffled lampshade also bring the décor up to date. The rug is of Feraghan weave. This was one of at least ten houses owned by William C. Whitney when he died in 1904. After it was out of the family for a few years, his son Harry Payne Whitney purchased the residence furnished in 1910 for $3,000,000.

After his death, an auction in 1942 brought one-tenth of that amount for the contents of the house, and it was replaced by an apartment building.

28. HALL IN THE EDWARD LAUTERBACH HOUSE, 2 EAST 78TH STREET (1899). Within a stone's throw from the new (1894) main pavilion of the Metropolitan Museum of Art, Lauterbach—lawyer, railroad president and chairman of the board of trustees of City College—established his own domestic museum, and, as in the public repository, each room was devoted to the arts of a different culture. The stairhall was decorated in Islamic style and contained many objects imported from the Near East. Turkish items include two brass fireplace hoods and andirons (left wall), inlaid polygonal tables, folding chair and book stand, "mosque" lamps and embroidered hand towels on the stair railing. The ewer on the newel post may be Persian, and Bokhara embroidery is on the adjacent chair. A Mosul runner is on the steps and a Bijar or Tabriz rug on the floor.

29. DINING ROOM IN THE LAUTERBACH HOUSE (1899). If the Lauterbach drawing room (next plate) resembled the shin-skinning décor of Prince Ludwig II's Linderhof, the Lauterbach refectory reflected the mad monarch's Neuschwanstein Castle. Joist-beam ceiling, lancet and lobated arches, bulls'-eye leaded glass, armorial frieze and escutcheon motif on the chimneypiece proclaim inspiration from the Middle Ages. Romanesque squat colonnettes support mantel and dining table, and a more slender version flanks the backs of the curule chairs with trefoil ornaments. The Pre-Raphaelite illustration in the niche of the buffet opposite and the amplified ironwork in andirons and fireback at the right are noteworthy. The Sarouk-type rug is a reminder that the pointed arch of Gothic architecture was brought back by Crusaders from the Near East.

30. DRAWING ROOM IN THE LAUTERBACH HOUSE (1899). Through the doorway at the rear of the hall shown in Plate 28, one steps from Eastern into Western exuberance in the drawing room, where a welcome is extended by three-quarter-length, lifesize portraits of the host and hostess. The paintings are propped on low easels for an isocephalic effect; the display of them here may have been prompted by the lack of wall space. Beneath the gilded and polychromed Rococo tray ceiling is gathered together a collection of furniture

notable for its elaboration of detail, some apparently from the workshop of the metropolitan cabinetmaker John Belter. Exoticisms include the Japanese throw and vase on the piano, the cushion on the comb-crested sofa to the left featuring the *toughra*, or Sultan's calligraphic emblem, in a circle, and the Indian tiger and Arctic polar-bear skins on the floor.

31. BILLIARD ROOM IN THE LAUTERBACH HOUSE (1899). The walls are covered with delicate landscapes and the ceiling sprinkled with stenciled crests, and both are overspread with split-bamboo trellises in rectangular and cracked-ice designs. This otherwise charming Japanesque effect has been overdone by superimposing framed *kakemono* on vertical and horizontal surfaces, the ceiling rendered particularly confusing by a swastika arrangement on the diagonal. Evidently formerly used gas pipes are in the bamboo sheathing from which an electric light fixture (with exposed wire) is suspended. Suits of armor are grotesque addenda. The pedestal table, chairs and sideboard, the last loaded with swords and ceramics, are pushed as far away as possible from the billiard centerpiece. Its Nipponese cover is the mate to that on the piano in the drawing room (Plate 30). The parasol in the corner submerges comment.

32. BEDROOM IN THE LAUTERBACH HOUSE (1899). Napoleonic furnishings here are as homogeneous as can be found in the late Eclectic period. They include a platformed sleigh bed with crown canopy, cabinet-chests and several types of seats, all ornamented with gilded brass fittings, the two armchairs having swan and Egyptian Pharaoh heads on the front arm stumps. Empire motifs consist of lyre, anthemion, wreath and stars (on the upholstery), torches, swags and paterae (around the frieze), and sphinx tondos and laurel banding (on the ceiling). The eagle bracket for the hanging lamp on the back wall is as much a symbol of imperial France as of democratic America. Persian rugs and radial spindles in the scalloped arch of the window are as out of place as the electric arrangement for reading in bed.

33. BEDROOM IN THE HOME OF MRS. HUGHES (1899). Departing from the theme of her interior scheme presented no problem to Mrs. Hughes, as she adhered to none. She got the local handyman to provide a dais of two steps for her double brass bed and perhaps suspend a frame for

the canopy festooned with ball fringe and curtained backdrop for her ukelele. Reaching over the bars of the footboard, she could pull the chains to the bulbs in the converted gas chandelier, and on the wall by the headboard she could press the button to summon the maid. Wicker furniture and potted aspidistras contrast sharply with the ethereal painting over the plant, wherein the main figure and composition seem to have derived from Alexandre Cabriel's *Birth of Venus* in the Luxembourg.

34. DRAWING ROOM IN MRS. HUGHES'S HOME (1899). The drawing room has the same elaborate cornice and a four-arm mate to the chandelier in Mrs. Hughes's bedroom, but the wallpaper bears stripes, reflected in the textile on the window seat stationed by the side of the piano. Other articles of furniture shown are cabriole-legged. The draped mantel, gilded and mirrored chimneypiece, walls and other handy surfaces are overflowing with pictures, both facsimiles of paintings and photographs.

35. TURKISH CORNER IN MRS. HUGHES'S DRAWING ROOM (1899). Opposite the fireplace are a serpentine-back, closed-arm sofa and a balloon-back, open-arm chair in the Louis XV manner of Belter (a polar-bear rug in front), and at the window end is a bit of the mysterious East. Crossed lances are draped to form the *qobbah*, sheltering a divan piled with cushions, a polygonal plant pedestal and low table within reach, long and short swords, Japanese Noh masks and a small hanging étagère holding various curios on the wall. The alcove has been shifted somewhat from the position shown reflected in the mirror of the preceding plate. A graded set of bowl gongs and a banjo offered a choice of do-it-yourself Asian or African rhythms.

36. STUDIO IN THE HOME OF ERNEST THOMPSON SETON, 144 FIFTH AVENUE (1899). The studio on the top floor of Seton's residence bears evidence of 18 years' investigation of natural history and ethnic crafts. Among its contents are elk antlers, fox and bear pelts, numerous animal paintings and sketches, several botanical specimens, a kachina doll, an arch of repoussé metal (or perhaps of tooled leather or felt), an elaborately decorated parasol, Asian rugs (Caucasian in front of the fireplace), a Persian hanging with a border of horsemen, and Chippendale chairs. Seton al-

ready had published the most popular of his 42 books, *Wild Animals I Have Known*, and four decades later was to sum up his life's explorations in *Trail of an Artist-Naturalist*.

37. DINING ROOM IN THE SETON HOME (1899). If the studio contained the overflow from Seton's "fifty fat leather-clad volumes" of notes and sketches, the balance of the house became the repository for the residue of materials not accommodated in the studio. An assortment of swords and rapiers in the far corner of the dining room and the candlesticks on the stand beneath make a brave pretense at being legitimate collections, whereas mostly such miscellanea as peacock feathers, trapper's chains, scales and bed warmer have settled to the bottom of the house. Eastlake furniture is of no more cherished quality. The main rug on the floor looks like a Tabriz.

38. DINING ROOM IN THE RESIDENCE OF CHAUNCEY MITCHELL DEPEW, 27 WEST 54TH STREET (1899). The home purchased by Depew in 1888 was that built for Dr. William A. Hammond in 1873. The facade of the brownstone-and-brick house was modeled after an old residence in Nuremberg, and the interiors were specially decorated. Depew seems to have kept most of the décor intact. The Hammond dining-room ceiling, painted by Engel of Reynolds and Engel, was described in *Artistic Houses* (1883–84) as adorned "with golden butterflies and dragon-flies moving around stars within an elliptical border of conventional wild-growths." Greek, Latin, French and German inscriptions are at the base of the frieze of the room. Depew substituted his own ornaments on the fireplace shelves, pedestal table, spiral-legged, brass-studded chairs and glass-fronted cupboards. The plates in the cupboards are stacked to hotel china-closet depth. Collectibles vary from game birds to Persian bottles.

39. LIBRARY IN THE DEPEW RESIDENCE (1899). Depew inherited Dr. Hammond's Egyptian frieze and polychromed coved cornice and bizarre metal chandelier in the library. One of the Egyptianized terms on the old black marble mantel may be seen to the left of the fire screen. The Saracen's head (in archaic headdress) has a Delacroix intensity. Except for the contemporary rocking chair, the furniture is a generation outmoded, like the Eastlake desk. The rug is of northwestern Iranian workmanship. Here Depew repaired to

his "mental laboratory," and beneath the outstretched wings of the stuffed albatross he would pace back and forth composing the witty afterdinner speeches for which he was famous.

40. DRAWING ROOM IN THE DEPEW RESIDENCE (1899). Engel is said to have devoted three months to decorating the upper portion of the drawing room, primarily in turquoise blue. The coffered ceiling contains Celtic crosses and other ornaments, and the frieze is taken from the embroidery called the Bayeux Tapestry, that milestone of art showing the transition from Anglo-Saxon to Norman style. Depew has the arch of the doorway concealed by a hanging and portieres added. He also has introduced electricity and lamp shades to the old gas chandelier. The mirror remains from the Hammond occupancy. The new furnishings are less exotic, though equally varied, combining a round-back spindle chair with simplified Chippendales and pieces of doubtful ancestry. Depew's taste in paintings gravitated to landscapes. The room as it looked in Hammond's time is shown in the Introduction.

41. BEDROOM IN THE DEPEW RESIDENCE (1899). This chamber lacks the unifying theme (Egyptian or Celtic) of the rooms just seen in the same house, and its stylized painted ceiling poorly accords with the realistic vines in relief of the frieze. Hammond loved inscriptions and the streamer about the perimeter of the ceiling shows a few Latin words. Two Turkish chairs (far left and on the right by the open door) and the Eastlake bed and dresser belong to the same set. The tall mirror is flanked by vanity lights with adjustable arms. The level of the chandelier is adjustable as well, by means of weights. The garniture on the mantel includes a clock and three bronze figures and two long-necked vases, which serve as props for an array of mounted photographs. The pair of ceramic vases on the upper shelf betray Eastern influence in form and decoration. A stuffed baby alligator strikes a defiant attitude on the cornice of the fireplace mirror.

42. KITCHEN IN THE HOME OF MRS. SANDS (1899). Following the establishing of a sanitary shell, consisting of Miller and Coates' flooring of encaustic tiles (composed of three shapes in as many colors) and white walls, a Dangler iron range in lush foliate style, equipped with natural gas, and a relatively modest laundry tub were installed in the Sands kitchen. Winter chill was combated by a Joy steam radiator (which has crazed the wall behind it), and the visual confusion caused by the labyrinth of pipes was compensated for by the physical comfort they provided. An alarm clock on the wall and coal shovel in the corner each had its use.

43. KITCHEN IN THE HOME OF MRS. THEODORE SUTRO, 320 WEST 102ND STREET (1889). Mr. Sutro was a distinguished German-American lawyer and writer, and his wife (née Florence Edith Clinton), also versed in law, was an accomplished musician (receiving the first doctorate of music bestowed upon the distaff in the United States) and an inveterate clubwoman. Their kitchen had vitreous-white-tile walls and wood floor, with a Janes and Kirtland "Beebe" coal-burning stove upon the hearth stone, hood over, a shining hot-water tank adjacent to the left and a porcelain iron sink between draining boards on the right. A waste receptacle is in the form of a tree stump. A marble counter under the window, an eggbeater, a small hourglass egg-timer, a measuring cup and various brushes and scouring preparations complete the room's conveniences. Water conduits transversing the ceiling indicate the ample supply of bathrooms in the house.

44. KITCHEN IN THE HOME OF MRS. BURTON HARRISON, 43 EAST 29TH STREET (1899). The basement kitchen of historian Mrs. Harrison (co-author of *History of the City of New York*, 1896) has a homier feeling than the two preceding examples, owing to the lack of exposed pipes and the presence of domestic furniture, including a round pedestal table covered by an East Indian silk spread remnant. Even the square of linoleum bears a resemblance to a rug. Cooking could be performed by either gas or coal fire. A pendulum clock hangs on the dumbwaiter chute.

45. KITCHEN IN THE HOME OF MRS. F. L. LORING, 811 FIFTH AVENUE (1899). An establishment in the mile-and-a-half row of millionaires' homes on Fifth Avenue would have a properly appointed hotel-size kitchen with appropriately uniformed chef (and adequate staff assistance) capable of preparing hotel-size banquets. The intercom phone and signal board (on a line with

the chef's cap) signify a well-ordered household. The presence of the singular lamps suspended from the rack over the center table is enigmatic; perhaps they were there for cleaning.

46. KITCHEN IN THE HOME OF DR. WARNER IRVINGTON (1899). This and the four preceding plates dating from the same time in Byron's file indicate a specific commission. In all probability they were to illustrate a magazine article on the domestic nucleus of the up-to-date American home. Dr. Irvington's kitchen contains the essential elements of the others (including two kinds of stoves), but the open door at the left reveals a more intimate location in relation to the dining room than in any of the others.

47. PARLOR IN THE HOME OF FREDERICK WALLINGFORD WHITRIDGE, 16 EAST 11TH STREET (1900). Whitridge was a lawyer, teacher and railroad executive. His Greek Revival residence had pilastered doorways whose order resembled that in the Stevens house (Plate 6). Perhaps the period style of the building suggested a somewhat Colonial manner for the room's decoration. Taking advantage of the light, in the left corner is a drop-front desk and in the right a kidney-shaped writing table. The side chairs and winged chair (center) show Sheraton or Louis XVI influence, though the curvilinear back is alien to both styles. The bentwood rocker is somewhat Eastlake. Neat sets of uniformly bound books and loosely fitted bird-and-branch printed chintz slip covers are characteristic of the opening of the century. On the right-hand wall, small reproductions of two Reynolds paintings are in the top row (the *Mop Hat* nearer the window), and two views of Venice are next to the door. Photographer Joseph Byron at work is reflected in the pier mirror between the windows.

48. MUSIC ROOM IN THE OLIVER M. FARRAND HOUSE, 238 WEST 113TH STREET (1900). The corridor shape of this room would suggest placing the diversified furniture along the outer wall. Opposite are only the piano and tea table, with a frail corner chair set in the middle. Having walls and ceiling related in blond tonality avoids an oppressive effect. Reliefs like popcorn strings, and bird and foliage sketches, on the ceiling are more effete than subtle. Carpeting, sold by the yard, with matching border, has been adjusted to simulate custom weaving.

49. BATHROOM IN THE HOME OF EDWARD BRANDUS, 16 WEST 88TH STREET (1902). The New York art dealer, son of a music publisher in Paris, where the younger Brandus maintained a second residence, had a luxurious bathroom for the beginning of the twentieth century. It had cross light and ventilation and a recessed gas heater. The floor was of hexagonal white tile, the dado of rectangular glazed tile, with an embossed frieze slightly tinted and a shallow capping. The wash basin was polychromed and sunk in a marble slab, over which were beveled mirrors, two of them serving as doors to corner cabinets (the far one reflecting Byron's camera).

50. DAUGHTER'S BEDROOM IN THE BRANDUS HOME (1902). The mediocre and miscellaneous furnishings of this chamber no doubt suited the tastes and needs of a teenager. Everything is contemporary. Strongest in period affiliation are the Louis XVI chair with arm posts and the colonnetted bed. The pieces close to the window are indistinguishable substyles with cabriole legs. The crossbar stool in the foreground has awkward proportions, and the natural-wood table and rocker to the left show mission influence. In 1954 this photograph became the basis for a pen illustration by Lili Cassel for Virginia Sorensen's novel, *The House Next Door*.

51. UPPER HALL IN THE BRANDUS HOME (1902). Befitting the habitation of a successful art dealer are the treasures in the upper suite of the 88th Street residence. Persian carpets of Sarouk type lie on the parquetry floor. Dante chairs stand in front of Empire pedestals, which support a marble bust and a classic urn. On the fireplace shelf, between elaborately figured kraters, is a spectacular marble-and-gold clock, whose face is the wheel of Apollo's chariot. Through the curtained doorway to the parlor may be seen French gondola chairs, a deeply carved console table, flanked by sinuous turn-of-the-century stands with urns on top, and a continuation of the painting collection that remains obscure in the Byron photograph.

52. LIVING ROOM IN THE HOME OF MRS. ELLIOTT (1902). The staid Victorian parlor underwent a complete metamorphosis to emerge as an informal living room like this. Two rooms

of different size are joined by a wide opening, and the sense of irregularity is furthered by the square Shirvan rug, big spool armchair, small yoke-crested Windsor chair, low trestle table and gothicized bookcase placed askew. The one elegant piece of furniture, a high chest, is relegated to the far left corner. It appears to be a Centennial "highboy," and as such is not inappropriate in this setting that avoids antiques. The studio couch is shorn of Turkish references. Over it is a reproduction of William Morris Hunt's *Bathers.* At the left the lunging Herculaneum wrestler and the metal stand with the sheet music of Wagner's *Parsifal* supply further cultural mementoes.

53. BEDROOM IN MRS. ELLIOTT'S HOME (1902). The diminutive hall chamber, which came into existence on floors above the entrance in New York town houses following the Revolution, persisted in late Victorian and Edwardian flats. The heavy window frames and the two-paned sashes indicate that this room is in such a building. It has been papered recently in Art Nouveau pattern. The furniture makes concessions to the limited space, the studio couch with Turkish kilim spread serving both for lounging and sleeping, the chairs and wastebasket being light for greater mobility. The chest of drawers in the corner belongs to the same family of reproductions as the centennial piece in the living room, this one having spiral colonnettes at the corners and gadrooning on the top edge, the current mode in mirror arrangement added. A print of Corot's *Dance of the Nymphs* hangs on the right wall, and a copy of *Harper's Bazar* is on the couch, while a program of the Savoy Theatre presenting Ethel Barrymore in a double bill (with Mrs. Elliott's gown) is on the chair. The rug is Caucasian.

54. A STAIRHALL (1902). The upper-middle-class suburban home at the beginning of the present century had such stock accessories as hard-wood parquetry floor and paneled wainscoting, mantels, a few columns or pilasters and ceiling beams. The fireplace opening was framed in amber or green glazed tiles, often with matching hearth, and it was not unusual to have a pair of vases, Chinese five-color or Japanese Satsuma (as in this case), on either side. The shelf garniture, in front of a beveled mirror, usually included a clock. Carpets were of the simpler (geometric) Near Eastern weaves; the stair runner here is a Karaja.

55. DINING ROOM IN THE. HOME OF H. ZIEGLER, 18 EAST 54TH STREET (1902). The wholly boiserie room, with inlaid, carved and raised-panel elements, has a long, built-in seat and oversized sideboard, the latter with bracketed upper cabinet, whose doors have leaded glass keying in with that in the bay window. The eclectic chairs around the pedestal table are leather-upholstered, the back cresting containing a few Rococo curls matching the relief work on the flower-vase panels of the screen in front of the door to the services, and the light-studded crowning of the sideboard cabinet. The medallion of the Old Sparta carpet is picked up in a miniature stencil on the ceiling panels.

56. DINING ROOM IN THE HOME OF MRS. R. E. SCHROEDER (1903). The motif of this room is deep carving, whether late Gothic, as in the beam and mantel imposts, and dining table and chairs, or Baroque, as in the sideboard. The chairs are somewhat reminiscent of those in the room with the Waverly-novel murals in the garden pavilion of Buckingham Palace. More remote from any prototype is the bulbous-legged table with apron and top-border elaboration. The caryatid-supported, sphinx-and-griffin-tiered sideboard carries an assortment of cut glass, porcelain, and silver candlesticks, and in the rack above is a set of Dutch Delft plates with whaling scenes. Ferns sprout from a Russian sledge between the corner windows, and the rug is Chinese or an imitation.

57. LIBRARY IN MRS. SCHROEDER'S HOME (1903). A rubber tree shelters the fiercest piece of furniture in the Schroeder household, the Folion armchair, whose first appearance in America was in the Chinese booth at the Philadelphia Centennial of 1876. The square plant stand beyond may have come through the same channel. The library table, with kneeling Atlas supports, high-relief frieze and gadrooning on the nosing of the top, is as much sculpture as furniture. Heavily framed bookcases look more secure on the floor than on the wall. A bone-scabbard Japanese sword hangs below the latter. The Bokhara rug, the Turkish inlaid table, and the tufted chair and couch are real or assumed Near Eastern touches.

58. DRAWING ROOM IN MRS. SCHROEDER'S HOME (1903). Village peasants in the large Flemish tapestry and more fanciful "country folk" on the backs of the Empire seats disport them-

selves, each group after its fashion. These needle pictures gain importance in a house not addicted to many framed paintings on the walls. The piano alone in the drawing room represents Mrs. Schroeder's preference for massive furniture. The draperies are unusual in resorting to three slightly different valance outlines, their materials of as many Chinese silk brocades, the first with Buddhist symbols, the second with flowers and the third with blossoms and bats. Kufic inscriptions are on the Turkish table and rug, the latter (which may be Syrian) declaring the unique supremacy of Allah. The ceramic Art Nouveau figure on the ewer (left), the bronze bell-ringer lamp on the piano and several carved ivories on the desk are conversation pieces. Apollo drives his chariot on the ceiling boss.

59. BEDROOM IN MRS. SCHROEDER'S HOME (1902). The bed on a dais, the chaise longue stacked with pillows, the rocking chairs, the flowers growing and cut, the children's photographs and the paintings of Venice make Mrs. Schroeder's chamber a sanctum of comfort and pleasant memories. The Egyptianized stool is similar to that in Plate 16. A Turkish lantern, Afghan rug and Chinese censers on the mantel represent the room's share of Orientalia.

60. CONSERVATORY IN THE HOME OF MISS N. MUNROE, 36 WEST 59TH STREET (1903). Palms reaching upward and asparagus ferns dropping downward approximate a bower in a mirrored city greenhouse. The birdbath, on an attenuated pedestal having a tripod base, fosters planting on two levels. The one on the floor brings rock-garden rusticity indoors. The Louis XV vitrine, the Louis XVI window seat and the piano are civilized outlanders in a brave attempt at a jungle in which a tiger sprawls on the ground.

61. BACHELOR APARTMENT OF MR. FOX THE TAILOR (1903–04). The certificate, fez and sword on the walls proclaim the tailor a Shriner, and boxing gloves (hung up Christmas-stocking fashion on the mantel) may imply that participation in the sport vied with club activities. Among the legs of the Grand Rapids furniture may be spotted a majolica cuspidor. A cut-glass punch bowl and several bottles of Jules Krug's Extra Dry are on the sideboard. A Turkestan kilim with newly attached tassel fringe covers the table. Joseph Byron made a

number of shots of this den and its two occupants. In the climactic pose they are informal in their vests, and from the brimming punch bowl, now on the table, Br'er Fox is serving his guest with an antique silver ladle.

62. DRAWING ROOM IN THE JOSEPH M. WEBER HOUSE, 136 MADISON AVENUE (1904). Weber belonged to the popular comedy team of Weber and (Lew M.) Fields, which had broken up about the time this picture was taken, though the two men came together on stage and screen many times during the next three decades. The single-footed, griffin-protome supports at the extremities of the mantel are among the oddest beasts derived by New York carvers. The three pieces of furniture most in evidence are derived from the Louis XVI style and have gilded appliqués. Much of the residue of the room's contents falls into the category of thespian gifts. The most unusual items are the two puppets perched on the bentwood stand to the left and the anthropomorphic butterfly in the right corner of the window recess. Judging by the wire that traverses the ceiling and drops down the wall to it, the butterfly could be illuminated. The mechanics of lighting and heating the room might better have been concealed backstage.

63. RECEPTION ROOM IN THE WEBER HOUSE (1904) Aspidistras thrive in majolica jardinieres on matching pedestals to either side of a steamboat screen. In the reception room beyond, a spiral-legged tête-à-tête chair stands on the Persian carpet. A Turkish window seat is behind it. The statuette alongside the clock on the mantel assumes the pose of the central figure of Jean-Baptiste Carpeaux's group The Dance on the facade of the Paris opera house. The marble bust with floppy hat on the column is a mate to that in the drawing room, entered through the doorway to the right. On the stool next to the opening, the dark bronze water carrier performs her task with an abandoned grace equal to that of the mantelpiece dancer.

64. MUSIC ROOM IN THE WEBER HOUSE (1904). The upright Steinway is provided with a recess accented with cutout grilles. The dark wood and claw feet of the Rococo bombé desk proclaim Chippendale influence, and the inlaid lacquer screen is Japanesque, whereas the side chair and lamp table allude but vaguely to period styling.

The bright smiles of the mannequin trio in the corner compete with the sunshine streaming between the tassel-fringed window curtains, but the lady on the love seat is pensive.

65. DRESSING ROOM IN THE WEBER HOUSE (1904). The sewing-machine stand and makeup dresser are accoutrements necessary to theatre people, and the framed photograph of Weber, Fields, Peter F. Dailey, David Warfield and others on the far wall, as well as the certificate regarding the Actors' Fund (see Plate 125) over the mirror, confirm our intrusion into an histrion's habitation. The clothes tree, rush-bottom chair and center table with shelf are frail furnishings for a room with such a pile of Gibson-girl pillows on the sofa and elaborately draped valance over the window.

66. ROOM IN THE STUDIO-HOME OF F. BERKELEY SMITH (1904). The son of artist and author F. Hopkinson Smith was an architect, illustrator and designer, and his domicile has the look of studied casualness, incorporating parts picked up during his peregrinations or left over from professional projects. This narrow room combines Gothic quarrel-paned leaded windows with a Classic Federal mantel that covers most of the end wall and poorly fits the fireplace opening. Above, the cast of a Quattrocento madonna-and-child relief imperfectly balances the wharf scene. The mission rocker, carpenter's bookshelves and beaded-board ceiling are elementary without being rustic. A frail hexagonal table with spiral legs and a rotund kidney desk collaborate with the code of contrasts.

67. ANOTHER ROOM IN THE STUDIO-HOME OF F. BERKELEY SMITH (1904). The ponderous bungalow chimneypiece displaying a William Nicholson alphabet print (another is on the door) and a Southwest Indian pot, and the batten wall containing a small ecclesiastical window and a Tiffany-glass landscape fragment show unorthodox taste. The plain carpet and furnishings of square shapes (some with commonplace carvings) are highlighted by a broad wing chair of simplified Chippendale form. Unframed paintings and geraniums in clay pots exude the rarefied atmosphere of 1904 middle-class Bohemia.

68. A CLUB ROOM (1904). This unidentified interior must be the headquarters of an organization, judging by the rows of seats in the adjoining room, the lack of carpet on the parquetry floor and the work spaces provided in the foreground. The chromo in the doorway has the look and setting befitting the image of Mme. Founder or Chairwoman. The preponderance of carved side-plaque or trestle furniture, repoussé metalwork, cabinets holding stitchery, picture and book stands on the table, and a laced-wood wastebasket connote a shrine to handicrafts. The chair in the right foreground has European medieval ancestry.

69. A BEDROOM (1904). The femininity of the chamber is attested to by the Gainsborough prototype flanked by two modern headgear derivatives in delicate oval frames over the mantel, the hand-embroidered bedspread, the lace skirt on the bed and the mantel shelf, the border to the drapery (with strings of beads) over the dresser and behind the bed, and the glass curtains. It is further expressed in the miniature Rococo piano and Dresden figures over the fireplace, and in the long mirror on the overmantel, the four looking glasses arranged in front of the kidney vanity and the one on the dresser. Even the bedside telephone betrays a feminine fatality. The shining brass cuspidor on the medallion rug is a bold masculine intruder.

70. DEN IN THE HOME OF ARTHUR J. JOSEPH (1905). Exercise and sporting paraphernalia overshadow study materials in this Columbia man's hermitage, where muscle-building apparatus takes the lead over implements of organized games. Flying rings, punching bag and weighted grip pulls (the pennant on the lower set precludes its frequent use) make it a working gymnasium. The stuffed osprey and pelts for carpets suggest sporting activities farther afield. The swivel, rocking and Morris chairs indicate a restless nature; while the double tier of pinup girls and the dozen pipes on the smoking board in the alcove betray extracurricular activities unbefitting a dedicated athlete. The print over the fireplate, a classical recitation scene by Lawrence Alma-Tadema, evokes nostalgia for the Neo-classic halls of Alma Mater.

71. DINING ROOM IN THE HOME OF ARTHUR J. JOSEPH (1905). The repeated motif is the dolphin, which appears in the chandelier, as consoles to the top shelf of the sideboard, as the legs of the pedestal table and the arms of the high-crested chairs, and on the valance of the tassel-fringed window draperies. A Cantonese stand holding Boston ferns is in front of the lace curtains. German beer steins hang beneath the plate rail capping the

paneling of the back wall, and canvas with a subtle pattern covers the upper surface. Cove and ceiling have stenciled borders, confronted dolphins included in the last. Several cut-glass pieces are remarkable for their size. The upholstery and rug designs are prosaic and contribute to an overall effect of the same character.

72. BEDROOM IN THE HOME OF MISS MC-NAMARA (1905). The girl seated at the desk by the telephone embodies the type made famous by Charles Dana Gibson, whose cartoon *When Doctors Disagree* hangs at the left margin of the plate. The color key of the room is high, with white background to the striped wallpaper and figured chintz curtains. The furniture is trivial, but the printed paper frieze gives the room some distinction. Perhaps it was this realization that prompted hanging pictures low on the walls.

73. A BEDROOM (1905). We deserve to know the identity of this princess' palace, which might be considered the dream equivalent of the imperfect version in the preceding plate. The appropriate style for an interior of white and gold is Rococo, and Louis XV curves characterize panel contours and furniture forms. The wide bed has shell carving applied to the curved head and footboard, and it is surmounted by an angel canopy ornamented with roses and ostrich plumes. The paintings in the overdoor trefoils are in the Boucher manner, and the room is lighted by graceful wall sconces and small bedside lamps. A mirrored door opens to the princess' robing room.

74. DINING ROOM IN THE HOME OF LEONARD J. BUSBY, 135 CENTRAL PARK WEST (1907). Some of Grand Rapids' mass productions in oak and leather (real or simulated) of early twentieth-century vintage was unlike anything made before or since. It was neat, but the forms were uninspired, colors and textures were dreary, and reliefs and other details were trite. In a room presided over by a fireplace whose colonnettes bypass the mantel shelf and connect with an architrave above the beveled mirror, with paneling and trim lacking interest, and the wallpaper pattern confused, the one aesthetic virtue achieved by the room is consistency. Even the Hamadan camel's-hair rug is about as nondescript as the pampas-grass arrangement. The Tiffany-type grandfather clock and gramophone are relieving features because of their mechanical proficiency.

75. DRAWING ROOM IN THE HOME OF MRS. KELLOGG (1907). The architecture of the room is Colonial Revival, with fluted Ionic pilasters (oddly spaced) mounted on a paneled dado and supporting a deep entablature. This basic orderliness is overpowered by the contrasting tonality of the wall covering and the window draperies, and it is made further ineffective by the miscellanea of furnishings. On the wall between the windows is a mirror resembling a pool of writhing eels, and the furniture includes a carved Renaissance trestle table, an armchair, a round pier table, a Turkish sofa, a triple-back love seat and a piano with a window bench for stool. The Bokhara rug is square with the room, but the Kashan, and the Anatolian prayer rug beyond it, are askew. The interior is a good illustration of the dichotomy that may occur between the basic concept and the final effect.

76. LIBRARY IN THE HOME OF CHARLES HITCHCOCK SHERRILL, 20 EAST 65TH STREET (1909). Sherrill was just beginning a career in international affairs, as minister to Argentina, when this picture was made, but his trophies show the 42 years of an active life behind him. The photographs over the bookshelves and the silver cups to the left proclaim his success in sports. The oars at the top of the wall signify membership in the New York Athletic Club team that distinguished itself in the Harlem Regatta in 1893. The inscription on the banner in the square frame testifies to his fleetness of foot, for having lowered "the American 150 yds. run record at the Berkeley Oval May 17, 1890 . . . [to] 14 4/5 sec." His track shoes hang over the left corner of the bookshelves. The meticulously conceived details of the cross-frame table and lion-footed sofa suggest the Prince Regent style. The fish motif terminating the seat of the sofa seems to have derived from designs in Sheraton's *Cabinet Dictionary* of 1803, commemorating Nelson's naval victories. The scene in the tapestry is provided with an elaborate proscenium arch hardly merited by the awkward gestures of the figures. The rug is a Bijar.

77. BATHROOM IN THE HOME OF MRS. HELEN TERRY POTTER, NEW ROCHELLE (1909). The five-fixture bathroom, with ample porcelain table space to the basin, tub porcelain outside (as well as inside) to the floor, separate shower bowl, curtained and with stool, bidet and water closet (which Byron consistently excluded from his pic-

tures), with tiled wall and floor, and even scales, was the epitome of luxury in 1909. The alignment of labeled bottles on the shelf under the mirror no doubt suggested to some enterprising manufacturer the modern recessed medicine chest.

78. KITCHEN IN MRS. POTTER'S HOME (1909).

No notable improvement in planning has befallen the kitchen since the last examples seen, a decade earlier (Plates 42–46). Here, oilcloth (in use for at least a century) covers the tables for easy cleaning, but coal and gas ranges stand side by side, and the sink still has a draining board of wood. However, this is a suburban residence, and it may have remained unchanged for some years. The wood dado was going out of style by the end of the first decade of the present century. A kettle for hot water has been on top of every kitchen stove shown.

79. A KITCHEN (1914).

Five years have elapsed between the preceding photographs and the present one, and this unknown kitchen (apparently in suburbia, judging from the scene through the window), has a more modern look, owing to the white unit panels on ceiling and walls and the improved stove, whose ovens have been raised to the level of the burners or higher, with a louvred wall and ventilator above. A bank of small, high fenestration (bungalow style) is over the sink, which is flanked by food-preparing surfaces, though the latter are crudely devised. Around the corner from the kitchen proper are the soapstone laundry tub and pump (another indication of suburbia). The rocking chair, the wood floor and the strip of carpeting are homely comforts provided for the contentment of the cook. A clock over the range and dish-washing paraphernalia have graduated from conveniences to necessities.

80. NURSERY IN THE HOME OF A. C. CRONIN (ca. 1915).

"In summer . . . I have to go to bed by day" (Stevenson) might be the title for this photograph, suggested by the child's holding the candlestick despite the bright sunlight outside. Typical infant accoutrements of just prior to World War I are the finger-pinching gate bed, child-size wicker chair, nightgown, pompon slippers, plush bunny, dog, wooden truck and dolls with breakable heads. More artistic "toys" are kept on the table. Properly relegated to the nursery are the indestructible mission rockers and the old Karabagh runner, whose border had been masticated by the domestic canine.

81. STUDENT'S ROOM (MISS NEWCOMB'S) AT BARNARD COLLEGE, BROADWAY ABOVE 116TH STREET (1901).

Founded in 1889, Barnard College moved uptown and became the female counterpart of Columbia College and part of Columbia University in 1900. A piano in a dormitory must be one of the "extras," like "French, music, *and washing*" (Carroll). Miss Newcomb evidently brought the two folding chairs and stool, the mound of pillows on the couch, and the coffee maker and tea set. The picture beyond the wall light is a reproduction of Corot's *Spring* in the Louvre. A fringed buckskin pouch on the wall in the corner is of the type used by explorers to the western country, and the little framed portrait may be of its original owner, perhaps an ancestor of the room's occupant.

82. DRAWING ROOM IN THE NATIONAL CONSERVATORY OF MUSIC, 49 WEST 25TH STREET (1905).

Founded by Jeanette M. Thurber about 1880, the music school was incorporated by act of Congress in 1891. The front end of the drawing room is occupied by a concert grand piano. A tambourine (under the Venus) and a lyre (left wall) are other musical instruments in view. In front of the pier mirror between the well-dressed windows meditates a Japanese gilded-wood Amida. The statue in the window to the left is set on a stand incorporating sculpture as large as that it supports. Chairs range from simple square Eastlakes through Louis XVI and Sheraton types to an intricately carved "Burmese"—a mid-to-late-nineteenth-century export item made in Indochina or Malaysia. The Persian rug accords better with this setting than does the polar bear. Some of the furniture-top ornaments look as though the maid had not yet tidied up after a tea party.

83. DINING ROOM IN THE NATIONAL CONSERVATORY OF MUSIC (1905).

The somberness of this musicians' refectory has been achieved not only by low-toned materials but by blocking the window at the end of the room by the mirror-backed sideboard. The twin buffets to either side, as well as the chairs, have spool-and-baluster supports. At the right are a pair of late-nineteenth-century Japanese vases, and the dining table is covered by a Syrian embroidery. The rug is similar

to that in the drawing room. A number of high-lights resulting from paired silver candlesticks and fresh flowers (hyacinths and jonquils or daffodils) sweeten the room's gloom. While director of the National Conservatory during its early years, Dvořák wrote his symphony *From the New World.*

84. A BEDROOM IN THE NATIONAL CONSERVATORY OF MUSIC (1905). The bed canopy, the curtains at the casement windows and the skirt on the marble mantel look matronly in their tasseled fringe; the dressing table is decked out like a bride. Also provided are a couch, three wicker chairs (one a rocker), a couple of side chairs, a desk and a table. The shag and rag rugs are properly institutional. The head of Athena, a detail from Botticelli's *Pallas and Centaur* in the Pitti Palace, is centered above the fireplace, and two heads of the Christ (over each end of the mantel shelf) are from drawings attributed to Leonardo.

85. LOUNGE OF THE LAWYERS' CLUB, BROADWAY BETWEEN PINE AND CEDAR STREETS (1901). Founded in 1887, the Lawyers' Club made its headquarters in the 17-year-old Equitable Building, then lately remodeled and enlarged by George B. Post. The edifice covered an acre of ground and housed 3500 tenants. The club lounge shown provided numerous seats built around massive square piers, with griffin-supported tables at the corners, each providing lamp, cigarettes, matches and call bell. From the piers spring wide arches joined by groin vaults. The polychrome surfaces are decorated with delicate classical filigree work in white. The Equitable Building burned at the beginning of 1912 (see Plate 93).

86. ENTRANCE TO THE HOTEL MARIE ANTOINETTE, BROADWAY AT 66TH STREET (1896). The hotel in the style of the Nouveau Louvre (Second Empire) was recently built when Byron took photographs of it. The elaborate ironwork details of the outer doors are a sample of the exterior enrichment. The tapestry serving as portieres inside is in the tradition of the fifteenth century. The carved members of the seat are confused as to their source of inspiration. The elegance of the service is represented by the uniformed doorman, in swallow-tailed coat and gaiters, the costume of an attendant at an eighteenth-century English manorial estate. Byron's flash is reflected in the plate-glass door.

87. A ROOM IN THE HOTEL MARIE ANTOINETTE (1896). The carving of the seat in the recess evidently is by the same hand that shaped the bench in the downstairs vestibule; the "tapestry" covering is a repeat pattern sold by the yard. The room is made oppressive by column-height paneling capped by bracketed plate rail, the arch stifled by velvet curtains. Spiral-framed or baluster-legged chairs with crested back, a double-tiered credence with colonnettes and a hexagonal Chinese plant stand are crowded into the visible corner of the interior. Protruding sconces with exposed bulbs throw each cusp and facet into a visual staccato. A Shirvan rug in the foreground and Karabagh rug beyond have come a long way from Transcaucasia to the New York caravansary.

88. TEA ROOM IN THE HOTEL PRINCE GEORGE, 14 EAST 28TH STREET (1905). A garden effect was achieved by means of trellises applied to posts and vaults, forming an arbor with wisteria painted on the background overhead, a ceramic niche with putto fountain, a few urns, rubber trees and wicker furniture. Light bulbs were distributed among artificial vines hanging from the crossing of the vaults, and electrified candlesticks were spotted around the tables and writing desks. The Prince George is still in operation.

89. LOUNGE IN THE HOTEL ENDICOTT, COLUMBUS AVENUE AND 81ST STREET (1908). Located on the West Side, near the American Museum of Natural History when erected and now closer to the more recent Hayden Planetarium, the Endicott achieved a brighter and more airy effect in its lounge than the Prince George did in its tea room. The uptown example makes use of iron framework and glass vaults, in the tradition of the Crystal Palace, built at London in 1851 and reflected in the New York version two years later. Daylight permits palm trees, and the floor is hexagonal mosaic tile in an unusual mesh design with a complex Greek-key border. French doors and wicker furniture are as at the Prince George. The rocking chairs are American, but a balustraded upper gallery transforms the setting into a classic Mediterranean courtyard.

90. LOUNGE IN THE HOTEL RITZ-CARLTON, MADISON AVENUE AND 46TH STREET (ca. 1911). New York's second "hyphen" hotel (following the Waldorf-Astoria) was built by Warren and Wetmore in 1910. Like the two preceding

examples pictured, the lounge strives for an out-door effect, repeating planting and French doors (here mirrored), and combining latticework and glass vault and upper balcony. Like the Endicott, the Ritz-Carlton includes Oriental carpeting, its gigantic Kirmanshah overspreading practically the entire floor. The furniture is not wicker but consists of small cushioned chairs of simplified Adam form and candlestand-size, glass-topped round tables. The tripod torchères with shaded electrified candles resemble stylized Christmas trees.

91. AUTO SHOW IN THE BALLROOM OF THE HOTEL ASTOR, BROADWAY AT 44TH STREET (1914).

The box-like, upright coach forms of the early automobiles in this (probably) Lancia section of the show contrast strangely with the flowing Baroque-Rococo décor of the Astor interior. Carpeting has been left on the floor, though protected by shallow pans placed strategically for petrol drippings. In magnitude these 1914 horseless carriages range from the little open, fenderless, two-seater runabout in the center, through the two-toned brougham (maintaining class distinction) at the right, to the driver-sheltered, seven-passenger limousine, second from the left. The convertible roadster in the left foreground has a snappy prow-shaped windshield.

92. A BAR (1898).

The miniature Colosseum beneath a crystal grotto would have provided a setting worthy of Carry Nation's most avid gladiatorial aggressions against alcoholism. Light bulbs stud the tips of the ribs of the glass umbrella overhead, and a fan dispels the heat that collects inside it. The machine on the drum counter in the center must be a mechanical player selector.

93. BAR OF THE CAFÉ SAVARIN, 120 BROADWAY (1901).

The well-known restaurant was opened in the Equitable Building in 1889, a couple of years after the remodeling and enlarging of the building and its occupancy by the Lawyers' Club (Plate 85). Befitting its basement location, the Savarin Bar had heavy marbleized pillars, round arches, relief decorations and colored-glass lamps in the Romanesque style. Yard-wide rubber matting provided a more secure footing for those imbibing at the bar than the exposed marble flooring elsewhere. This was a block north of Wall Street, and patrons were provided with the latest stock-market quotations by ticker tape. The brass bars and spittoons were kept immaculately polished.

94. BAR AND CAFÉ OF THE CASINO THEATRE, BROADWAY AND 39TH STREET (1900).

Kimball & Wisedell designed the Casino Theatre in Saracenic style, and when completed in 1883 Rudolph Aronson's oasis of comic opera and musical comedy contained an auditorium, a restaurant, a balcony terrace and New York's first roof garden. Lobated horseshoe arches, stalactite brackets, a dome more like Gothic tracery than like Moorish vaulting, its large, bulbous pendant having a ring of light bulbs dangling from the tip, overspread the sanctuary of refreshment. By 1900 its walls were bedecked with photographs of those who had performed on the adjoining stage over the past score of years (besides the large picture of Henry Bergman, Lillian Russell appears beneath the light fixture on the pillar; the man in the double portrait above is Nat Goodwin). The bar itself looked more like something out of McSorley's than the Arabian Nights. The building was demolished in 1930.

95. FRITZ'S CAFÉ, 124 CHAMBERS STREET (1906).

The bar is an elongation of the marble-shafted, mirror-backed New York pier table of the second quarter of the nineteenth century. Rails have been added top and bottom, and square posts rise from either extremity, with carrousel-type lion protomes at the summit, recalling the lion paws of the archetype. The pressed-tin cove and ceiling canopy the arena of white, starched linens and dark bentwood chairs. Ash trays and receptacles for seasoning—then as now—formed the centerpieces in such establishments.

96. A CHILDS RESTAURANT (PERHAPS THE ONE AT 47 EAST 42ND STREET; 1900).

Inexpensive, expeditious, sanitary and wholesome food (theoretically vegetarian) characterized the original Childs chain established in 1889. The one illustrated is tiled below and above the grained-marble dado, which is corniced with brass hat rack and coat hooks. The table tops and trestle plinths are of materials similar to that of the lower wall revetments. Seats are bentwood chairs and swivels. Propeller-fan stanchions force stale air to ceiling vents, and fixtures focus light on the diners, who sit shoulder to shoulder for their midday, midtown repast. Lazy Susans provide condiments and

additional serviettes. In nine shops, Childs fed between 15,000 and 20,000 persons each weekday in 1900. Self-service was the procedure; those desiring a glass of "Cold Fresh BUTTERMILK" fetched for themselves. The white-clad dairymaids only cleared the tables for the next customers.

97. THE O'NEILL AND BRISTOL OYSTER AND CHOP HOUSE, 364 SIXTH AVENUE (1906). In "the Village," a block west of Washington Square, this restaurant retained the Eastlake decorations and combination gas-and-electric lighting fixtures of a decade or so earlier. The flat paneling contrasts with the fully modeled banisters, railing and newel posts (with lantern finials) of the staircase. Planters on the low screen wall down the center contain aspidistras, and with mirror reflections on the side walls, the narrow room is opened up to respectable proportions.

98. MUSCHENHEIM'S "ARENA," 31ST STREET, EAST OF BROADWAY (1900). The Colonial Revival décor, Grand Rapids chairs and kerchief-type lamp shades bring this restaurant below Herald Square a step nearer to a home atmosphere. The carving on the pedestal post is remarkably similar to that on the natural-wood base of the pier in Fritz's Café (Plate 95), showing that a craftsman's work was mostly his own, regardless of the interior's style. Tinted glass in the arched windows admitted light but not the view into the spacious, barrel-vaulted back room. The simple contours of the table glasswear portend the characteristic shapes of the twentieth century.

99. THE GREEN TEAPOT TEA ROOM, 330 LEXINGTON AVENUE (1906). The domesticity of the Green Teapot is enhanced by a low ceiling with delicate plasterwork (compare Plate 48), a plate rail displaying an assortment of china pots and plates, framed engravings, a working fireplace, the Empire vase-splat and Victorian rose-back chairs, and a crystal candlestick and real flower and fern on each table. The total effect, the waitress and the patrons exude unqualified respectability. This place is typical of the ladies' tea shop, once omnipresent but now almost extinct.

100. LADIES' DEPARTMENT OF THE NEW AMSTERDAM NATIONAL BANK, 1411 BROADWAY AT 39TH STREET (1906). The mark of a discriminating institution early in the century was its ladies' entrance and/or ladies' department. In this

gilded repository of Athena, the acanthus surmounts piers and punctuates bars, furnishings are mahogany and plush, and a properly robed maid is in attendance. The principal rug is from the Caucasus.

101. THE GREENWICH SAVINGS BANK, SIXTH AVENUE AND 16TH STREET (1899). Begun on Carmine Street in 1833, the Greenwich Savings Bank moved up Sixth Avenue with the years. The building opened in 1892 at 16th Street was designed by R. W. Gibson. Its 50-by-150-foot interior was in the Roman tepidarium style and a forerunner of the outer concourse of Pennsylvania Station, built a decade and a half later. In the bank the public perambulated only around the perimeter of the sanctum devoted to the mechanics of banking, which today mostly are computerized.

102. THE TITLE GUARANTEE AND TRUST COMPANY, 176 BROADWAY (1916). A few banks in New York City still operate in such spacious marble halls, though with simpler furnishings and self-service in the matter of forms (and no feather duster exposed to view). The balcony affords more working space without curtailing the volume of the interior. The architectural order is composite. Its classic casing accords with the steel framework of the building no less closely than the leg-o'-mutton sleeves and sailor hat with the anatomy of the client in the foreground. The Title Guarantee and Trust Company had branches uptown (125th and 149th streets) and in other boroughs.

103. AEOLIAN MUSIC HALL, 42ND STREET BETWEEN FIFTH AND SIXTH AVENUES (ca. 1912–13). Byron was in his element when confronted with the proposition of photographing large interiors lacking daylight. In a theatre, he raised the camera above orchestra-seat level to include the depth of the stage floor. The Aeolian echoed the name of Aeolus, Greek guardian of the winds, and of the aeolian (wind) harp, and it appropriately featured a panoply of organ pipes across the rear of the stage. The style of the auditorium was such highly evolved American Colonial Revival that it was virtually English Adam, with broad, three-centered arches and vaults (having grilles in the pendentives for ventilation), and a plethora of gilded garlands. Feminine fashion of that period favored the singer: long-skirted, shoulders loose and back, chest out, and bust at

diaphragm level. In 1924 the Aeolian Music Hall was the locale of the Paul Whiteman jazz concert which introduced Gershwin's *Rhapsody in Blue.*

104. STAIRCASE WELL IN THE VANDERBILT PAVILION OF ST. LUKE'S HOSPITAL, AMSTERDAM AVENUE AT 114TH STREET (1899). The Episcopal hospital was incorporated in 1850 and occupied a building at Fifth Avenue and 54th Street in 1858. When this became inadequate, property for a new plant was purchased in 1892 on Washington Heights north of the site of the cathedral (St. John the Divine), and the French Renaissance Vanderbilt Pavilion, designed by Ernest Flagg, was opened the following year. Except for the plain capitals and plinths of the superimposed piers, the well containing the staircase wrapped around the gilded-cage elevator shaft was without architectural dress. The wrought-iron railings have a curvilinear design for the practical consideration of safety. This photograph illustrated an article on the hospital in the January 1900 issue of *Munsey's Magazine.*

105. THE JERRY MCAULEY BOWERY MISSION (1897). McAuley, a converted ex-convict, had opened an earlier mission on Water Street in 1872, and on the left-hand wall of this later hall is a plaque dedicated to him. The structural posts, braces and beams are encased in planks. The lighting and ventilation, by means of windows, air shaft and double-armed gas fixtures, are elementary. Crude artificial graining is on the beaded-board dado below the eye-level inscriptions, and a paper border encompasses the room adjoining the ceiling. The meeting-house wood benches and the hemp-rope runner on the aisle constitute the physical comforts offered. The Shaker simplicity of the benches would make them more desirable to collectors and home owners today than more opulent pieces of their period. A piano accompanied hymn singing, and the speaker's lectern and seats were raised a single step above audience level. The room was unpretentiously inviting, and it sought to eliminate barriers between the flounderers and rescuers. The current McAuley Mission is at 90 Lafayette Street.

106. THE NEW YORK OFFICE OF THE HAMBURG-AMERICAN LINE, 45 BROADWAY (1908). Symbolizing both the stability and the progressiveness of the transoceanic steamship company, the design of its ticket office is traditional and the handling contemporary. The arc motif determines the shape of the counter and the arches, which spring from piers of strongly figured marble. On the keystone of the principal arch hovers the goddess of transportation, who clutches Mercury's caduceus, the figure resembling those at the springing of the arches at the top of Louis Sullivan's Bayard Building (1897–90) on Bleecker Street. Putti flank the cartouches in the corners of the cove above, and latticed Art Nouveau glass panels between tie in with the skylight above. Lion's heads, swags and fasces are more conventional motifs.

107. THE NEW YORK OFFICE OF THOMAS COOK AND SONS, 245 BROADWAY (1906). Thomas Cook launched a new career through promoting a temperance tour from Leicester to Loughborough in 1841, and during the Paris Exposition of 1855 he took Londoners to Europe. Soon afterward he switched from conducting tours to planning them. The Thomas Cook and Sons branch in New York took care of arranging transportation and accommodations, looked after the conversion of money to foreign currency, and offered advice on where to go, what to do and how much it would cost. Travel folders are provided on the right, and bentwood chairs are for customers to sit and discuss problems over the counter. With a 10-day trip to Bermuda costing $47.50, one wonders today how serious their problems were.

108. A BARBER SHOP (1903). Excluding those times when it was customary to shave the head, the end of the nineteenth and first half of the twentieth century saw the male throughout the civilized world with the shortest hair in history. The barber shop did a booming business, and a full staff consisted of white-coated barbers, white-bloused manicurists and a bootblack-porter with whiskbroom under his arm. Marble tops were lined with bottles of tonics and talcums, and shelves held clients' personal shaving mugs. Gas and electric fixtures and mirrors scattered light and reflections about this emporium of grooming. Basins for shampoo are glimpsed to the right. Seniority of operators was signaled by a musical-chairs march from the back to the patrons' entrance at the front of the shop.

109. THE IVES BILLIARD PARLOR, 42ND STREET AND BROADWAY (1897). Elaborately carved 10-foot tables, carpeting, high tin ceiling, abundant

lighting, uniformed attendants and easy chairs for spectators distinguish this as a high-class establishment. There are tables for both kinds of billiards: the regular or French game, with three balls; and pocket billiards or pool, the English version with fifteen numbered balls and a cue, and pockets in the four corners and center of the two long sides of the table.

110. SODA FOUNTAIN IN A HEGEMAN AND COMPANY DRUGSTORE (1907). The soda fountain had become an American institution during the second third of the nineteenth century, and by the end of the 1800s, figured marble and onyx were its distinguishing substances. At Hegeman's they form a pavilion with canopy roof of beveled glass. The fountain centers on a thick square pier bedecked with grape lighting fixtures, and crystal-fringed lamps cap round marble pedestals on the counter. Beyond, at the far end of the empty confectionery case, may be seen the suction-tube device connecting with the cashier's desk for making quick change.

111. THE RIKER'S DRUGSTORE AT 23RD STREET AND SIXTH AVENUE (1908). Included among some 7,000 such refreshment stands was Riker's chain, scattered throughout greater New York at this time. The Chelsea shop resembles a contemporary bar (compare Plate 95), except for the difference in materials, the absence of a footrail, and the presence of carbonated-water spigots mounted on hefty marble balusters. Bronze figures hailing one another in the niches between the mirrors are symbols of the practice of meeting for a soda-water break at the fountain.

112. A BURDSELL DRUGSTORE (1907). Also belonging to a chain, the store shown crowds the soda fountain to a minimum for the greater display of merchandise. Prominent in the front case are Huyler's chocolates, and deeper in the emporium are towers of "Cucumber Cream Soap" and "Dr. Jackson's Remedy for Kidney's & Liver, 65¢ a Bottle." Other procurables are Sozodont dentifrice, Moxies and personality postcards. The sculpture in the lunette to the right evidently represents the effect of an unexpected ice-cream treat in the nursery. The intricate but industrialized cove and ceiling are designed and executed with feeling and care. Chandeliers are a compact intricacy of metal and glass.

113. A CORNER OF THE ABRAHAM AND STRAUS DEPARTMENT STORE, FULTON STREET, BROOKLYN (1907). The photograph was commissioned by the Brooklyn Metal Ceiling Company, as an example of a recent installation, at which time Abraham and Straus was nine or ten years old. In the foreground is the ladies' notion counter, and beauty and hygienic aids are on the case beyond. Alligator and leather handbags are around the corner. Farther afield are sewing and underwear sections, and in the rear may be glimpsed luxurious hammocks with pillows and fringe. The cash-credit system is accelerated by mechanical cups, which buzz along on overhead tracks and disappear through the ceiling for change or charge approval upstairs.

114. ABERCROMBIE AND FITCH STORE, 55 WEST 36TH STREET (1912). Abercrombie and Fitch recently had moved from Reade Street when this photograph was made. The latitude of sporting goods is shown to range from aids to relaxing, such as lounging in a sailcloth hammock (less elegant than that in the Brooklyn department store) and camping out in a tent (furnished with folding canvas armchairs and stands), to equipment for vigorously combating the snow, like snowshoes for tramping over the hills and skis for gliding down the inclines. Rear shelves are devoted to night provisions, including a kerosene lantern and all kinds of bedding. The sharply defined attitudes toward quadrupeds, from pampering the house pet with its own doghouse (upper shelf of case to the left) to exterminating all wild animals (steel traps, foreground), has altered (due to publicity on endangered species) over the last three-quarters of a century.

115. A DISPLAY AREA IN THE W. & J. SLOANE STORE, 884 BROADWAY (1902). Opened opposite City Hall in 1843, this furniture and carpet store has moved steadily uptown, except for its most recent shift from the corner of 49th to 38th Street on Fifth Avenue. The alcove shown is set apart by coupled Roman Ionic columns, a motif much used in pergolas and porches at the time. In front, the dolphin pedestal table, high crested armchairs, tufted semi-Turkish chairs upholstered to match, and cabinet-ended seat with Renaissance details and leaded glass in arched panels are neither authentic reproductions nor pieces showing much creativity. The vases with ormolu mounting and

the chandelier with fleur-de-lis escutcheons at the base of Rococo arms are no more remarkable than the pieces below.

116. THE MUSIC DEPARTMENT OF SIEGEL-COOPER COMPANY, SIXTH AVENUE BETWEEN 18TH AND 19TH STREETS (1899). Customers probably were waiting for their companions at the base of Daniel Chester French's 18-foot allegorical figure (a one-third-size reproduction of his *Republic* at the Chicago Fair) near the front door, before rushing the music stand, where the clerks seem well pleased with the latest hit tunes in sheet music. "She Was Happy Till She Met You" and "A Bunch of Rags" are being plugged. The framed portrait is of Andrew Mack, who specialized in performing plays with eighteenth-century Irish settings; he was then starring in *The Last of the Rohans*, which featured his song "Heart of My Heart." Chinese lanterns above create an alien mood.

117. FOOD COUNTER IN R. H. MACY'S DEPARTMENT STORE, HERALD SQUARE (1902). The midtown emporium of the Nantucket boy who made good in the big city was new when the photograph was made. Foodstuffs mostly were bottled or canned in those days. The sterilization process was discovered (though its connection with microorganisms was not understood) in France almost a century earlier, as a result of the prize offered by Napoleon for supplying his commissaries in the field. A familiar brand name still is Armour's, whose "Star" bacon and lard are displayed here. There is also Armour's grape juice. Another prominent brand was Veribest. Cans of ox tongue and pork and beans are to the clerk's right, and farther down the counter are Veribest's mince meat and chile con carne. Various candies are immediately to the right, and preserved fruits are on the shelf behind the attendant. A tall pyramid of Lighthouse cleanser is in front of the column (center). Bottles of spirits are at the rear. The supermarket concept is adumbrated here.

118. THE STORE OF JOSEPH FLEISCHMAN, FLORIST, 71 BROADWAY (ca. 1899). Most of the room is viewed as a reflection in the mirrored wall behind the marble-topped table in the center of the photograph. Through reduplication, square chandeliers with crystal ropes and pendants make an impressive display. Fleischman pioneered in selling fresh as opposed to artificial flowers, and the re-frigerated case contains his store of "High Class Flowers at Fair Prices." Although the angle was chosen carefully, the camera managed to catch its own image through the small office to the right (directly over the telephone).

119. HENRY MAILLARD'S RETAIL CONFECTIONERY AND LADIES' LUNCH ESTABLISHMENT, 1099 BROADWAY AT 24TH STREET (1902). Maillard came to New York from France in 1848 and opened a candy factory on Walker Street. A quarter of a century later he was turning out 3,000 pounds of sweets daily. At the beginning of the 1900s his principal retail shop was under the Fifth Avenue Hotel. The allegorical ceiling paintings are by Charles Mueller. Floors are inlaid with patterned mosaic tile and covered with carpeting. The season approaching the anniversary of Easter, the Teutonic goddess of fertility is being panegyrized through her emblems of eggs, baby ducks and chicks (stuffed) and flowery baskets. For the moment the chocolate delicacy is being suppressed beneath the springtide trimmings.

120. CIGAR STAND AND McBRIDE'S TICKET AGENCY IN THE HOTEL CADILLAC, BROADWAY AT 43RD STREET (1907). Eugene O'Neill was born in this hotel, then called the Barrett House, in 1888. The Astor Hotel opposite (a block north of the buildings seen through the windows, right) was but three years old when this picture was taken. The square (now Times Square) was the nucleus of the theatre section, and "Broadway" was acquiring a new histrionic meaning. Five wall phones and two table models indicate a good call-in business for theatre tickets. Posters advertise *The Man of the Hour* at the Savoy Theatre (Douglas Fairbanks was in the cast), Raymond Hitchcock in *A Yankee Tourist* at the Astor Theatre and Lew Fields in *The Girl Behind the Counter* at the Herald Square Theatre.

121. MOE LEVY AND COMPANY, CLOTHIERS, WALKER STREET (1908). Frills and fancy décor are eliminated in favor of featuring the merchandise in this well-stocked depot of men's furnishings, where the clerks are tailored in the latest fashion as sales models. Radiators are twisted around columns to conserve space, and clothes are displayed at mid-shaft. The stacks of garments are high for wide selection, and the scale of prices is low. A Brooklyn branch of Levy's operated on Fulton Street near Gage and Tollner's gaslit restaurant.

122. SIMPSON, CRAWFORD AND SIMPSON COMPANY, SIXTH AVENUE BETWEEN 19TH AND 20TH STREETS (1904). A bit upstream in the popular shopping concourse centered at Sixth Avenue and 14th Street, Simpson-Crawford's rebuilt in 1900 from plans devised by William H. Hume and Son, architects, and the new store was provided with the city's first Otis escalator. The Easter decorations in the Francis I court, shown here, were made by the Bronze and Papier Mache Company of 345 West Broadway. Lilies are real and simulated in heroic size. The mammoth bunny emerging from the 18-foot egg could bow and turn his head and wink, and he was attended by fifty smaller versions. All resemble Tenniel's version of Alice's host, the March Hare, at the subterranean tea party.

123. AN ART GALLERY OR AUCTION ROOM (1905). Genre subjects predominate, followed in frequency by landscapes, in these paintings, all of which are presented in heavy, gilded, custom-made Rococo frames. Most of them are set in shadow boxes, undoubtedly as an expedient to prevent chipping of the fragile scrolls in handling. The oils seem mostly the work of lesser artists of former periods, spanning from a seventeenth-century cellist wearing a ruff, through mid-nineteenth-century peasant scenes (à la Millet). Chairs back-to-back indicate more paintings opposite.

124. A PORTRAIT PHOTOGRAPHER'S STUDIO (ca. 1893). The *fin-de-siècle* photograph of grandmother, looking very much at home in her surroundings, may have been taken in a studio like this, where the background reflected the sitter only inasmuch as she selected it in preference to others from the limited stock available. Light coming through the great skylight was supplemented by reflectors and flash for a good impression of the patient subject, who, after all, could hold a pose, without visible movement, only momentarily. The heirloom image of grandmother had for intermediary a perishable glass negative.

125. THE BOOKKEEPING AND EXCHANGE DEPARTMENT OF *The New York Dramatic Mirror*, 1432 BROADWAY AT 40TH STREET (1898). First issued at the beginning of 1879 as *The New York Mirror*, the weekly claimed shortly before Byron's professional visit that it had been for some twenty years "the organ of the American theatrical profession," justifying the addition of the word *Dramatic* to the title. Its proprietor was Harrison Grey Fiske, husband of the stage luminary Minnie Maddern Fiske. The pictures on the wall reflect some of the interesting theatrical characters who made the office their occasional rendezvous. To them the *Dramatic Mirror* lent a sympathetic ear; its editorials led to the founding of the Actors' Fund of America. Office space is restricted: lavatory and telephone are within arm's reach of one another, and papers needing another's attention could be handed over without rising. This was part of the secret of getting out in time over 2,200 issues before the periodical expired in 1922. This photo appeared in the 20th-anniversary issue, Christmas 1898.

126. OFFICE OF THE BUTTERICK PUBLISHING COMPANY, 161 SIXTH AVENUE (1904). Ebenezer Butterick, a tailor of Sterling, Massachusetts, conceived the idea of printing clothes patterns and opened an office at Broadway and John Street, New York, in 1864. Byron's photograph was made soon after E. Butterick and Company had moved into its own 16-story building at Spring Street and Sixth Avenue. The architectural design was by Horgan and Slattery, and interiors were by Louis Comfort Tiffany. The office is simple and a unifying motif is the stylized tulip appearing in the clerestory and on the soffit of the ceiling beams. The furniture is in the craftsmanship-mission style, characterized by square members, panels and brass studs, and it came from the workshop of Gustav Stickley. The Butterick Fashion Marketing Company still operates in the same building, though now a division of the American Can Company.

127. OFFICE OF *Success* MAGAZINE, 32 WAVERLY PLACE (1902). The pull-up canvas awning disappeared from the American window long before it was replaced by the air conditioner. *Success* was a title that appealed to the normal American of the time. The editor and publisher of the monthly sits before a remarkably commodious desk, its kneehole cavernous and its pigeonholes of aviary proportions. The ends of the roll top are hinged to open back, and a multidrawer case is on top. To the right are cover designs, and to the left is *The Success Library*. A bamboo easel holds an illustration. The Grand Rapids chairs are nondescript. This seems to be a time exposure taken only by

daylight: the photographer's hands in the lower left corner count off the seconds for holding the pose.

128. OFFICE OF EARL AND WILSON COLLAR MANUFACTURERS, 33 EAST 17TH STREET (1903). A business that rode the crest of fashion, Earl and Wilson was one of a number of makers of men's detachable collars, which were of paper, celluloid or starched cloth. The labyrinth of banistered corrals provided well-defined spaces for executives and employees, and it symbolized a well-ordered bureaucracy. The pilastered screen with leaded colored-glass windows further departmentalized the workers. Electricity has been brought down to the desk lamps. No females are visible in this headquarters of male attire, which enjoyed a lucrative reign until the whim of fashion changed.

129. OFFICE OF THE AMERICAN TYPE FOUNDERS COMPANY, 2 DUANE STREET (1902). The exposed brick walls, the plain piers, the suggestions of steel-and-concrete inner construction, the natural-wood floors, the suspended lighting and the similar tambour desks do not measure up aesthetically to the white-collar office just shown. Nor is the office protocol so firm: the presses to the right and rear indicate that the top staff has a close affiliation with the production operations of the concern. A single prim secretary breaks the sex rigidity of the staff.

130. A LOUNGE ON DECK A OF THE S. S. Lusitania (1907). Built in 1906 for the Cunard Line, the turbine-powered luxury liner was given quiet Classical decoration with a neat elegance of detail. Upholstered, built-in seats to either side of the simplified Adam mantel afforded the coziness of the county-house inglenook, and a porch-like informality is effected by the inlaid linoleum floor, uncarpeted, the potted palms, and the wicker chairs and tables.

131. DECK A DINING SALON ON THE Lusitania (1907). Probably the same as the Verandah Café, listed on the left-hand post in the preceding plate, the dining area is arranged around an open circular well supported by Roman Ionic columns. Palms spill over from the collection in the lounge. The furniture is bolted to the floor. Well-padded chairs swivel for ease in sitting down at or leaving the table. The cachepots on each table are Art Nouveau. The Lusitania was torpedoed by a German submarine off the Irish coast on 7 May 1915. This hostile action against a civilian vessel prompted resentment in America and led to its support of the Allied cause in World War I.